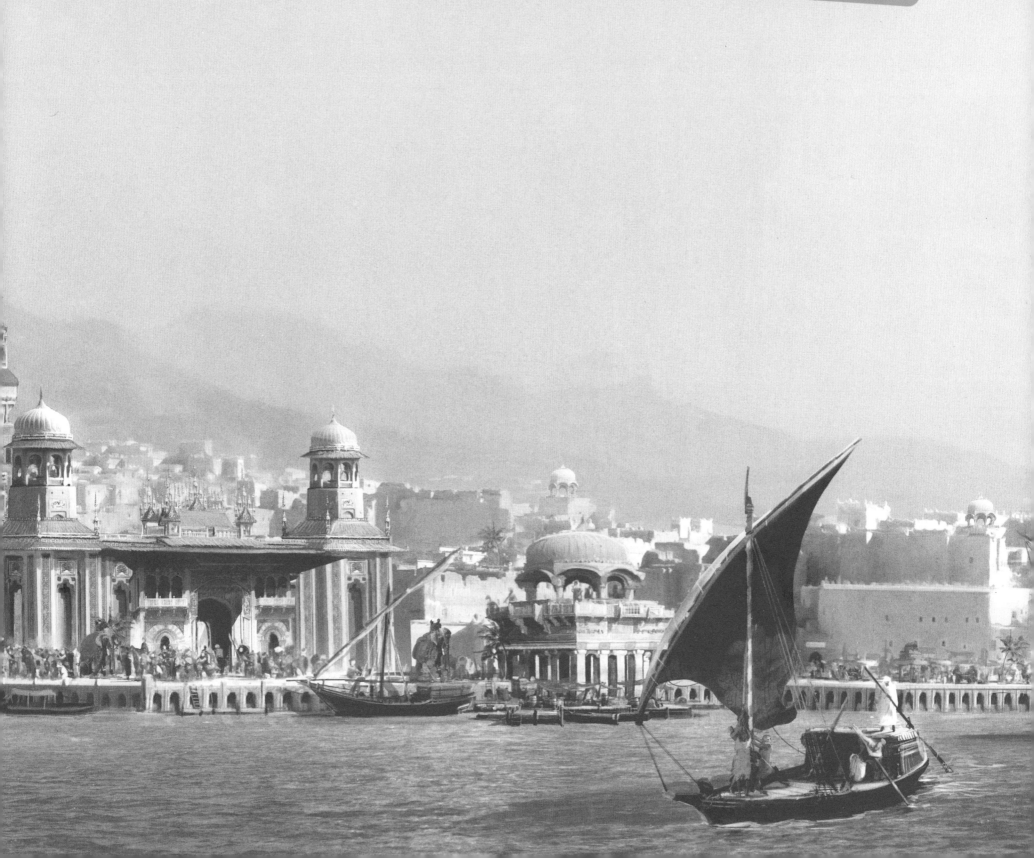

THE ART AND MAKING OF

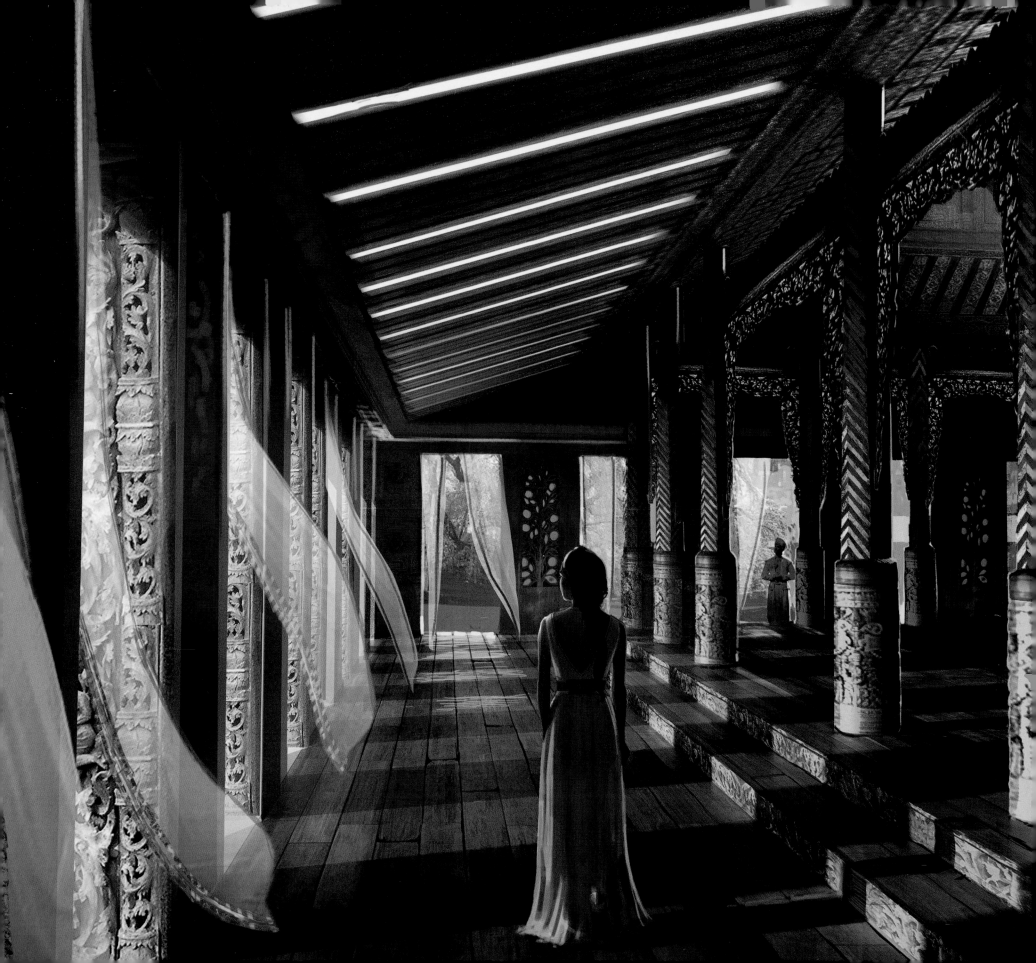

THE ART AND MAKING OF

Disney

Aladdin

INTRODUCTION BY GUY RITCHIE
WRITTEN BY EMILY ZEMLER

INSIGHT
EDITIONS

San Rafael, California

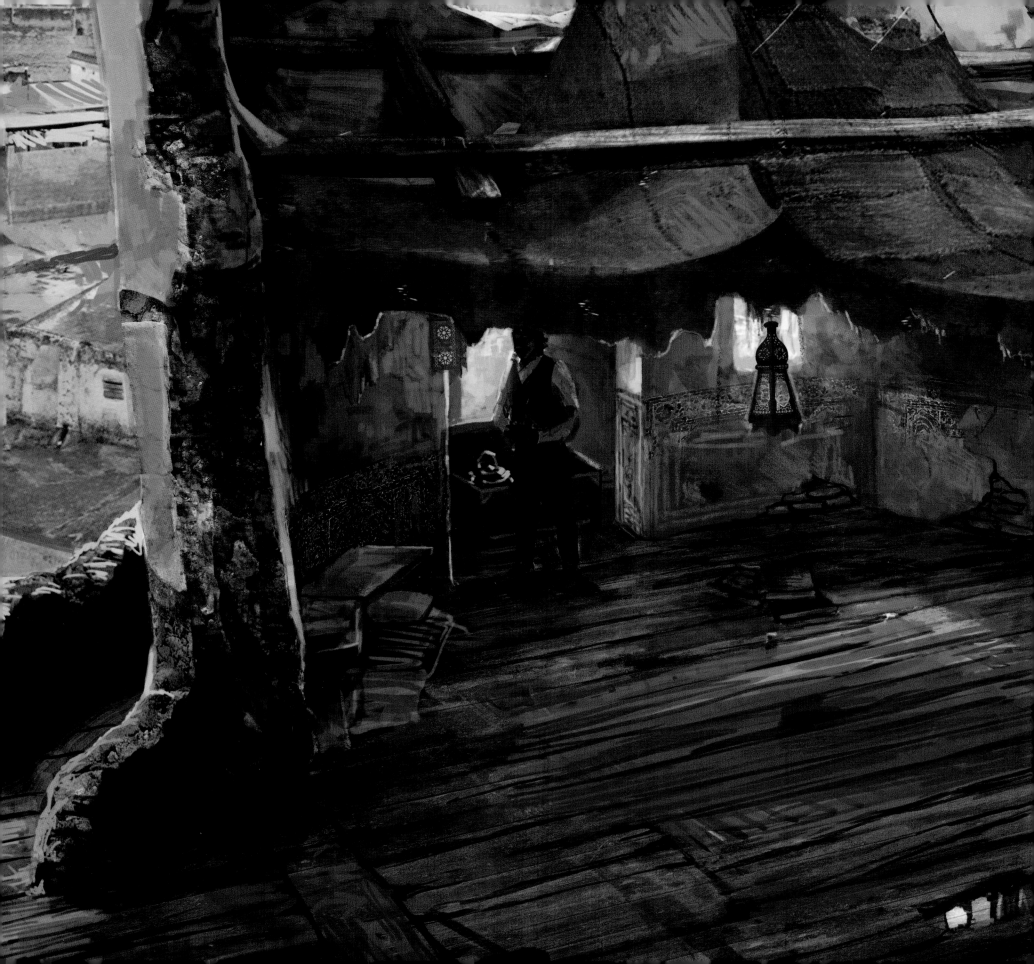

CONTENTS

PAGE 2: Concept art depicting Princess Jasmine walking through the palace.

OPPOSITE: Concept art showing Aladdin in his tower.

INTRODUCTION
By Guy Ritchie

When I was approached with the idea of making a live-action version of *Aladdin*, I had an instinctual reaction to say yes. Because I have five children, I already live in a world of Disney, and I knew I could manifest an original version of the character Aladdin. The movie is very much about how a street kid can transcend his roots, a theme I've previously explored in my films. I felt that *Aladdin* would fuse two worlds—Disney's and my own—which is what made it exciting for me.

Disney and I were on the same page from the very beginning—they wanted a filmmaker's vision for this movie, one that would provide a natural evolution to the story with the transition to live action. I aimed to impress a fresh take upon the narrative without departing drastically from the nostalgia of the animation. The film needed to have just the right balance of old and the new.

Jasmine is a modern Disney princess with a definitive voice and new aspirations. Aladdin's character arc is about coming face-to-face with temptation and learning from it—it is a classical narrative: Temptation allows the character to evolve and delineate his identity; it leads to the realization of one's inherent value, irrespective of the environment into which one was born.

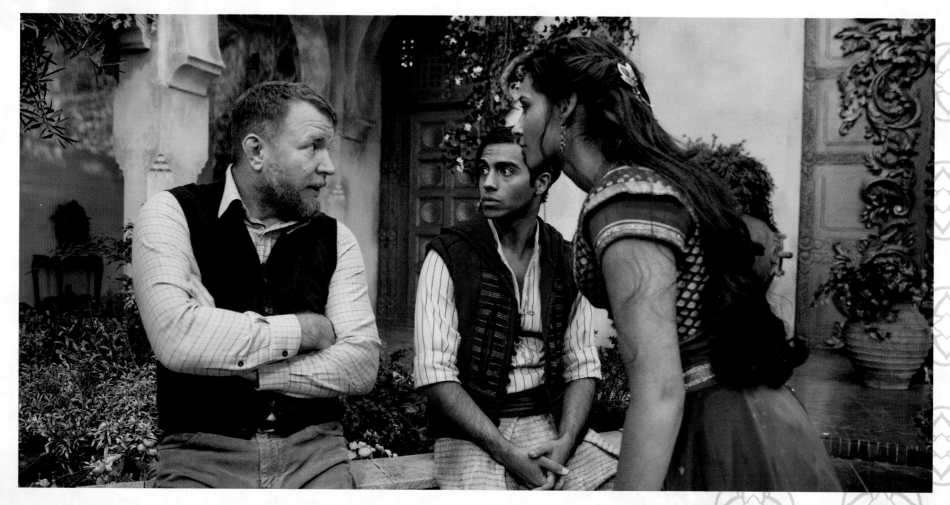

BELOW: Director Guy Ritchie speaking with Mena Massoud (Aladdin) and Naomi Scott (Princess Jasmine).

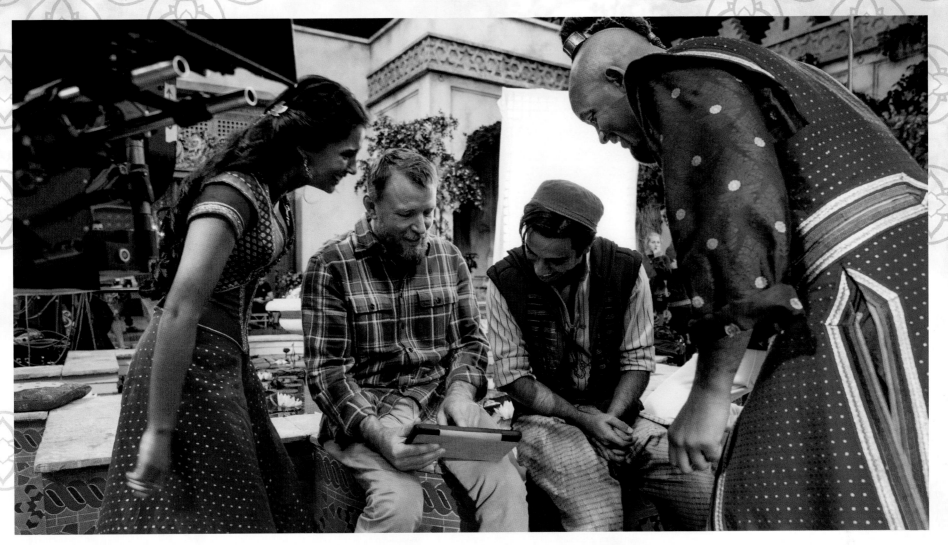

ABOVE: Guy Ritchie explains a scene to Naomi Scott, Mena Massoud, and Will Smith.

Although I love the big, wild song-and-dance numbers in the film, one scene in particular represents the nuance and charm I was trying to conjure in this retelling: the moment when Aladdin breaks into the palace and meets Jasmine for the first time. There's a sort of chemistry and magic between them. Ultimately, *Aladdin* is a human story told in a fantastical world of magic and music.

Most of my films have been heavily influenced by music. In fact, I'm surprised I've never made a musical before. I see songs as the perfect interface between the prosaic and material and the theatrical and the ethereal. The music in *Aladdin* is an efficient vehicle that allows you to take a sojourn somewhere whimsical and exciting.

Getting the Genie right was our biggest task, and we had to make sure our film reinvented the character. Robin Williams went down a particular path for his interpretation, and we found ourselves going down another with Will Smith. Will and I

discussed in depth how best to re-visualize and revisit the character. We wanted to have a dynamic, entertaining, serious, and witty Genie that also felt organic. Working with Will was a wonderfully creative and positive experience for me. I'm excited by what I feel is a confident and fresh interpretation of the Genie.

The book you hold in your hands offers a glimpse into the process of reimagining Agrabah and reveals the detail and care that went into every aspect of the filmmaking process. I've enjoyed making this movie more than any other. There is a positive DNA at the core of this story. Even though it was challenging creatively, we never stopped trying to come up with new ideas. This is the sort of film I would like to sit down and watch with my kids, and I hope the audience feels the same, and that watching *Aladdin* is an exhilarating, fresh experience for them. I hope they'll find themselves lost in a whole new world.

–Guy Ritchie

Chapter 1

RETURNING TO AGRABAH

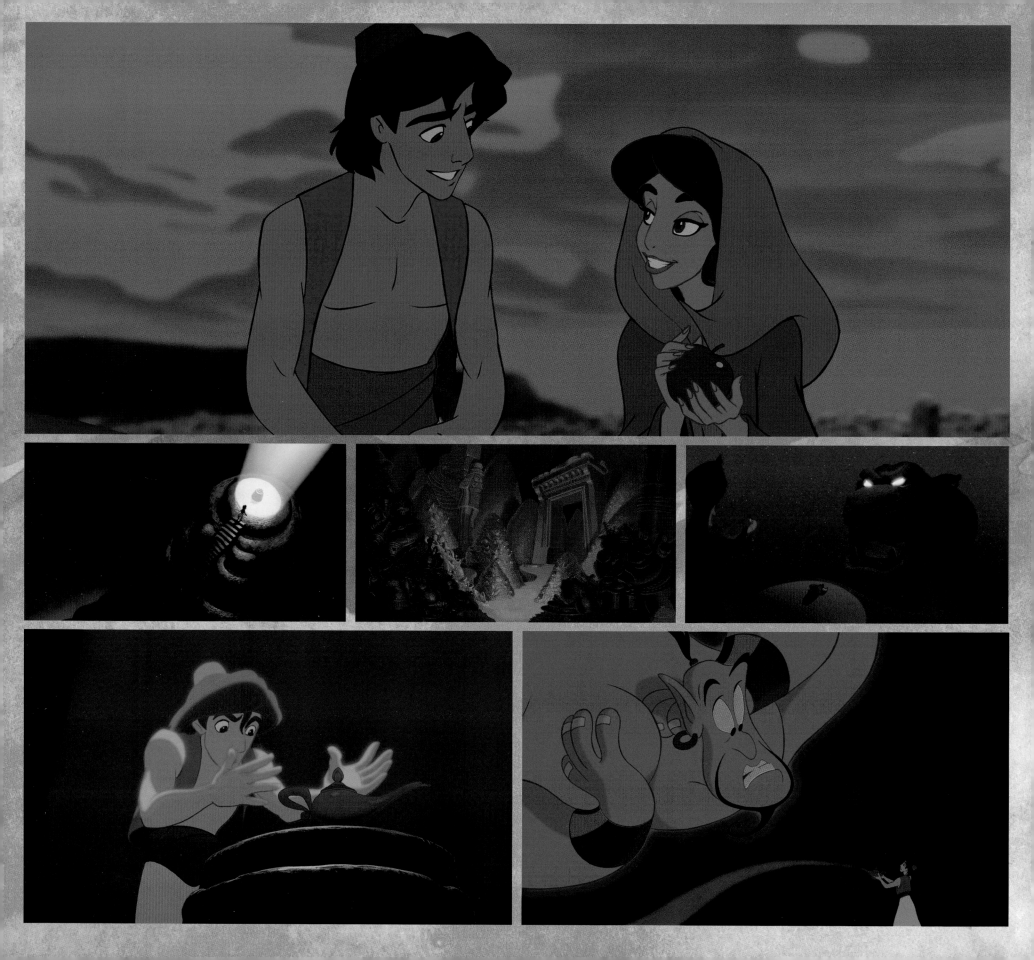

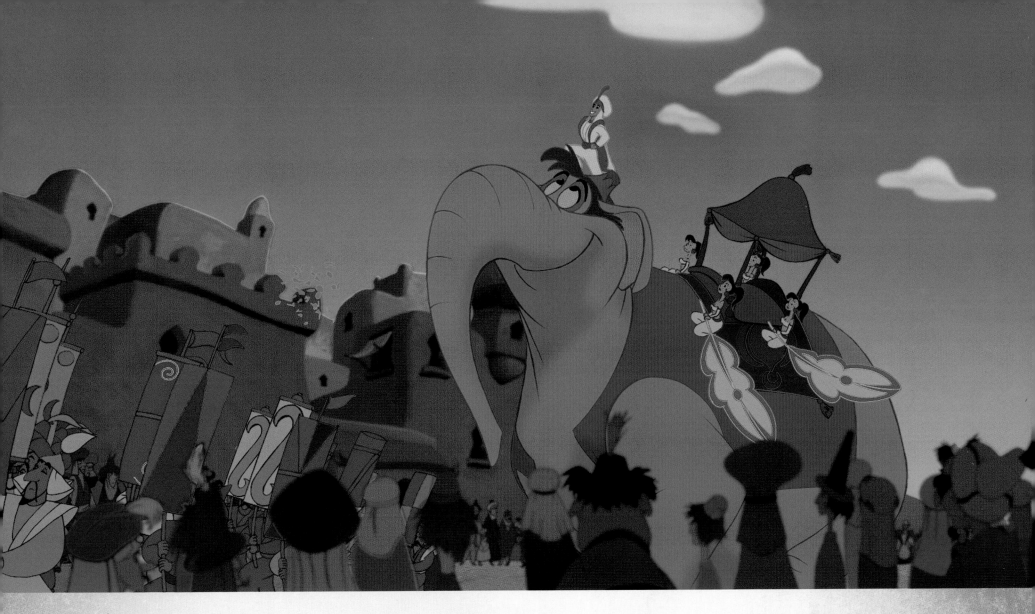

In 1992, a magical animated tale arrived on movie screens, transporting viewers to a whole new world filled with stunning palaces, powerful magic, a desert cavern that overflows with riches, and beloved songs. *Aladdin*, created by Walt Disney Animation Studios and directed by Ron Clements and John Musker, has since stood the test of time, becoming a favorite movie of adults and children all over the world. The story was adapted from a Middle Eastern folktale that appeared in *Arabian Nights* called "Aladdin and the Magic Lamp," and Disney's version brought the tale to life with original music composed by Alan Menken. Set in the fictional city of Agrabah, the story of a street rat named Aladdin and his journey to the palace unfolded with heart, comedy, and dramatic flair, thanks especially to the performance of comedian Robin Williams, who voiced the Genie.

At the end of 2015, producers Jonathan Eirich and Dan Lin approached the studio to develop and produce a live-action remake of *Aladdin*, pitching a version that would pay homage to the original while translating it for contemporary audiences. The idea was to take inspiration from the first film, both visually and emotionally, and to retain its iconic songs and characters—but with a fresh new take. Eirich felt that selecting the right director for the film would be essential to reimagining the tale through an original lens without losing any of its core elements. "The big breakthrough for all of us to realize was, 'Okay, we don't have to necessarily reinvent all the story if we just bring a different perspective and a different attitude in the way we're making the movie,'" Eirich says. "It's got to feel fresh and yet still deliver on everything that audiences are looking for in *Aladdin*."

PAGES 8–9: Concept art showing the port of Agrabah.

OPPOSITE TOP: Aladdin and Jasmine share a moment in the original 1992 animated movie.

OPPOSITE MIDDLE ROW: The Cave of Wonders from the animated film.

OPPOSITE BOTTOM ROW: Aladdin reaches for the magic lamp and encounters the Genie in the animated film.

ABOVE: Aladdin enters Agrabah with a parade during the animated sequence for the song "Prince Ali."

To help imagine the colorful world of *Aladdin*, the producers brought in Guy Ritchie, a director with an energetic vision for the story who also felt connected to Aladdin's plight as a street kid. "With *Aladdin*, we wanted to make sure we embraced having a really good time with the movie while still delivering all of the emotion and impact," notes Sean Bailey, president of production at Walt Disney Studios Motion Pictures. "[Guy] brings a tremendous amount of energy and fun. If you look at Guy's body of work, a lot of the films I most admire are about street hustlers if you look at the root of them, and I think if you look at the root of *Aladdin*, it's one of the definitive tales about a street hustler who ultimately made good."

For Ritchie, joining the film was a no-brainer, as the director had an immediate reaction to the new script, written by John August. Aladdin's story was reimagined with more contemporary relevance and new characters. Ritchie notes, "As soon as I heard Disney was creating a live-action version of *Aladdin*, I thought, 'Well that's a bit me.' Most of the movies I choose to work on are about a gut reaction, and that happens in seconds. For a start, I was interested in doing a musical. I've got five kids, which does influence the decisions that you make, and my house is all about Disney at the moment, so there's a conspiracy of elements that encourage you to go certain directions."

He adds, "The conversation that I had with Disney, initially, was about how they wanted a filmmakers' interpretation, so I hope it feels like a director's film. I like embarking on new creative challenges, and this was certainly that."

The cast took to Ritchie's vision quickly, especially actor Will Smith, who reimagines the Genie in a fresh and unique way in this film. "What's great about Guy, particularly for this project, is that Guy's really edgy," Smith says. "He's a little bit rough—he practices mixed martial arts every single day so he's like a gruff, hard fighter with this tender heart pumping at the center. [This film] doesn't feel like any *Aladdin* that you've seen before. He just knows where the heart is. We laughed, we cried—it was fantastic. He's giving you that full spectrum of emotion in a way that's current and powerfully unique."

LEFT: The sun rises over Agrabah, a bustling port city.

The filmmakers' goal was to create a movie for viewers of all ages, genders, cultures, and backgrounds, offering a universal tale of what it means to find your inner strengths and become comfortable with yourself. This version of *Aladdin* reframes the story by bookending the narrative with a character called the mariner recounting the story to his two children. This reframing offers an entry point for young viewers and also adds more details to the Genie's story, hinting at what's happened since Aladdin freed the Genie from the confines of the magical lamp. The mariner also replaces the character of the peddler from the original animated film and pays homage to the fact that directors of the animated film, Clements and Musker, had always intended to reveal that the peddler was the Genie at the end of the original movie. Ritchie's ultimate goal was to make the film

into a comic adventure, packed with action, stunts and chase scenes, while always being mindful of the relationships and heart at the core of the story.

Ritchie was inspired by the idea of telling the story of a kid from the streets but in a new environment—in a Disney film. "I thought I could take a sojourn into that creative sphere. Aladdin was familiar enough as a character, and the Disney tableau was exotic enough for me to be inspired," Ritchie says.

To make Agrabah relevant to today's world, the filmmakers shifted its location from desert-bound metropolis to bustling port city. It's a fictional, mythological locale in an undefined time of the past, but the city is grounded in Middle Eastern history. Agrabah is located along the trading route known as the Silk Road, making it a hub of cultures and

BELOW: Concept art showing a wide view of Agrabah's bustling docks.

OPPOSITE: Concept art showing the varied people that inhabit Agrabah.

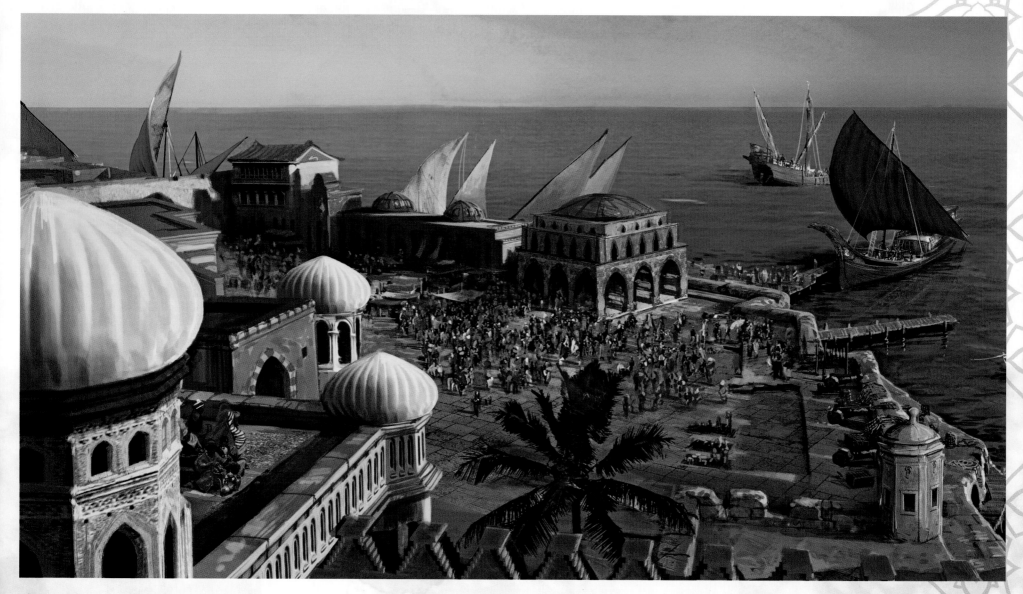

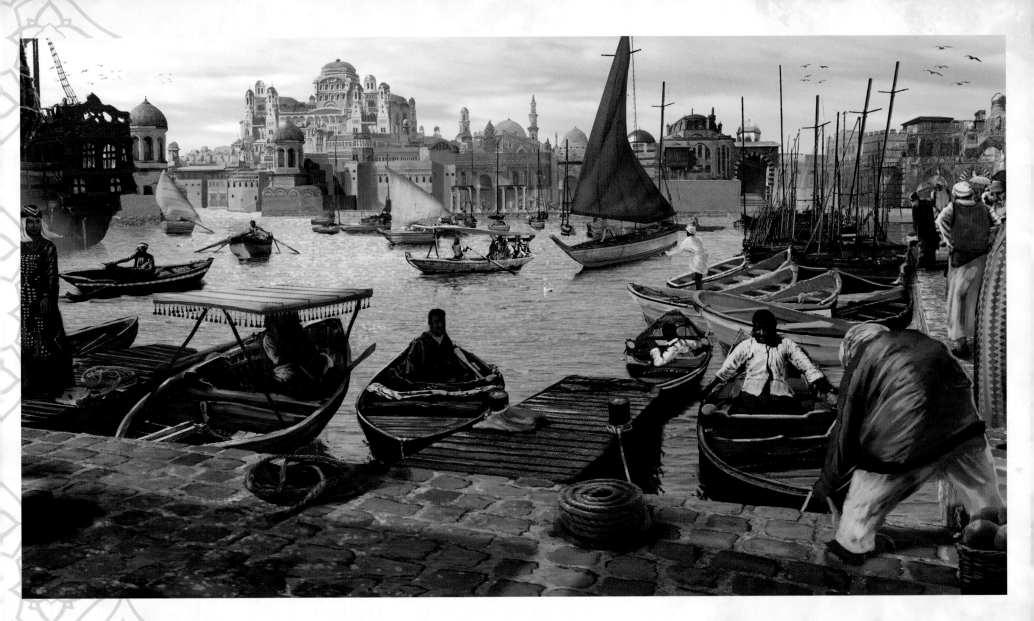

bringing together people from across the region. Inspiration was drawn from the Middle East, North Africa, Central Asia, India, and China, and the city itself is a mix of all sorts of inhabitants.

"Everyone on the production wanted to embrace that," executive producer Kevin De La Noy says of Agrabah's diversity and authenticity. "Everyone wanted to be true to the text and true to the story."

Bailey adds, "We wanted to be very respectful of the culture in the making of *Aladdin*. We talked to a number of experts and consultants from all over the world with a lot of perspectives on both the text and the region. Agrabah is a fictional place. We established it as a center of commerce between Africa, the Middle East, Asia, and Europe. So while it is still fictionally of

the region, it also has people coming and going and trading from all over those regions."

Along with the refreshed setting, new characters also arrive in the story, including Dalia, Jasmine's handmaid who acts as the princess's confidante and friend. A palace guard named Hakim also comes into the mix, as does Prince Anders, an outrageously dressed suitor of Jasmine's who travels to Agrabah from the far north.

De La Noy notes, "By putting these other characters in, they bring new forces with them in the script, they bring humor within the script. You've got more things going on—it's more engrossing, the narrative is more complex. It just gave us more people to cut away to, better conversations, more fun. It's a more complex story."

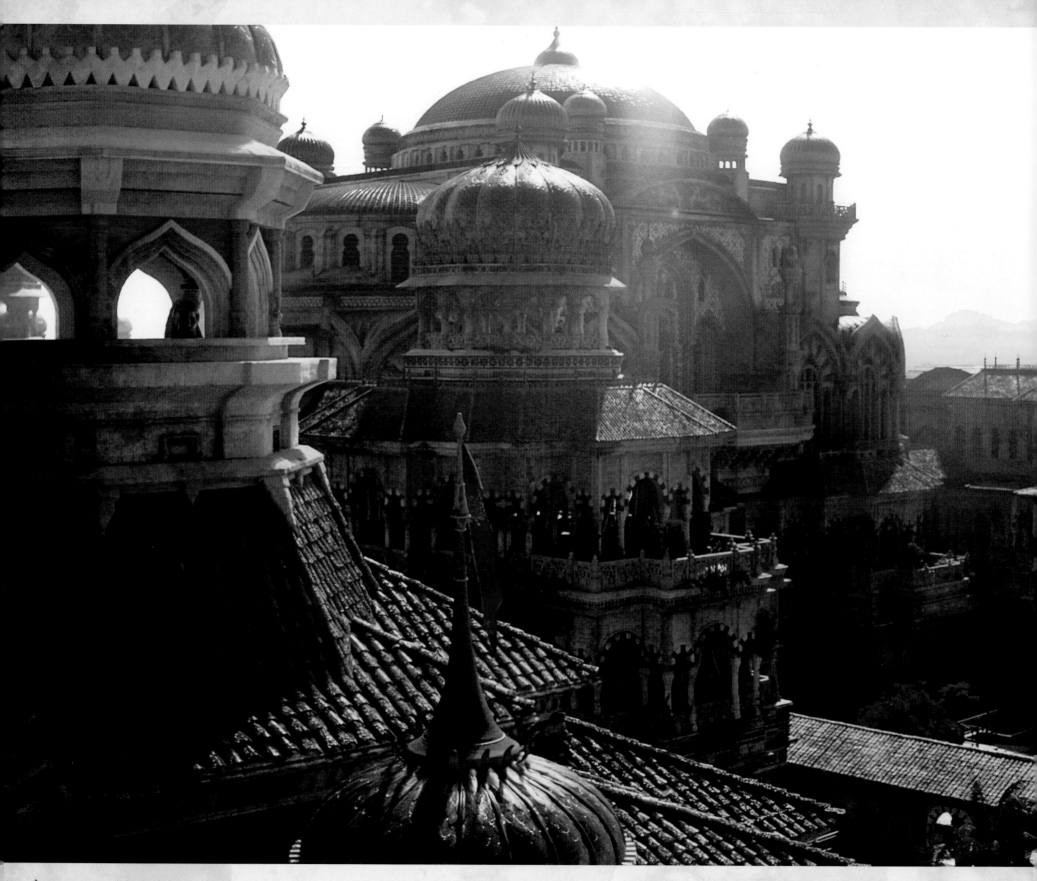

Music is a key element in the original *Aladdin*, so the film-makers wanted to update the iconic, classic tunes, as well as add new songs. Alan Menken, the original composer for 1992's *Aladdin*, as well as 1991's *Beauty and the Beast* and other iconic Disney classics, returned to helm the music, and Benj Pasek and Justin Paul, an award-winning duo who have composed music for Broadway plays such as *Dear Evan Hansen* and movies including *La La Land* (2016), were brought in to pen new lyrics. Directing a musical was a first for Ritchie, who embraced the challenge of building massive spectacles of song and dance.

"This is a musical in its traditional form," the director remarks. "I like the challenge of that. I'm not trying to be too ambitious in what it is that we're creating, and I'm not trying to reinvent the wheel in terms of a musical. I want to just make sure that it felt fresh and contemporary, but simultaneously doffing my cap to the original tone of the animated film."

In many ways, this is the Agrabah fans grew up with, inhabited by familiar characters that viewers have enjoyed for years over and over again. It's infused with new energy, its spark relit so the magical world of Aladdin now exists in a new medium that connects fans to the timeless story once again.

"You want to go see the *Aladdin* that you fell in love with when you were a kid, but you also want to re-fall in love with it," notes Mena Massoud, who was cast in the title role of Aladdin after a long casting search. "We as a society, as a generation, have grown up, so we want to see these remakes grow up with us. We're different now, so we have different influences. Yes, you want to bring the authenticity of it, but you also want to bring a different flair. We want everybody in the theater, whether you're seventy years old or five, to leave this movie theater falling in love with these characters, falling in love with the story, falling in love with the world that we've created."

LEFT: Agrabah's palace.

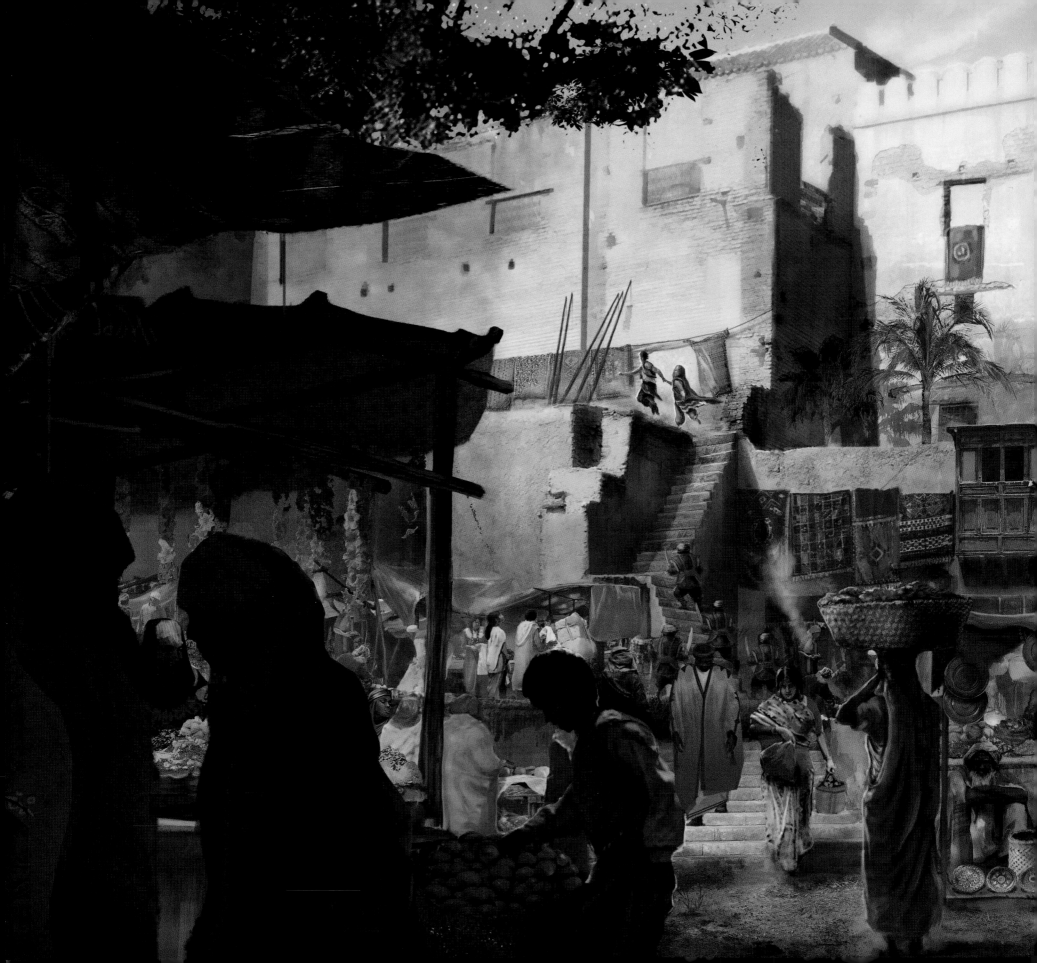

Chapter 2

CREATING A GLOBAL CAST

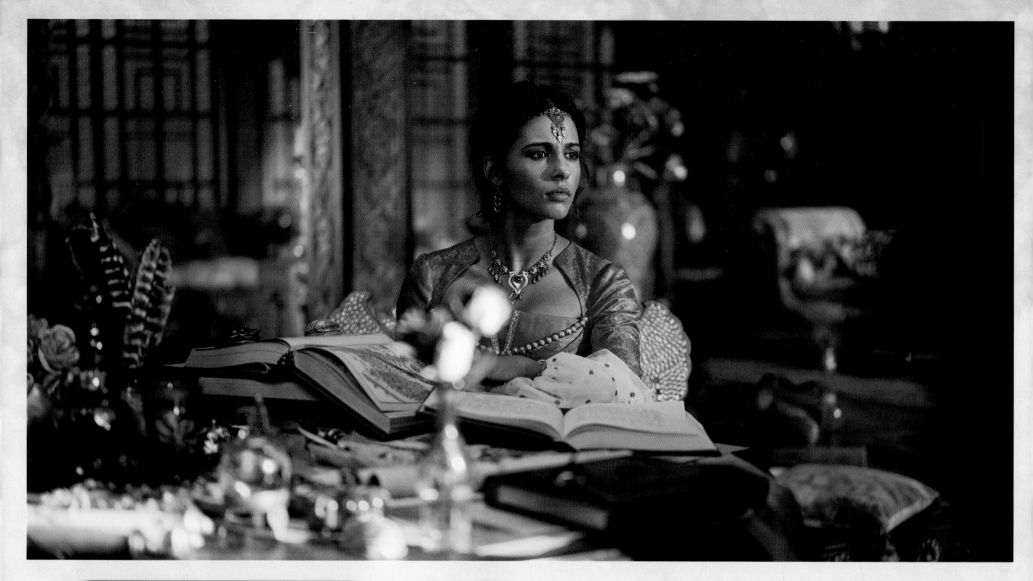

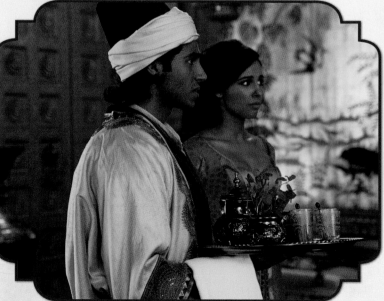

Finding the right actors to embody much-beloved animated characters was a priority for Disney, especially since the filmmakers wanted to ensure authenticity in the casting. The call was put out in the spring of 2017 searching for Middle Eastern, Indian, North African, and Asian actors who would fit Agrabah's diverse makeup—performers who could sing and, ideally, dance. Hundreds of actors were considered for the iconic lead roles of Aladdin and Jasmine, and finding the right actor to play the multitalented Genie was a special challenge.

"We were exhaustive in casting all throughout the region. We met thousands of actors from the region in trying to deliver the very, very best cast for this," says Disney's president of production Sean Bailey.

"What's so incredible about this movie is we've been able to have such a diverse cast, and there are so many different

PAGES 18–19: The city of Agrabah teems with life in this concept art.

ABOVE: Jasmine, played by Naomi Scott, sits in the palace reading her books.

BOTTOM LEFT: Aladdin and Jasmine in the palace, after he has snuck in to see her.

influences," remarks Naomi Scott, who plays Jasmine. "We've been able to create this gateway into the Eastern world. It is fantasy, and it is obviously not a real place, but we've been able to take from all these different cultures to create our own world. I think it's important to show this world in such a beautiful, fun, and adventurous way, and to show these positive, amazing, strong characters in a positive light. What an awesome discussion opener for a child who doesn't really know much about this area of the world and for them to see it in a fantastical and magical way."

The emphasis on using actors primarily from the countries and regions that influence Agrabah extended beyond the starring cast members, all the way to the extras and background dancers. Shooting in London allowed the filmmakers to search out a variety of extras from different backgrounds to fill out the shots. "Our extras casting department have been sensational," executive producer Kevin De La Noy notes. "We have extras from all over the Middle East—every country is represented in the huge breadth and width of our casting. The diversity of faces, colors, and creeds was true to the story, which is great."

Ultimately, the filmmakers built a global cast who brought the vibrant world of Agrabah to life. Each actor brought something unique to the table during the film's production, giving the well-loved characters a new shine.

BELOW: Jafar, played by Marwan Kenzari, stands in his study.

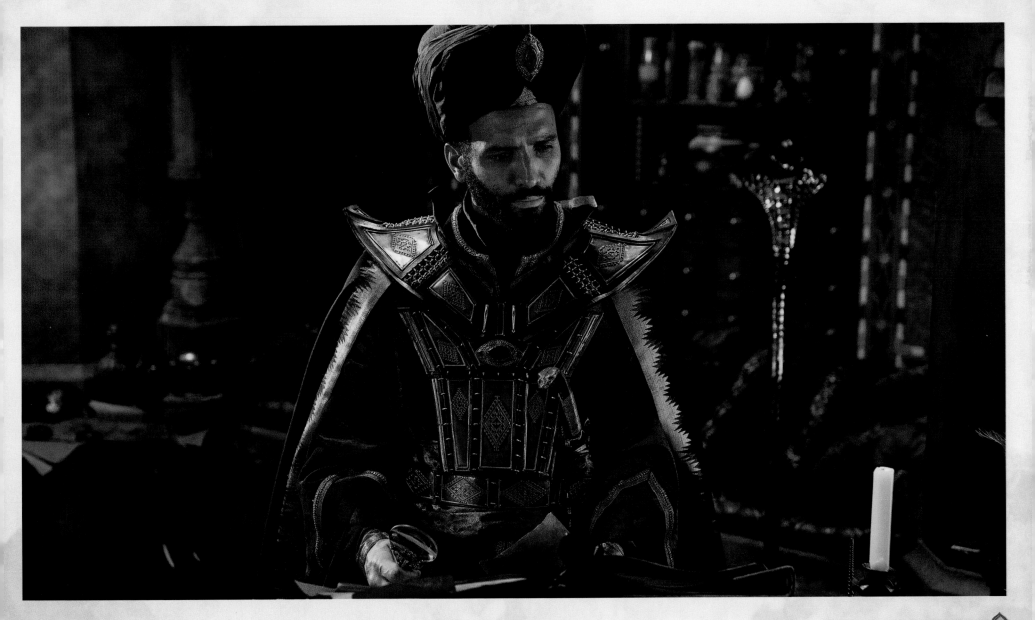

Aladdin
MENA MASSOUD

The search for the right actor to play Aladdin took the filmmakers across the globe and back. The audition process was extensive, with numerous screen tests and reads for each potential actor. Ultimately, the team went with Mena Massoud, who was born in Cairo, Egypt, and grew up in Canada. Massoud initially sent in an audition tape and then anxiously waited to hear back as he was shooting the TV series *Jack Ryan*. The producers eventually asked for another tape, and later brought him to London to read, where they were impressed with his grounded take on the character. "You have to go through the process," Massoud says. "You have to do this a few times because they want to get it right."

Once they were 100 percent certain, the filmmakers offered Massoud the role. As director Guy Ritchie puts it, "We were very fussy about our Aladdin. It did take us a long time, and I could argue that it may have been the most thorough search in history for a role. We looked on almost every continent and I think most countries. It was only three weeks or so before we started principle photography that we were convinced we found the right guy and when you look back, you can't imagine that it could have been anyone else."

Producer Jonathan Eirich says, "It's amazing how late in the process we found Mena. The whole search for Aladdin was fairly well documented in the media, and part of the challenge for Guy and the team was just being relentless about finding the absolute, perfect actor in terms of performance who was also culturally true to the part." This version of Aladdin stays true to the original animated character but delves even deeper

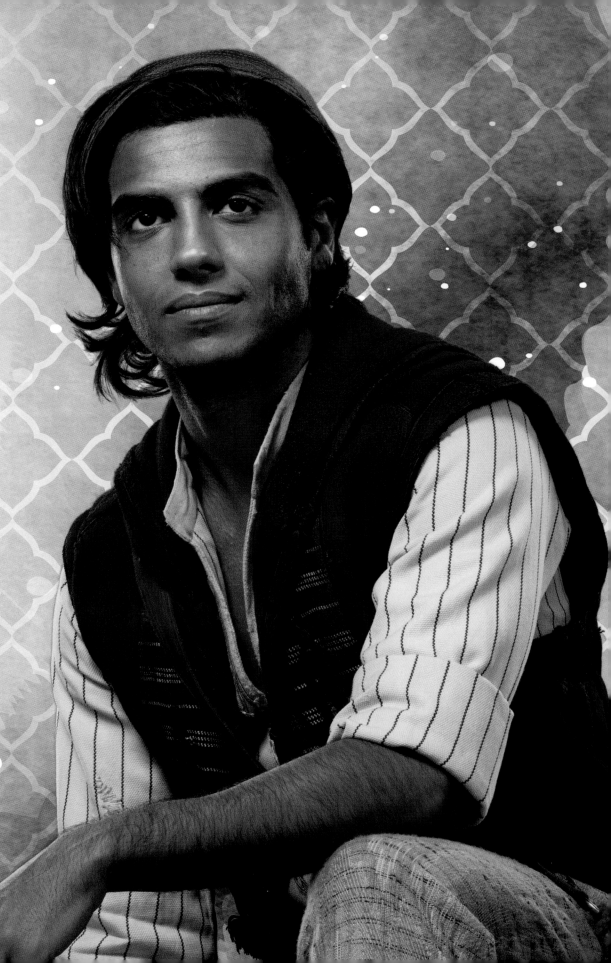

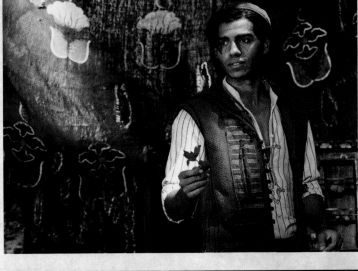

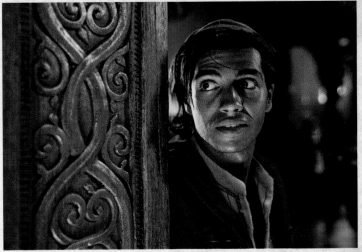

OPPOSITE: Mena Massoud as Aladdin.

ABOVE: Aladdin juggles some fruit in the marketplace.

TOP RIGHT: Aladdin in his tower.

ABOVE RIGHT: Aladdin in the palace.

into who he is and what he wants. Here Aladdin is a lonely, street-wise, clever kid with big dreams and lots of untapped potential—whose only friend is a cheeky monkey named Abu. "Aladdin connects so much with audiences because he's all of our own insecurities wrapped up in one character," Eirich explains. "He is lovable, charming, self-deprecating, and capable of anything—he just doesn't realize it yet. That's the endearing thing about him. You're just longing so much for him to realize his own value, that he is enough."

Massoud adds, "We're talking about a young kid who's lost his parents at a really early age and been on his own. He sees a future for him that's greater than what's been set out at the present moment. He doesn't know how he's going to get there, he doesn't know how he's going to do it. He doesn't even really know exactly what it is, but he knows that there's a greater future for him."

Aladdin's look evolves throughout the film, from street rat to Prince Ali of Ababwa, an elegant figure with an equally opulent outfit. Costume designer Michael Wilkinson kept many classic elements of the character's style intact, including his vest, but also gave Aladdin a more youthful, contemporary look that evokes today's streetwear trends. The character is no longer shirtless, but he still has a rugged sensibility.

Massoud took on immense preparation for the role. He had to work out to increase his physical conditioning, undergo dance training, take on dive training for the underwater scenes, work with a vocal coach—and, of course, learn all his lines. "He couldn't have worked harder," Eirich remarks. "Acting, stunts, singing, dancing . . . Mena threw himself into everything full bore, and I think ultimately the character he was able to portray was exactly who Guy had in his mind . . . this cool—but not too cool—version of Aladdin."

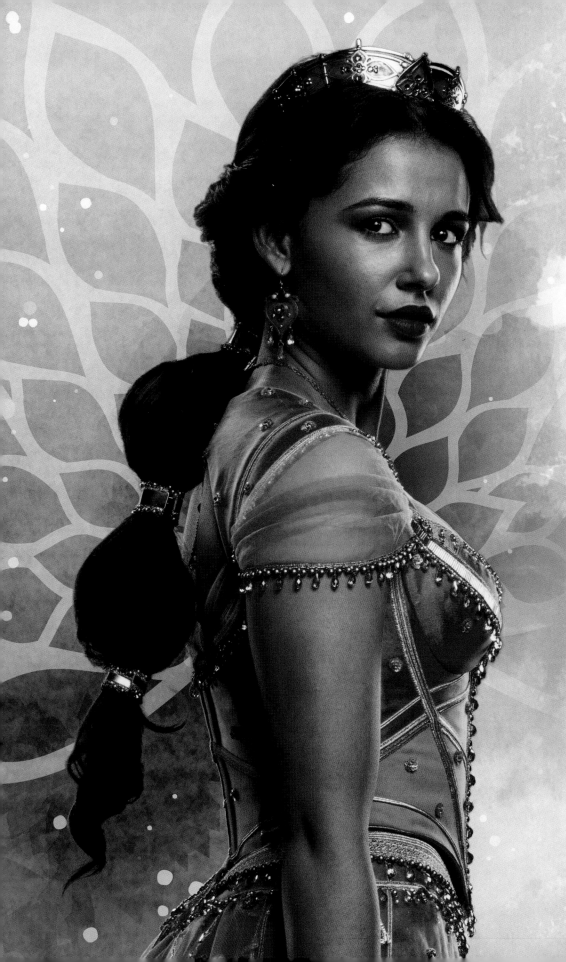

Jasmine
NAOMI SCOTT

In the original film, Jasmine is a fierce, admirable character, but the filmmakers felt that she needed to evolve in several ways. In this version, Jasmine aspires to become the leader of Agrabah and wants to succeed her father as sultan. She's well-read and thoughtful, and she tries her best to connect with the people of Agrabah even though the Sultan has kept her locked in the palace to keep her safe after the death of her mother.

The filmmakers wanted to update Jasmine and bring her into the current era, giving her more agency and aspirations. "She does still want to fall in love, but in this version, she also has her own goals and dreams to one day lead," producer Jonathan Eirich says of Jasmine's character.

The filmmakers looked at Naomi Scott, who had recently appeared as the Pink Ranger in *Power Rangers*, early on in the process and felt she had many of the qualities they were looking for. Scott, who went through a long cycle of auditions and meetings to land the part, immediately honed in on the idea that Jasmine needed to be a role model for young viewers and embrace characteristics of strong leadership and emotional vulnerability in equal parts.

"In the original movie, I always remember Jasmine as strong and someone who knows her own mind," Scott remarks. "Those are fantastic qualities that I obviously wanted to replicate. In this adaptation, Jasmine wants the best for her people. She wants the best for Agrabah, and she feels like what's best for them is that she leads. That's really where Aladdin comes in, and that's what Aladdin shows her. He really opens her eyes to the kingdom that she loves so much. She really wants to lead, and the story is a progression of how she finally speaks out and steps out and no longer goes silent."

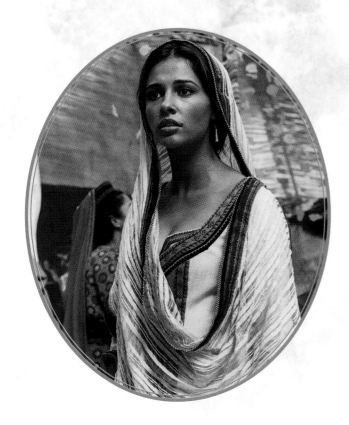

In this film, Jasmine wears numerous looks, many of which evoke her animated costumes but update them to be more functional and elaborate. Hair and makeup designer Christine Blundell used a styled wig to re-create Jasmine's signature ponytail, using small jeweled hairpieces to pull her locks back. Many of the costumes use trousers to allow Jasmine to easily get in on the action. Naomi Scott trained in dance, practiced her stunts, and worked with a vocal coach to get the best performance possible. Although Scott had previous experience singing and had released two solo albums as well as several singles, this film took her to a new level. "I've tapped into things in my voice that I didn't necessarily realize were there, and the training has strengthened my voice," she says.

OPPOSITE: Naomi Scott as Princess Jasmine.

TOP: Princess Jasmine in her disguise after she sneaks out of the palace.

RIGHT: Princess Jasmine enters the Great Hall to meet Prince Anders.

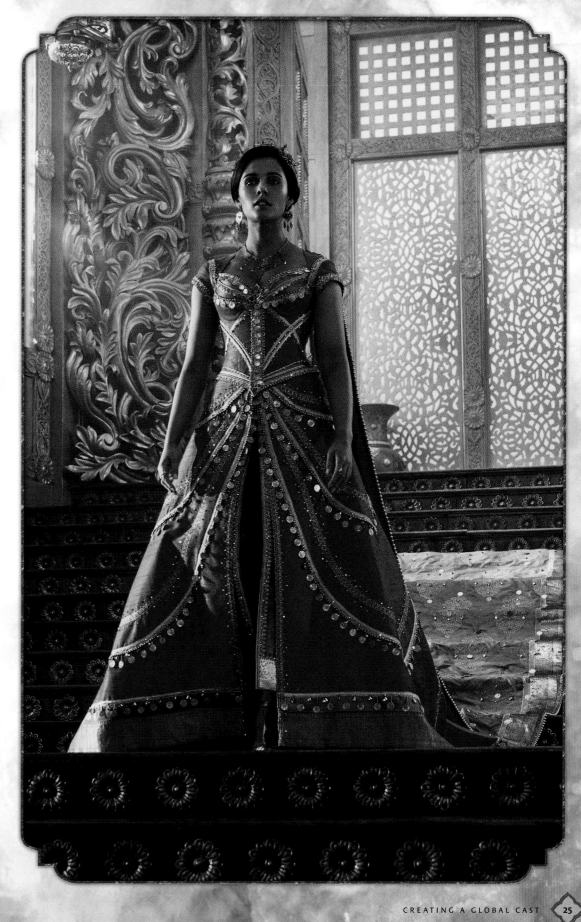

Jafar
MARWAN KENZARI

No story is complete without a great villain. To fill the role of Jafar, a nefarious character who acts as palace vizier to the Sultan of Agrabah, the filmmakers sought Marwan Kenzari, a Dutch actor of Tunisian descent with a lot of experience with performances in dramatic roles. The actor is notably younger than his animated counterpart and while the character stays true to his evil intentions of conquering Agrabah for himself, he also gains his own backstory: He himself came from the streets of Agrabah and rose through the ranks to obtain the role of palace vizier, the Sultan's right-hand man, in the palace. He's a self-made man, and he has an extensive military background, evidenced by the armored breastplate he wears. His ultimate desire is to take over Agrabah and its neighbors by sheer force and rule an empire.

"I think Jafar is quite a lonely man," Kenzari says. "He's the only real antagonist in this story. He's all in when it comes to what he wants. He's an angry man whose biggest motive is to become the most powerful man in the world—in the universe, actually." He adds, "It wouldn't be very interesting, for me, to copy whatever the character in the cartoon is doing. My face is different, my voice, my age. So you try to take from your own sources."

The challenge for the filmmakers was to make Jafar feel grounded but maintain the lively, villainous tone from the animation. He needed to evoke a mustache-twirling bad guy but also feel realistic. This Jafar has a real point of view and belief system that explains his actions.

"Jafar's bitterness stems from the fact that he wasn't born into royalty and he knows he can never rise any higher than vizier," producer Eirich explains. "He desires power, he wants to be at the top, and he feels like he's earned it. There's an argument to make . . . that obviously he's cunning,

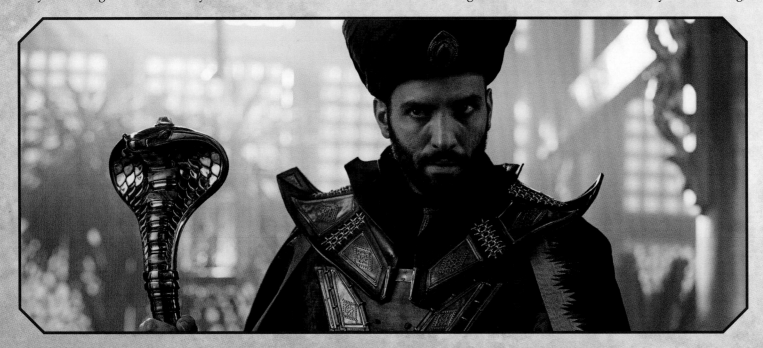

he's intelligent, and he's worked his way up to being second in command in Agrabah. In his mind, he deserves the top position but ultimately he knows he can never have it without the magic of the lamp."

Jafar's costumes evoke the character's ill intentions and also reference the animated version. Wilkinson used dark reds and black tones in the costume pieces, augmenting each look with a sweeping, ornate cape. As Jafar attempts to seize power, his look shifts several times, first as he becomes sultan and later as he grows into an almighty sorcerer. In each look, his signature snake motif appears, but it is most notable in his fierce, magical staff. The staff was an essential aspect of imagining Jafar. Prop master Graeme Purdy offered Ritchie several options for the final design and created numerous versions of the final design—some plated in metal and some in rubber—to allow for action sequences and stunts. Jafar also has a sinister dagger he uses as a weapon, though the character tends to rely more on magic than on brute force.

OPPOSITE: Jafar, played by Marwan Kenzari, is the palace vizier who attempts to exert his influence on the Sultan.

LEFT: Jafar as an almighty sorcerer.

TOP: Jafar's costume features a black breastplate that indicates his military background.

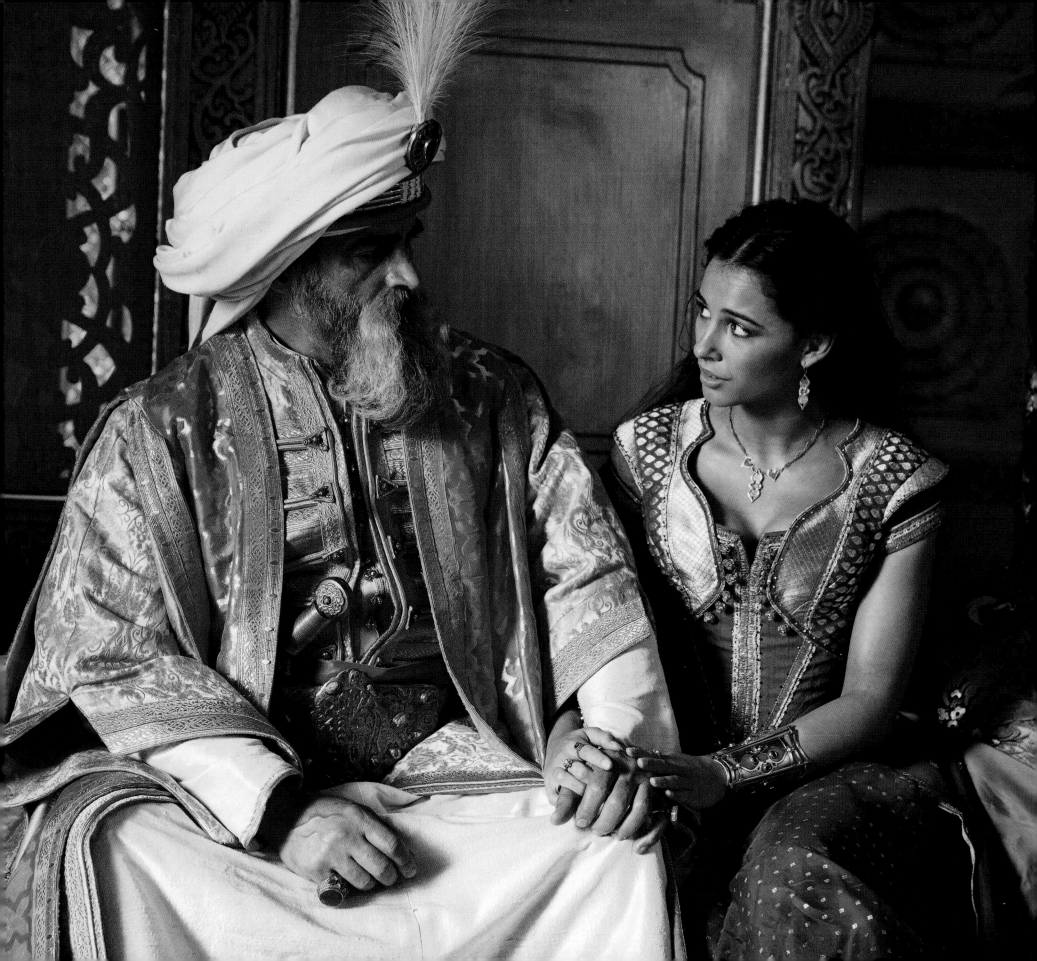

The Sultan

NAVID NEGAHBAN

For the ruler of Agrabah, the filmmakers tapped Navid Negahban, a TV and film actor best known for shows such as *Homeland* and *Legion*, and the actor quickly realized that he needed to find a new interpretation of the character.

"I was trying to go after the cartoon character and be a little bit more silly or goofy," Negahban says. "Guy said, 'No, no, no. I see him as a man who has been through wars, as a man who understands the world. And he really cares about his people.' So that gave me the core or the strength of the character."

Here the Sultan is a regal ruler living in a sumptuous palace, but he's still recovering from the grief of losing his wife and has become overly susceptible to Jafar's ill-intentioned influence.

The Sultan dons opulent ensembles that incorporate vibrant hues, luxurious cream fabrics, and gold detailing, reflecting his stature as the leader of Agrabah. While the Sultan loves his daughter immensely, he's become overly protective and can't figure out how to allow her to live her own life.

"The worry that the Sultan has for Jasmine is he sees how bright and how brave and how passionate she is about life, and how much she cares about her people," Negahban says. "And he is just worried that maybe she is not safe. Maybe something [might] happen to her. He is just trying to protect her. He is not trying to stop her from being who she is—he's trying to warn her about the obstacles that might be on her path."

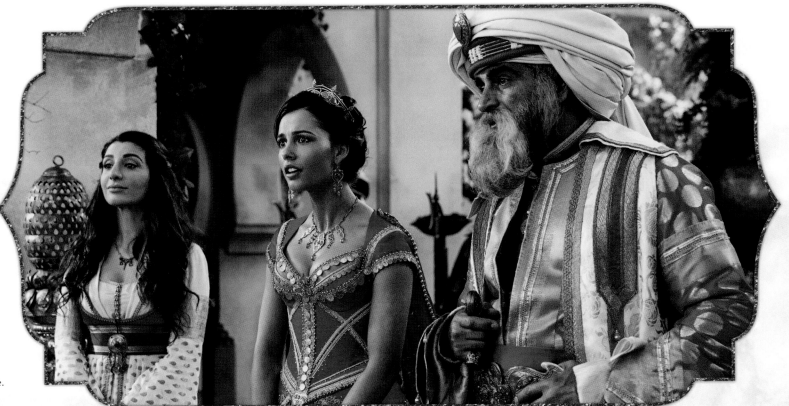

OPPOSITE: The Sultan (Navid Negahban) sits with his beloved daughter, Princess Jasmine.

RIGHT: Dalia, Jasmine, and the Sultan stand together in the palace.

Dalia
NASIM PEDRAD

While Jasmine was the only major female character in the original film, Ritchie's version gives the princess a confidante and friend in Dalia, her handmaid at the palace. Played by Nasim Pedrad, the character is funny and quick-witted and gives Jasmine someone to talk to besides Raja, Jasmine's beloved pet tiger.

"Dalia lives among the citizens of Agrabah but spends most of her time at the palace with Jasmine," Pedrad explains of the character. "She's honest, sassy, and generally terrified of Jasmine getting herself in trouble. Dalia has been by Jasmine's side for years, and you can tell she really looks out for her. I have a younger sister I'm really close with, and it reminded me a lot of that dynamic. Jasmine's strong and in the face of tradition can be a bit of a rebel, so Dalia's always trying to keep her out of trouble."

The character is brand new for this film, and Pedrad loved determining how Dalia would best fit in the preexisting story. "When I first heard about the remake, it made sense to me that, aside from her beloved pet tiger Raja, Jasmine would have a girlfriend she could confide in," the actress notes. "Dalia works for Jasmine, but they're very close, and Guy really wanted to capture the friendship and bond between them. He wanted their dynamic to feel relatable."

LEFT: Nasim Pedrad plays Dalia, Jasmine's best friend and confidante.

OPPOSITE: Dalia and Jasmine talk in Jasmine's room.

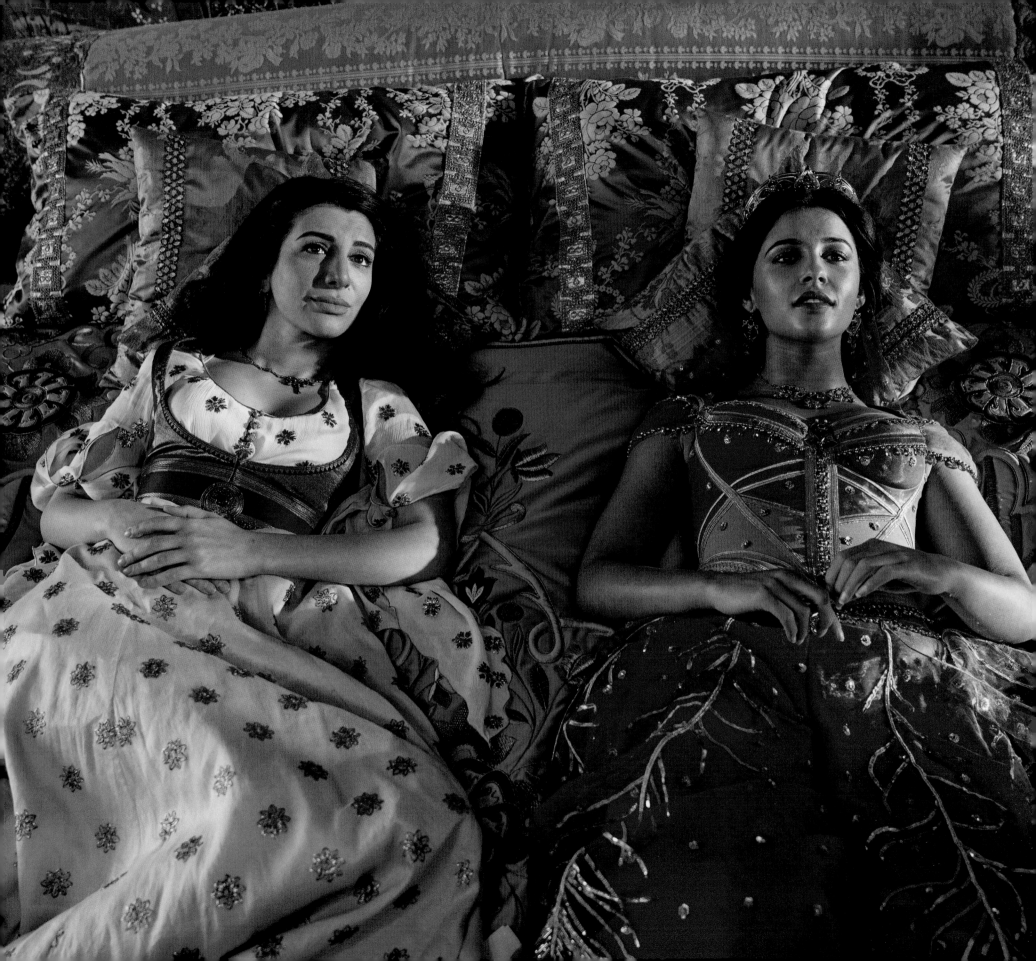

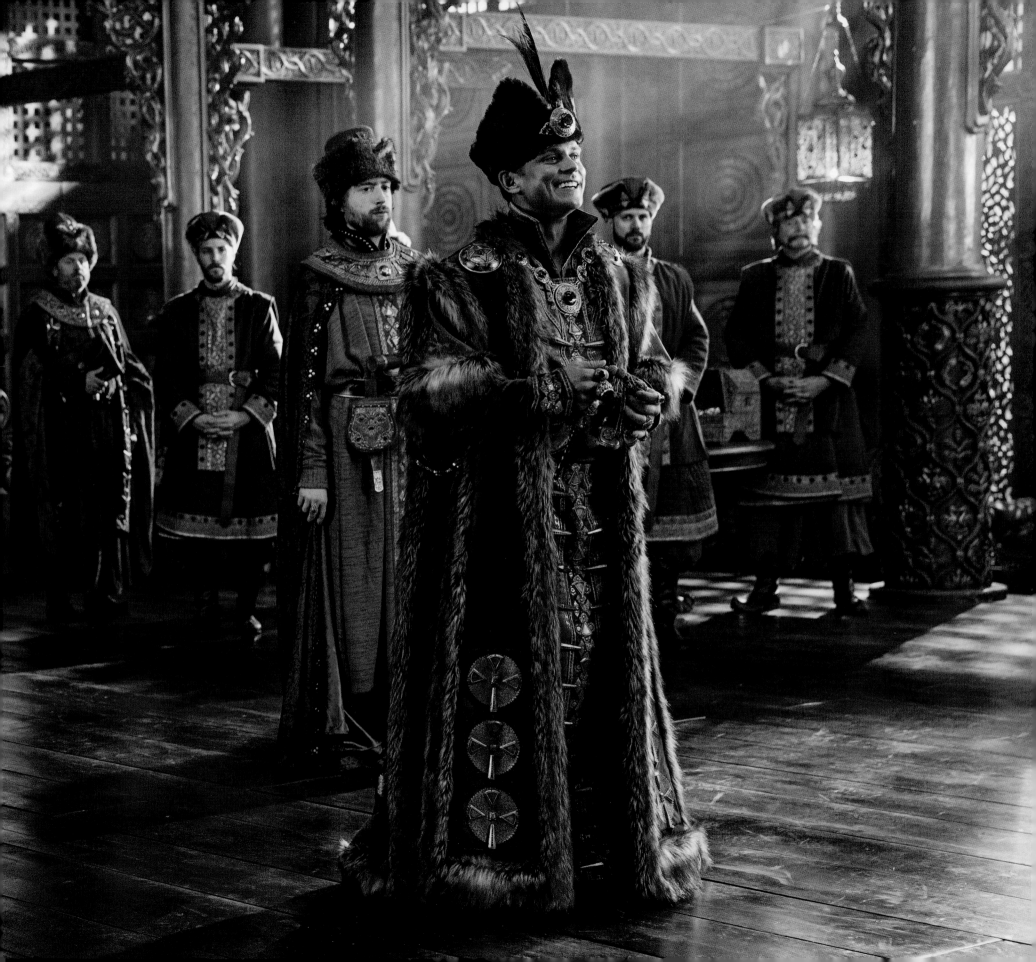

Prince Anders
BILLY MAGNUSSEN

As new character Prince Anders, actor Billy Magnussen brought a sense of comedy and fun. The character, a ruler of a snowy northern country, arrives in Agrabah for the Harvest Festival in hopes of wooing Princess Jasmine. The filmmakers imagined him looking comically out of place in the hot desert environment. He wears a massive fur-lined ensemble that is far too heavy for the climate of Agrabah, yet he refuses to remove any layers. Because Anders comes from a fictional place, Magnussen and Ritchie were able to develop him in a creative, humorous way.

"Prince Anders is from Skånland," Magnussen says. "It's not a real place. So I came up with the Prince Anders accent by thinking of Bobcat Goldthwait doing an impression of Mike Myers doing an impression of the Dutch [character from Austin Powers]. And then the Dutch guy doing a German accent on top of it. Also, just to put a little sprinkle on top, I put the lemur from *Madagascar* in there. You know, because he's royalty too. With Prince Anders, I felt the voice was a very, very, very big part of who he was."

Prince Anders's visit to the city also represents Agrabah's status as a global trading center where cultures from all over the world collide. The character may be silly, but he reflects the filmmakers' desire to be inclusive and showcase that this fictional, fantastical world is one where all types of people come together.

OPPOSITE: Billy Magnussen plays Prince Anders, who is vying for Princess Jasmine's hand in marriage.

LEFT: Prince Anders is from Skånland and wears heavy furs that are out of place in Agrabah.

Genie
WILL SMITH

Translating the unforgettable character of the Genie to this live-action movie was a daunting task for the filmmakers. Robin Williams had so memorably and expertly embodied the magical blue character in the 1992 animated film, and it seemed impossible that anyone else could fill those shoes.

"The fear from day one was always, 'Yes, there's so much in the original that you could potentially bring a fresh spin to in live-action, but what are you going to do about the Genie?'" producer Jonathan Eirich recounts. "How are you not going to have everyone just say, 'Eh, it's good, but it's not Robin Williams?'"

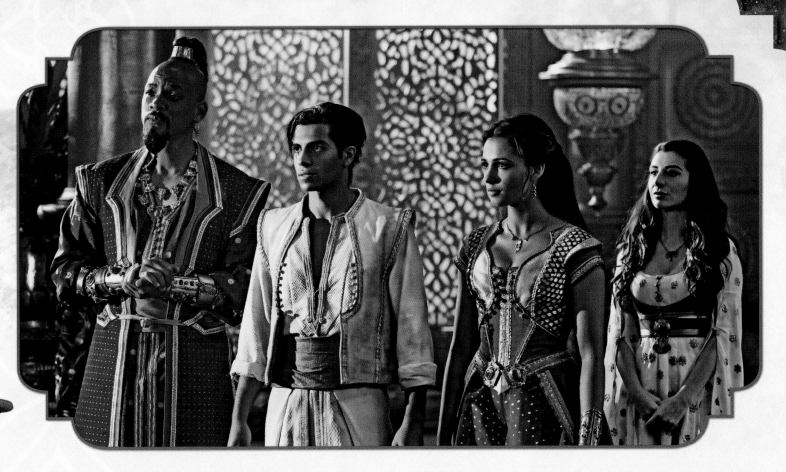

OPPOSITE: Will Smith as the Genie in his human form.

TOP RIGHT: The Genie, in his human form, stands with Aladdin dressed as Prince Ali, Jasmine, and Dalia.

"You have to have a very serious conversation about the Genie," Disney's president of production Sean Bailey adds. "Robin Williams's portrayal was legendary, iconic, highly memorable. So how do you honor that, but also do something new?"

It was important that this incarnation of the Genie offer an inventive take on an iconic character that would make him feel both classic and new. The producers wanted to keep Genie just as comedic, genuine, and whimsical, but they knew they'd have to add something fresh to the character to avoid constant comparisons. The filmmakers went through a list of possible actors, but it didn't take long to determine that Will Smith was the best choice based on his acting strength and musical background.

"I think Will Smith was in the first conversation," Ritchie says. "And then suddenly we hit a bump in the road where we heard that he wasn't interested, but it didn't intuitively ring true to me. With further investigation, we found out that he was [interested]. Now it seems impossible to imagine anyone else playing that part." Bailey adds, "With the casting of Will Smith as the Genie, there is this incredible energy and vitality and understanding of what Robin [Williams] did, but Will also has made it very, very much his own."

Smith brought in his background as a rapper and also tapped into his comedic side, which has been loved by audiences for decades. It was also a chance for the actor to explore new ways of expressing himself on-screen.

"When I got the call for [Aladdin], those crazy childhood memories came splashing back, and I was all the way down to play the Genie," Smith remarks. "This is the first project since The Fresh Prince of Bel-Air that used so many of the things that I like to do. In this film I get to sing, dance, rap, perform, and do comedy and drama. It's a great opportunity to use myself fully as an artist. So I was on fire for this project."

This version of Genie takes on two forms, a human form that looks like Smith and a fantastical form that the filmmakers call Big Blue, created using motion capture and CGI. Much like his animated counterpart, Genie is fun-loving and whimsical. He's mercurial, too, often shifting quickly between forms or changing his look. In Ritchie's film, Genie develops a strong and sincere—and often comical—relationship with Aladdin. He also begins to court Dalia, Jasmine's handmaid, and eventually develops his own love story in a departure from the original film.

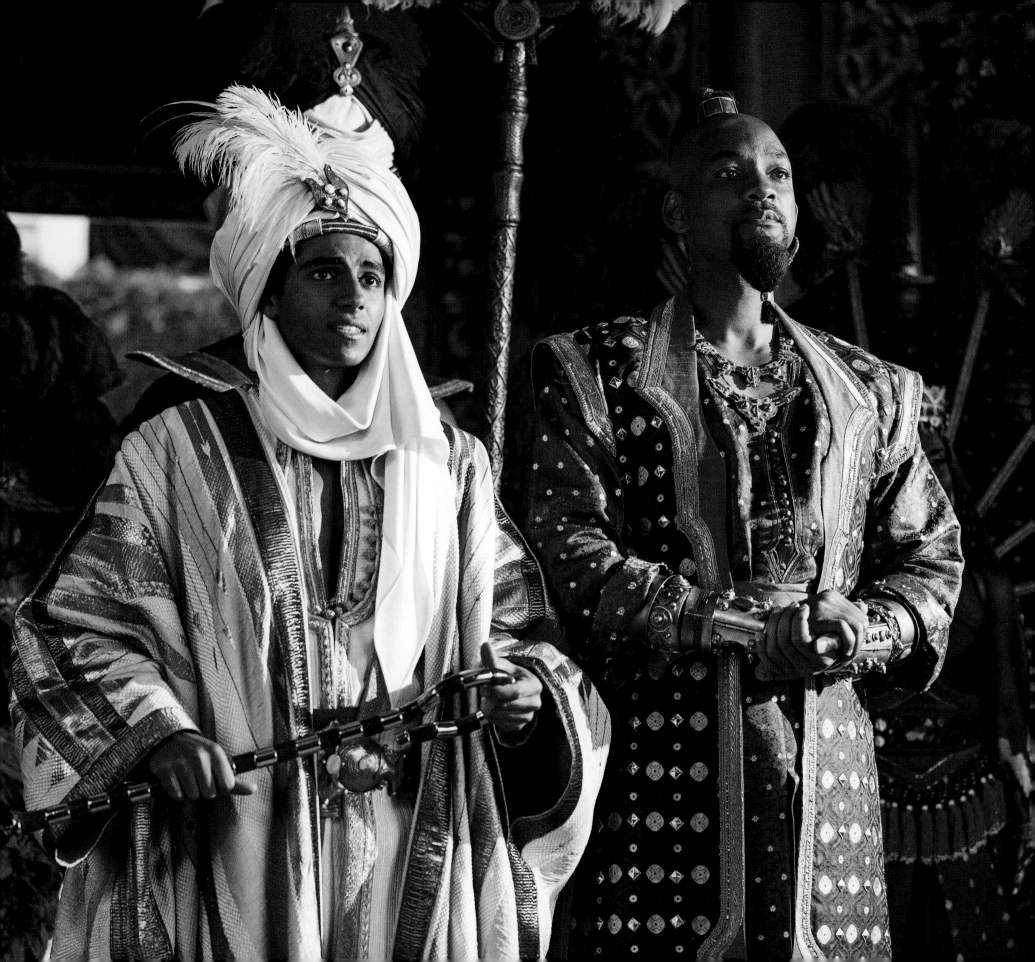

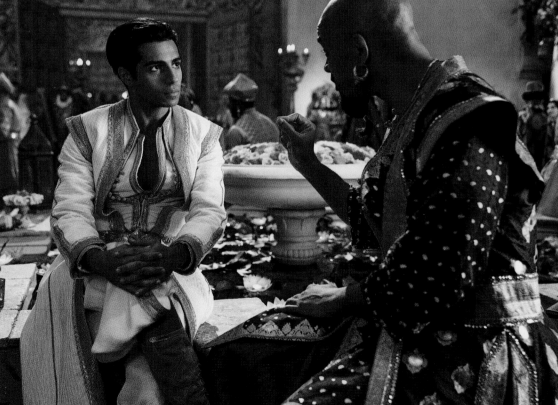

For Smith, Aladdin's growing friendship with Genie was an essential element of the story. The actor focused on revealing the shifting dynamics between the two characters, which ultimately helps both characters grow and change.

"The relationship between Genie and Aladdin is master and genie, but it's also father and son," Smith says. "Sometimes Aladdin's the father and sometimes Genie's the father. It goes back and forth with these wonderful comedic dynamics. I think that's the thing people will be most surprised about—how funny the movie is. Guy Ritchie has taken it into a beautiful, heartwarming, comedic space. I love that. That's where I'm most at home."

Smith portrayed both the human version of Genie and the CGI-assisted Big Blue. For Big Blue, visual effects supervisor Chas Jarrett used a new system developed by Disney Research to record Will Smith's face in exacting detail, and the visual effects team added the blue body in postproduction. Big Blue is an updated version of the classic character, often playful and transformative, with pearlescent blue skin and a humanlike but very muscular upper body.

"From the outset, we were really conscious of the casting and who was going to bring soul to the character," Jarrett says. "Having Will come on board was a big sigh of relief for a lot of us. He instantly brought really big enthusiasm and larger-than-life charisma to the role. That really helped us, but it's still technically challenging doing very convincing digital characters, especially ones who need to convey such a range of emotions physically and facially."

Genie is still a fun-loving, soulful character, with visual hints at the animated versions, but the filmmakers ultimately hope that Smith's Genie is judged of his own accord. "The Genie was challenging for whoever took the role because they had to fill the shoes of Robin Williams, who made it an iconic character," Ritchie says. "Will had a fresh take on the Genie but was still familiar enough as the character you know. Will's an incredibly easy chap to work with. He's very professional. It's been the greatest collaboration."

OPPOSITE: The Genie escorts Prince Ali into the palace.

TOP: Will Smith and Mena Massoud work on a scene with director Guy Ritchie.

LEFT: The Genie gives advice to Prince Ali.

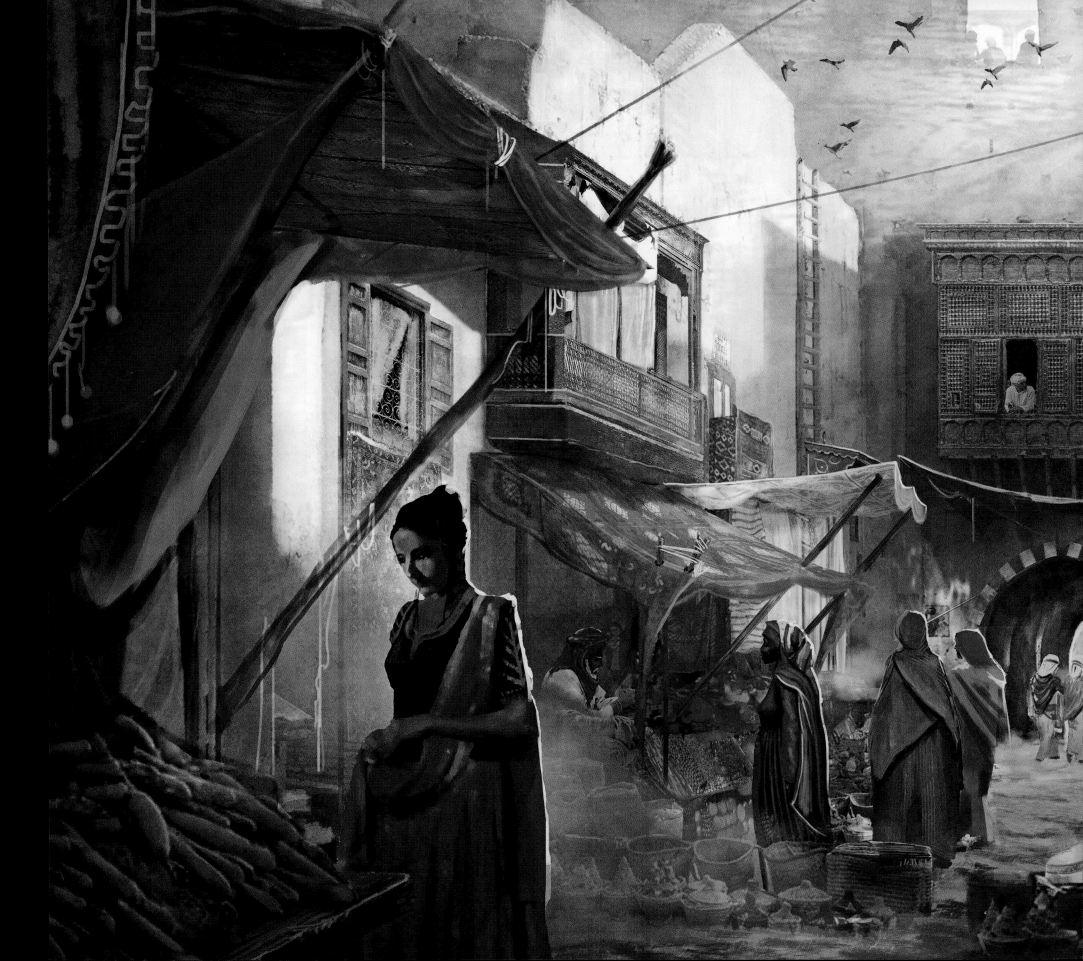

Chapter 3

BUILDING A WHOLE NEW WORLD

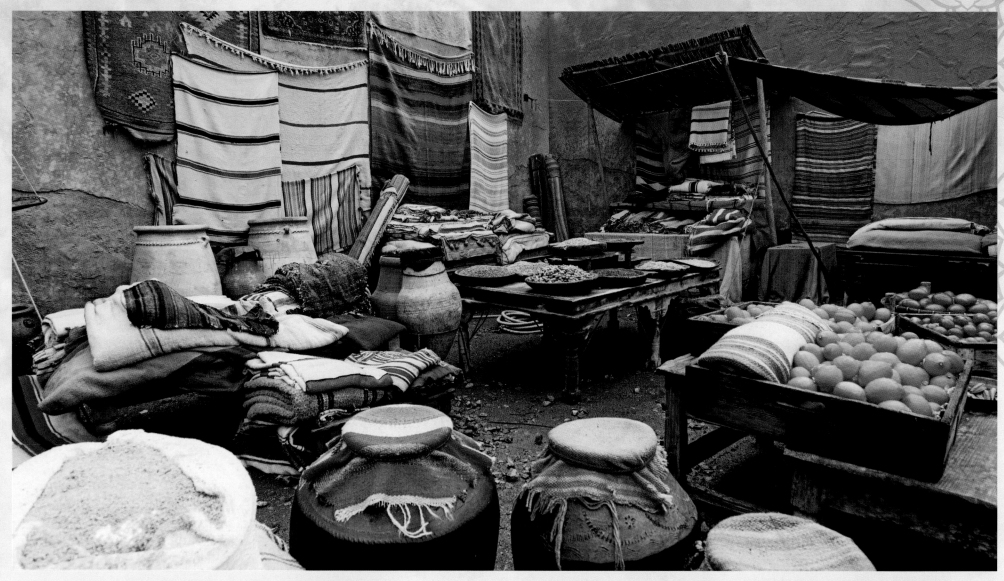

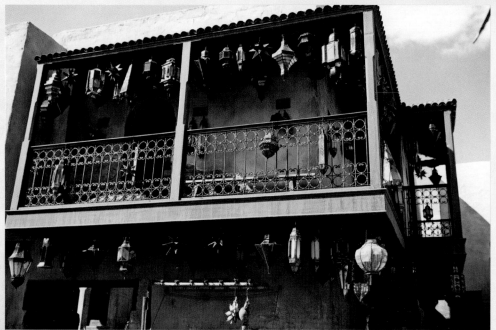

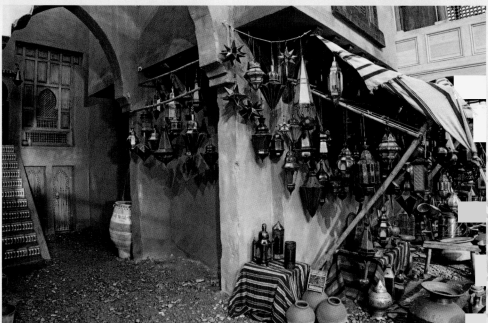

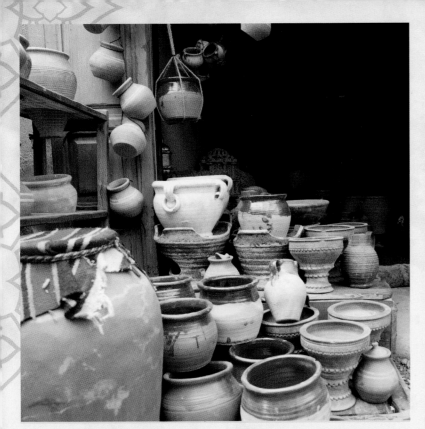

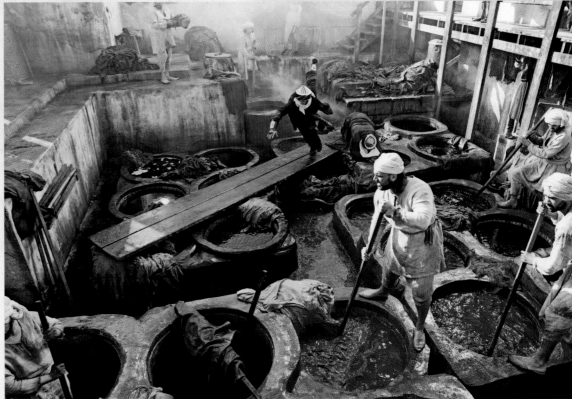

Bringing the imaginative, animated world of Agrabah to life was a challenging yet rewarding task. Originally the filmmakers wanted to shoot on location in Morocco, using the winding alleys and storied buildings of the country's cities as a stand-in for the Agrabah marketplace. Production designer Gemma Jackson took several trips to Morocco and was attracted to its colorful aesthetic. But because of logistical concerns, the filmmakers ultimately decided to build their sets from scratch.

The production settled into Longcross Studios outside London, where Jackson and her team were tasked with building the palace rooms and a sprawling version of Agrabah from the ground up. The team had fourteen weeks to construct the sets on Longcross's back lot, and the idea was to tailor various parts of the city for specific major sequences in the movie. Because of the demanding timeline, Jackson's team began building the sets before the film was even cast. The idea was to create a set that was accessible 360 degrees around so that the filmmakers and actors could move throughout the spaces. Jackson brought over two shipping containers filled with items like doors, windows, balcony ironwork, and painted tables from Morocco to help flesh out the setting. She and her team had two weeks to create the models before moving on to work on the set itself, which took over two hundred people to build. "I'm very proud of

[that set]," Jackson says. "[We've] got so many different facets to it—streets that link and different corners. I took all the bits I really liked from Morocco."

Jackson decided to keep as much Moroccan influence as possible, especially in the color palette. The city's walls are a sun-faded pink with the plaster crumbling away at the bases to evoke an aged look. Jackson selected the color after vetoing a Grecian blue tone that didn't seem to fit its surroundings. "The palace is [a] Marrakech pink. Imagine that against sand dunes and then the ocean. We just had such fun because there were little alley-ways that you could go down like you have in Marrakech, where it gets really narrow and the walls come in around you."

It was particularly challenging to imagine a hot, desert location in a rainy England parking lot. "The biggest headache and something people won't understand is clearing the floor in Agrabah," prop master Graeme Purdy notes. "I had ten guys every single morning sweeping the water out of the set and with big dryers—big blowtorches—drying the set off. We filmed Agrabah in the UK, and most mornings we'd be sweeping the rain out to dry it out." The light was another factor. The filmmakers brought in massive lighting rigs called sun guns to create the effect of the hot desert sun shining over Agrabah despite real-world clouds and allow the team to control the direction of the light throughout the day.

AGRABAH'S MARKETPLACE

Agrabah's bustling marketplace was specifically created to facilitate the sequence for the musical number "One Jump," which requires Aladdin and Jasmine to leap across buildings and dash through narrow alleys. "Building it from scratch made it so we could design it around the song," production designer Jackson says. "It would have been very hard to have done all that on location. We worked the whole thing out for the song and dance, and then obviously other things happen there as well."

The team constructed a movable model of the city to determine the right placement of the buildings for action sequences such as the performance occurring during the song "One Jump Ahead" and the elaborate "Prince Ali" parade number. "Everything about the construction of our Agrabah had been oriented for our two big musical numbers," producer Jonathan Eirich notes. "So every building placement, the way each street turned, the way the houses and roofs were designed—there was a logic to all of it that was really contingent on how we were going to film 'One Jump' and 'Prince Ali.'"

The marketplace includes a tannery like those found in Fès and Marrakech, but Jackson also drew on other parts of Africa and southern Spain for inspiration. Growing in the marketplace's center is a living two-thousand-year-old olive tree, which Jackson sourced from a company called Living Props. The awnings and hanging fabrics were made from hand-dyed fabrics to evoke a period aesthetic and create a space that felt truly lived-in and realistic, with as many authentic details as possible.

"Gemma and I, together, went to Morocco on a prop-buying trip and spent a lot of time wandering around the streets of Marrakech, taking photographs, making observations of things that we wanted to see in Agrabah, but obviously taking it back several hundred years," set decorator Tina Jones says. "But a lot of Marrakech still remains the same, essentially, apart from obviously the electrical lights. You still have the same type of street vendors that you would have had several hundred years ago and the rug sellers and the mint tea vendors. There were lots of photographic references that we were able to draw from historically as well, but essentially Marrakech was most of our references that we were using."

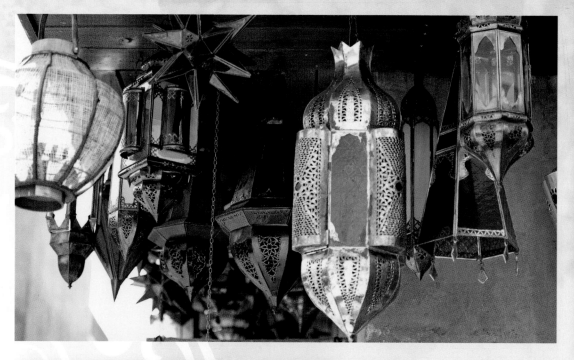

ABOVE: Detailed close-ups of lamps seen in the marketplace.

LEFT: Textiles found in a market stall.

OPPOSITE TOP LEFT: An alleyway in the marketplace.

OPPOSITE BOTTOM LEFT: Food laid out in the marketplace.

OPPOSITE RIGHT: Additional set decoration.

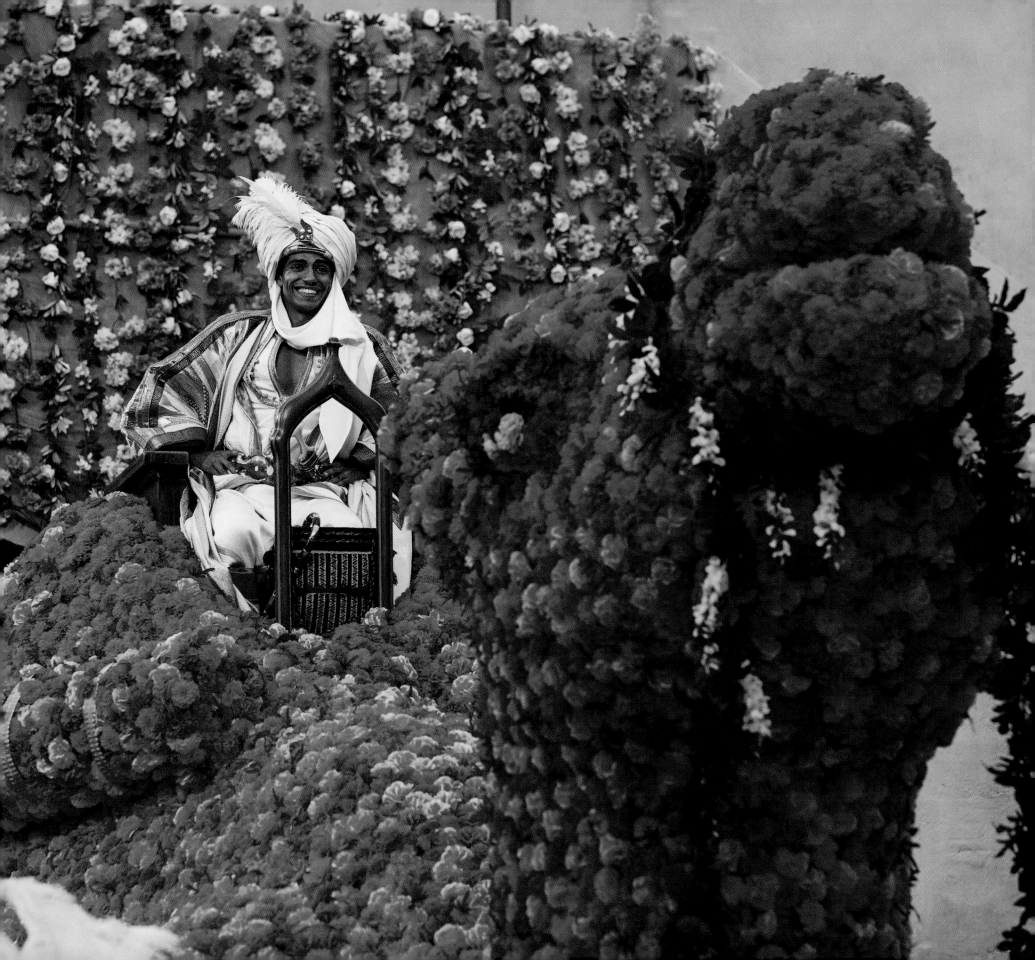

THE PARADE ROUTE

Prince Ali's arrival in Agrabah required an over-the-top spectacle. In the animated film, Genie and a transformed Aladdin burst into the city with a lively parade, filled with animals and dancers, and Ritchie wanted to create a similar sequence that worked with live-action. The director was inspired by London's annual Notting Hill Carnival, as well as the carnival in Rio de Janeiro, and he tasked the crew with bringing a colorful, wild scene to life on set.

The festive parade traverses a wide street that leads through Agrabah to the palace doors. This required Jackson to take the parade's size into consideration when constructing the route. The parade and its massive floats pass through an archway, which nearly topples the structure Aladdin rides in on. That float, an ornate camel created with floral blossoms, was conceived by set decorator Tina Jones.

"I started looking at Las Vegas carnival parades and noticed that a lot of things were often made of flowers," Jones says. "Our Aladdin was going to arrive on the back of a real camel, which I felt was possibly going to pose a bit of movement problems and also didn't feel impressive enough, and so I thought, 'What about a carnival float that is actually a huge, gigantic camel made of flowers?'"

The team only had three weeks to design and build the camel, which is constructed from over thirty-seven thousand flowers. It was so big that it could barely get down the Agrabah thoroughfare. "When Guy saw it and understood what we were doing, he said, 'Right. Okay, so I want it so that he almost can't get through the archway, that his head's almost touching,'" Jackson recounts. "So it's that big. It was such a big statement and covered in all those orange flowers."

"On the day when we did the full dress rehearsal, it was just amazing—the sun shone and these incredibly beautiful, great big creatures made of thirty-seven thousand flower heads came through the archway, and it was a real magical moment," Jones adds. "I think that was probably one of the best moments of my career also because to actually be working on a musical is quite a unique experience."

OPPOSITE: Prince Ali rides into Agrabah on an ornate camel adorned with flowers.

BELOW: Sweets in Agrabah's marketplace.

BELOW RIGHT: Close-up view of the flowers on Prince Ali's float.

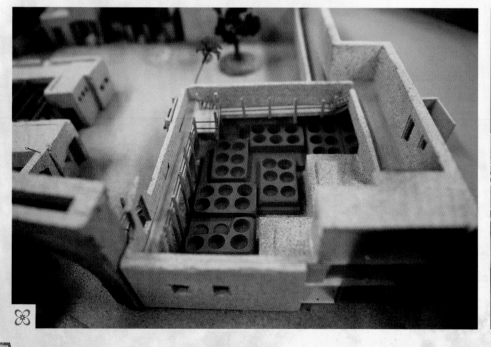

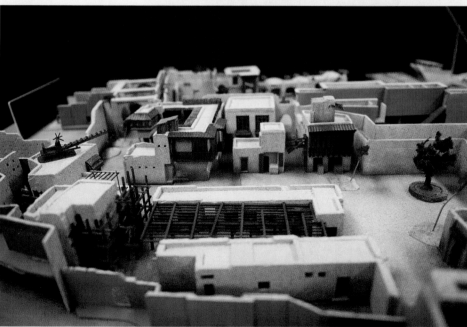

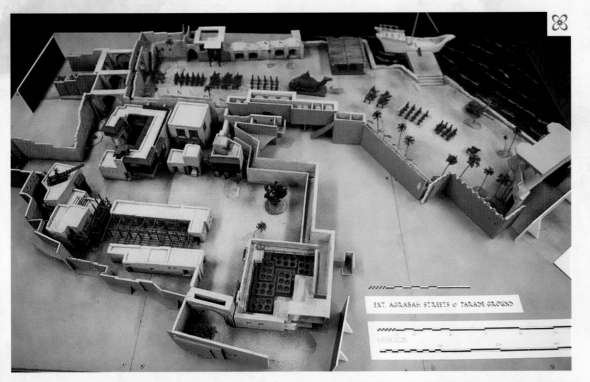

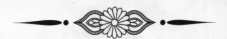

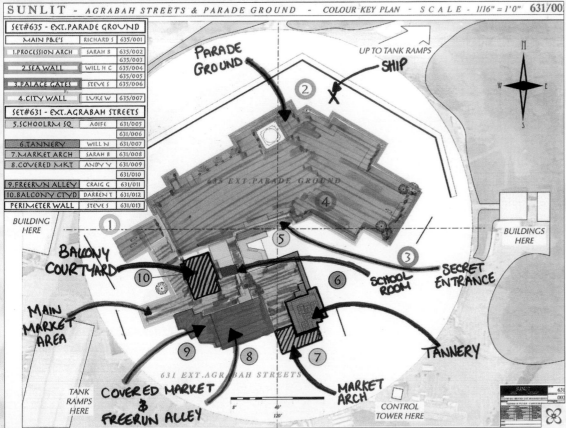
EXT. AGRABAH STREETS & PARADE GROUND

SUNLIT - AGRABAH STREETS & PARADE GROUND - COLOUR KEY PLAN - SCALE - 1/16" = 1'0" 631/00

SET#635 - EXT. PARADE GROUND		
MAIN P&E's	RICHARD S	635/001
1. PROCESSION ARCH	SARAH B	635/002
		635/003
2. SEA WALL	WILL H C	635/004
		635/005
3. PALACE GATES	STEVE S	635/006
4. CITY WALL	LUKE W	635/007
SET#631 - EXT. AGRABAH STREETS		
5. SCHOOLRM SQ	AOIFE	631/005
		631/006
6. TANNERY	WILL N	631/007
7. MARKET ARCH	SARAH B	631/008
8. COVERED MKT	ANDY V	631/009
		631/010
9. FREERUN ALLEY	CRAIG G	631/011
10. BALCONY CTYD	DARREN T	631/012
PERIMETER WALL	STEVE S	631/013

PARADE GROUND

UP TO TANK RAMPS

SHIP

BUILDING HERE

635 EXT. PARADE GROUND

BUILDINGS HERE

BALCONY COURTYARD

SECRET ENTRANCE

SCHOOL ROOM

MAIN MARKET AREA

631 EXT. AGRABAH STREETS

TANNERY

TANK RAMPS HERE

COVERED MARKET & FREERUN ALLEY

MARKET ARCH

CONTROL TOWER HERE

CREATING THE PARADE

The colorful camel float was joined on set by several real-life camels and horses, as well as dozens of dancers who had to follow an exact choreography over a four-day shoot that took place early during production. Wilkinson created over two hundred colorful, sparkling costumes with distinct looks for each group of dancers as they arrive into Agrabah, and makeup designer Christine Blundell designed definitive makeup looks for each dancer, emphasizing heavy lines and gold accents. Choreographer Jamal Sims had to consider the camel float as well as the live animals when constructing the dance sequence. "Choreographing animals was something I've never done," Sims notes. He continues with a grin, "Let me tell you: Camels cannot dance. They're horrible dancers, actually."

Rain threatened the production during the first day of shooting the parade, and the filmmakers had to bring in massive lights to ensure the desert sun kept shining. Ultimately, the scene was even more spectacular than the filmmakers had envisioned. "We had seven cameras going for that sequence to make sure we captured everything because there was so much going on," producer Jonathan Eirich says. "We knew there was going to be far more incredible footage than we'd ever be able to use, but that was a good problem to have. This sequence was a big opening moment for us on this shoot because it was early in the schedule and took so much effort to pull together, but there was this real sense of victory by the time the week was over."

OPPOSITE: Close-up views of the scale model created for the "Prince Ali" parade and marketplace.

TOP: Wide view of the model of Agrabah's marketplace.

LEFT: Diagram of the marketplace's layout.

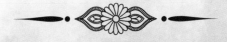

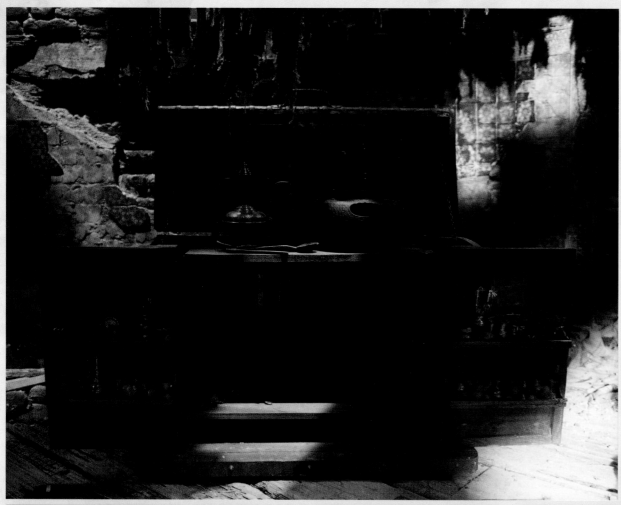

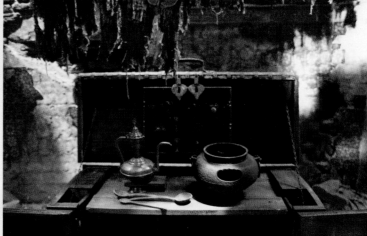
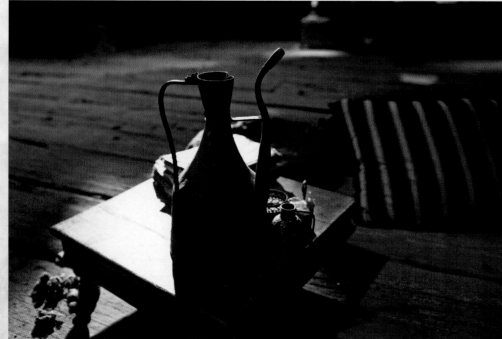

THE BROKEN TOWER

Aladdin's secret living quarters—known as the "broken tower"—are located high above the city with views of the port and the palace. The crumbling tower room is more than it seems, elaborately crafted by production designer Jackson and set decorator Tina Jones. "Guy wanted Aladdin to have a lot more mystery than just being the lad sleeping under a box somewhere, so we created this place," Jackson says. "We built it really elaborately."

"When Aladdin arrives in the broken tower, he operates the canopy, which gets lifted, revealing all his furniture," Jones explains of the design. "We wanted him to appear as this clever, cheeky chap who actually was able to impress with his intelligence. The canopy lifts to reveal the furniture, and then he has a little kitchen area where the doors open, and it mechanically sort of all flips around."

The small kitchen was created from a cabinet imported from Jodhpur, India, that opens to reveal a tea-making set and other useful items. There's even a box nearby that's been transformed into a bed for Abu. The canopy itself was constructed from hand-dyed Indian cotton with a pattern that was loosely based on a wall covering from the Amber Palace in Jaipur. "For our canopy to be believable, as painstaking as it was, it was all hand-painted on a hand-dyed fabric because we wanted it to have that irregularity that you just wouldn't get if you were to digitally print it," Jones notes. "As far as we can, we will make things look very handmade."

OPPOSITE: Set dressing for Aladdin's living quarters known as the "broken tower."

LEFT: The canopy in Aladdin's tower unfurled.

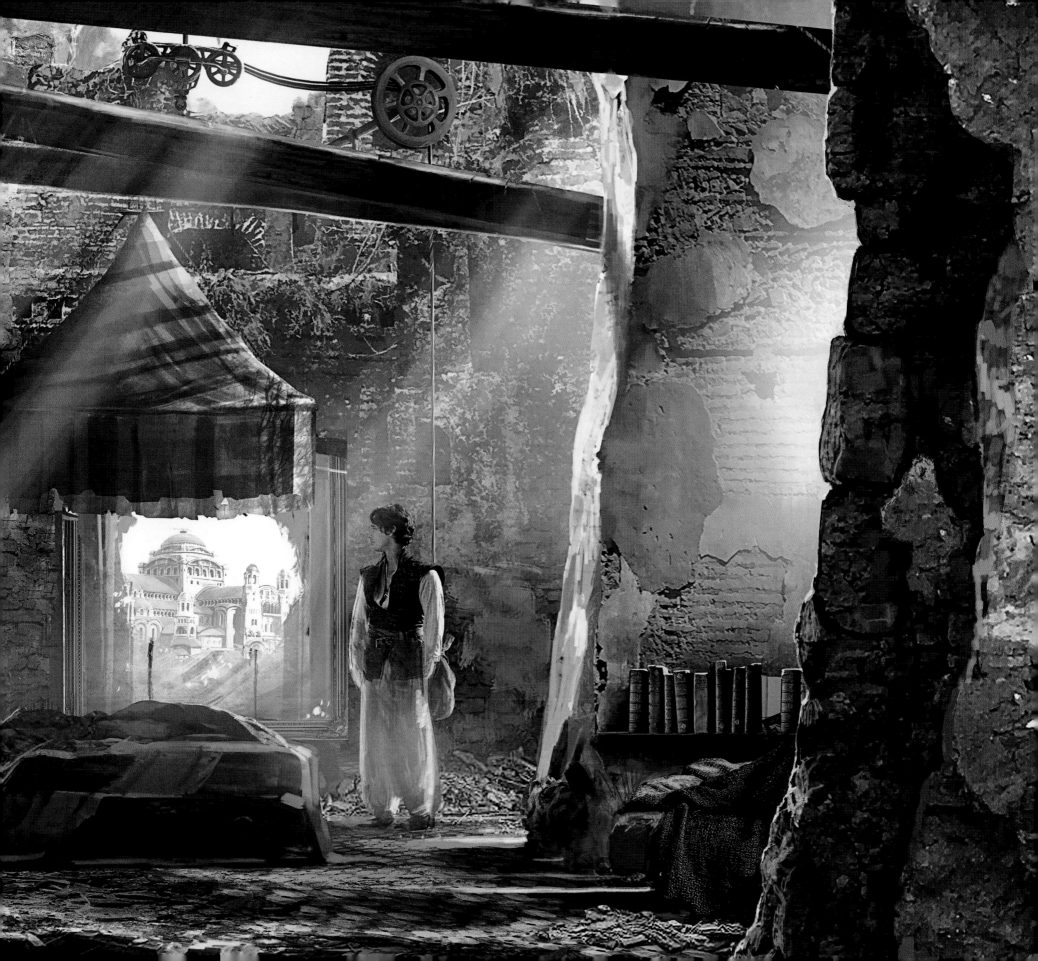

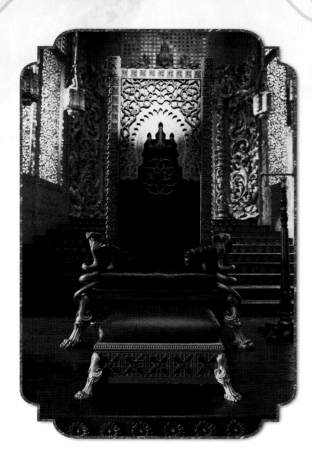

THE SULTAN'S PALACE

To create the Sultan's palace, which towers over Agrabah and stands as the center of cultures in the port city, production designer Jackson researched various palaces from around the world. Her final design is based on a monastery in Burma, which was made of wood then painted gold, and elements of Turkish and Moroccan design also thread through the rooms. Jackson was especially interested in bringing a Byzantine style into the palace as well. "I found some really beautiful images of a Burmese monastery," Jackson explains. "Everything in it was wood, all painted gold, and very tarnished in places. I was really struck by this, so I started to use that idea for the interior, which puts you in a certain period, [but] I didn't want it to be overtly Burmese, so I glided back toward Byzantine."

PAGES 50–51: Concept art of Aladdin standing in his tower.

RIGHT: A portion of the palace hall showcasing the wooden elements painted gold.

TOP: Jafar's throne.

OPPOSITE TOP: A model of Agrabah found in the palace.

OPPOSITE BOTTOM ROW: Various sections of the palace and Great Hall.

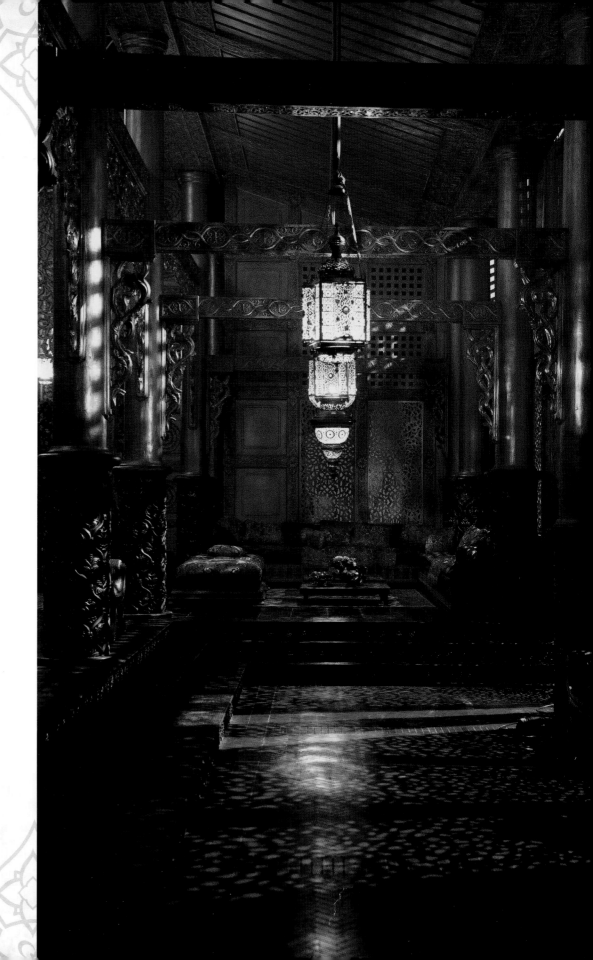

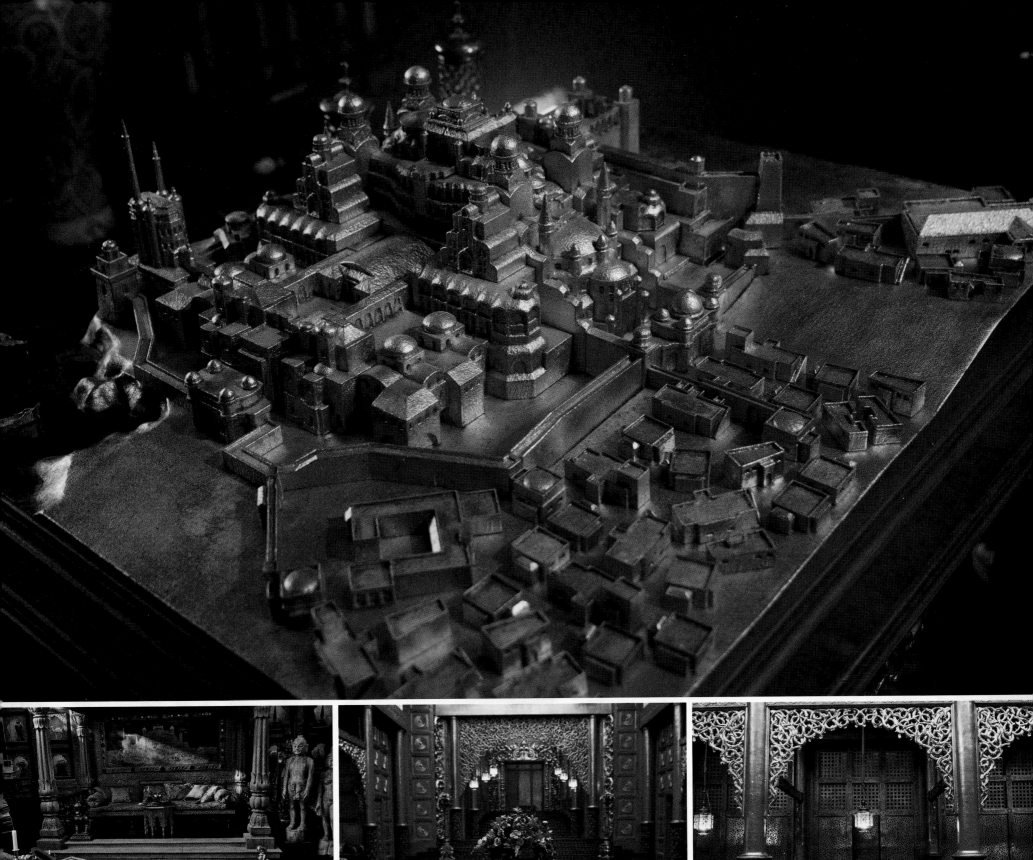

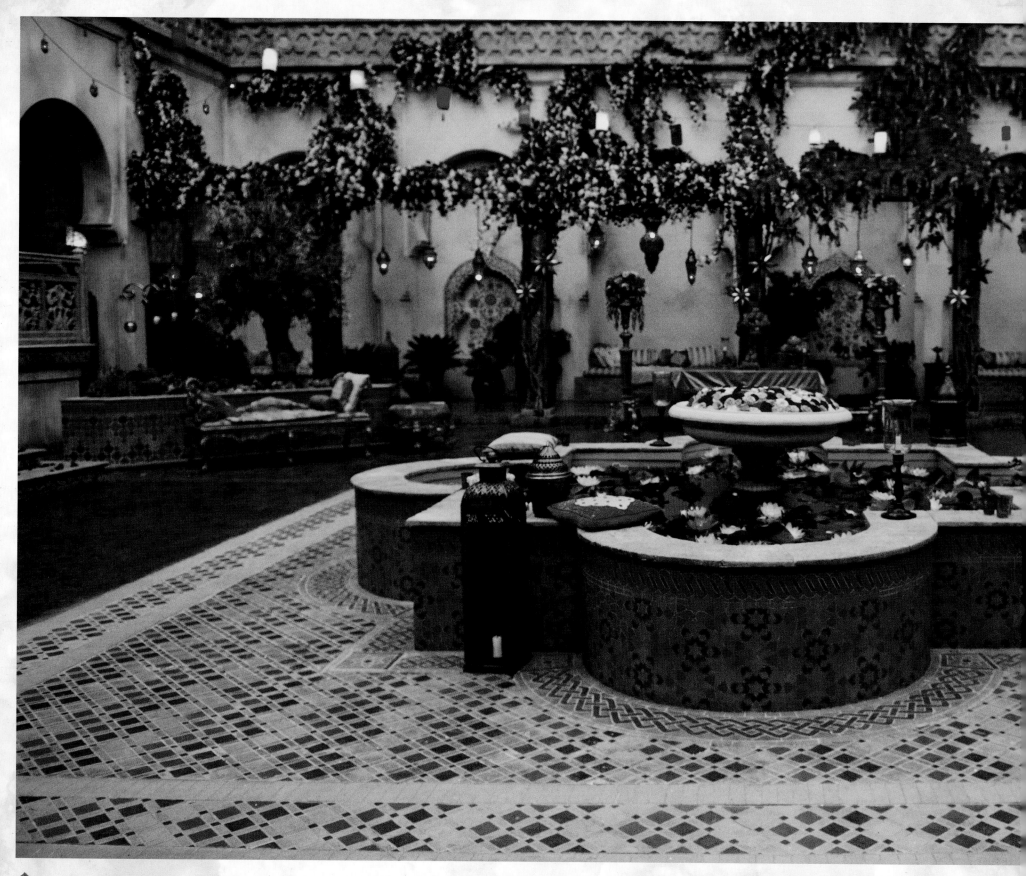

The specific geography of the palace became very important, especially since certain scenes required certain rooms to be placed strategically throughout the building. The team had 3D models created to help navigate the rooms and ensure the layout was logical. "It got very big, for lots of reasons, because you're having to respond to so many demands from the script," Jackson notes. "[Someone might have] a view of the ocean, but then the other person can see into that person's bedroom, so they've both got a view, which means they're both quite high up."

Jackson developed a house style that is consistent throughout the palace—with the exception of Jafar's rooms—and created the palace with both indoor and outdoor spaces. The courtyard features tiles taken from a Moroccan design, and there are Islamic flower motifs throughout the building. Under the Sultan's rule, there is purposefully no throne room and no throne; instead, the Sultan sits in the palace's Great Hall. Real trees and plants were brought in by Greens Team, including more olive trees, adding a realistic element to the palace. "The greens were fantastic," Jackson notes. "When we started to bring in the trees, I thought, 'Yes, this feels alive.'"

To construct the ornate walls, which are meant to evoke carved wood and gold, the sculpture department molded panels and columns. Each mold was then filled with plaster, and the final structural elements were painted. "It's important to get in the decorative elements involved with the actual structure," Jackson says. "We actually invented a visual language for this whole place, which was very much experimented with and explored when we were doing the big entrance room."

LEFT: The palace courtyard and gardens.

TOP: This unit photography shot shows how the Great Hall opens directly into the courtyard.

PAGES 56–57: Concept art of the palace interior.

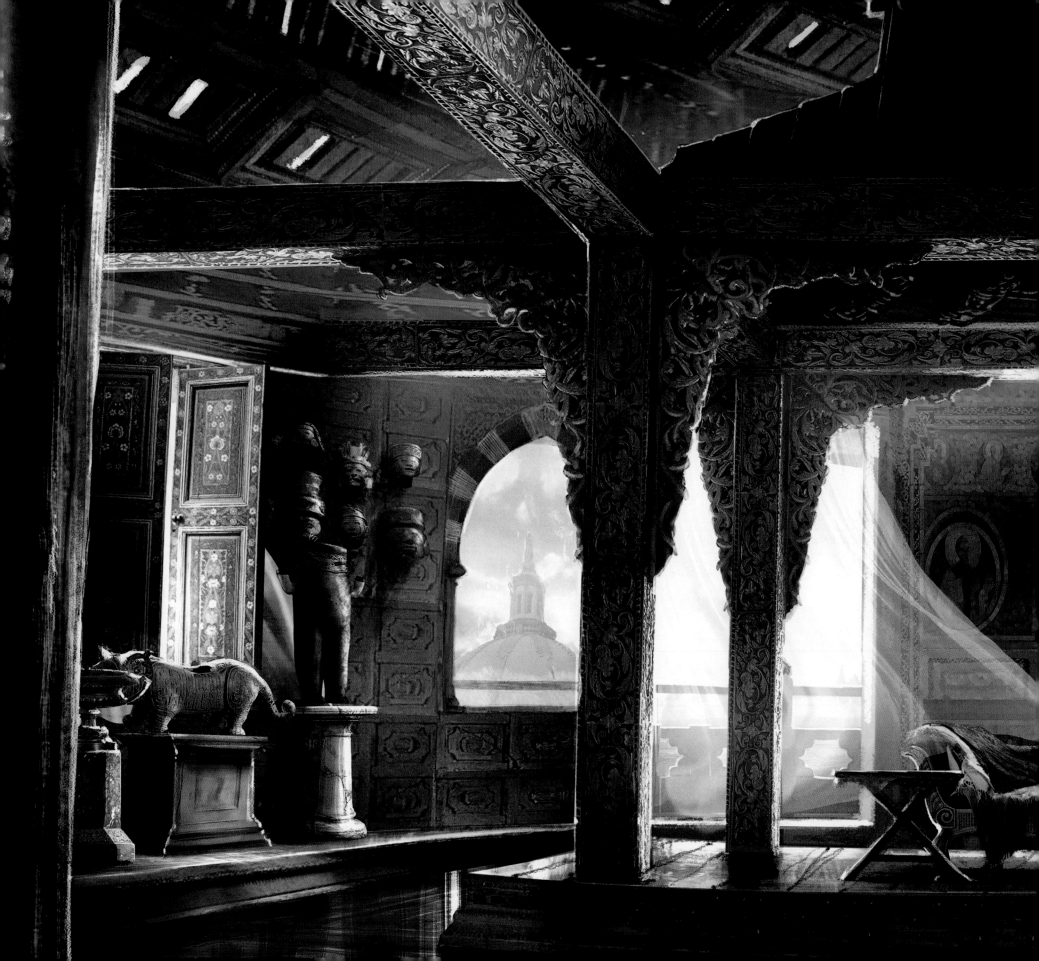

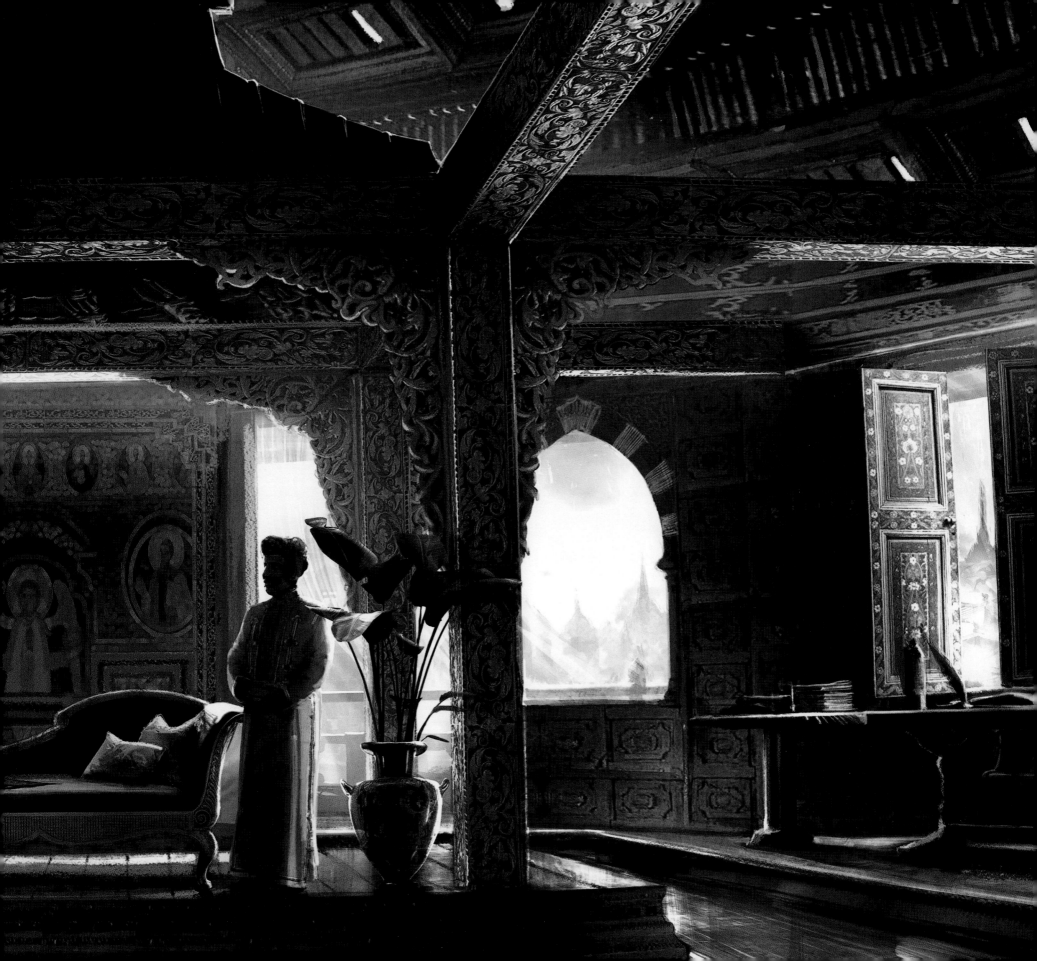

JASMINE'S BEDROOM

Jasmine's bedroom centers around a large bed covered in a bedspread that was hand-embroidered in Pakistan, and the team had to consider where Raja would be located in the space. "We also had to consider the possibility that there was going to be a tiger lying on the bed, so the size of the bed was dictated by the size of the tiger," Jones says of Raja. "The bed was a design that had to be concepted and was made by us in-house."

The room itself has many small niches filled with art that Jasmine has collected over the years; it has a deeply layered feeling. There are painted panels on the walls, as well as golden elements that reflect the overall gilded aesthetic of the palace.

She has books and maps to illustrate her intelligence and education, and the space is meant to feel very lived-in. "Hers had more layers to it because it needed to look like she's spent a lot of time there because she's essentially a prisoner in her room," Jones notes of Jasmine's room. "It just needed to feel like it was the room where she took her meals, that she read books, that she looked at maps, played music."

"We had a lovely platform and then a lower area that Jasmine and Raja could move around and really own the space," Jackson adds. "There's also a lovely big balcony looking out. It has to feel like an indoor-outdoor life since it's warm there all the time."

BELOW: Unit photography showing Jasmine's bedroom.

OPPOSITE TOP: Jasmine's bedroom featured a bed large enough that a tiger could lie on it.

OPPOSITE BOTTOM ROW: Detailed scale models were created to design Jasmine's bedroom and determine how it connected to the rest of the palace.

PAGES 60–61: Jasmine reads while Raja lounges on her bed in this concept art.

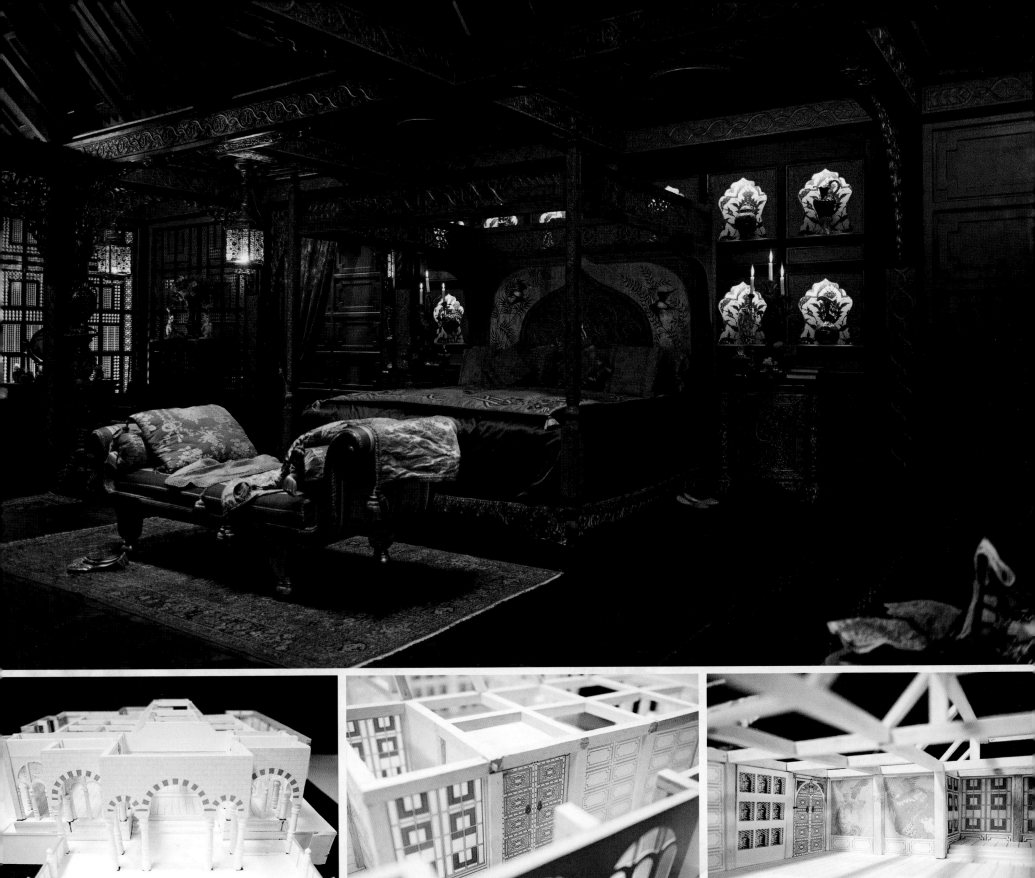
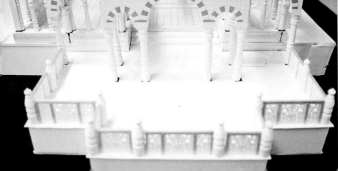
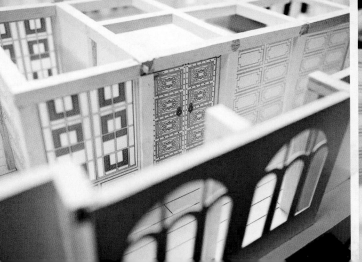

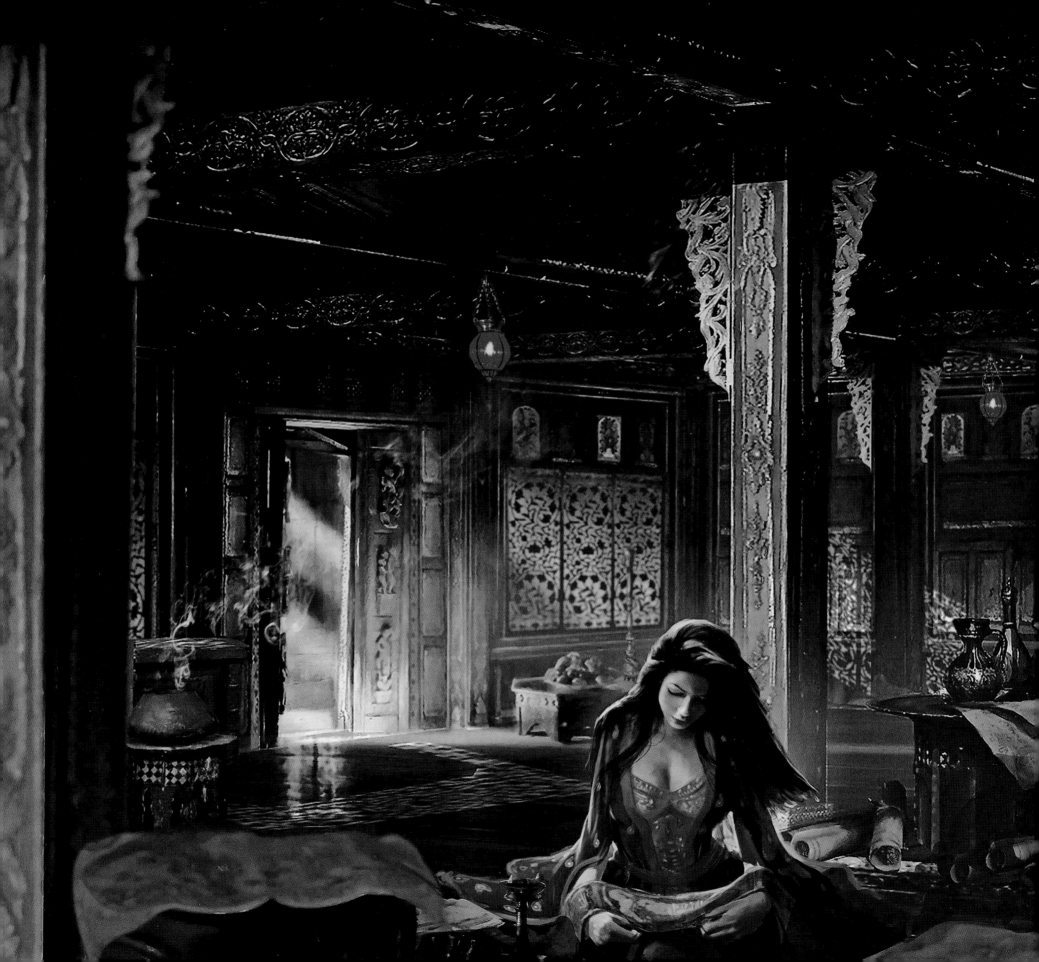

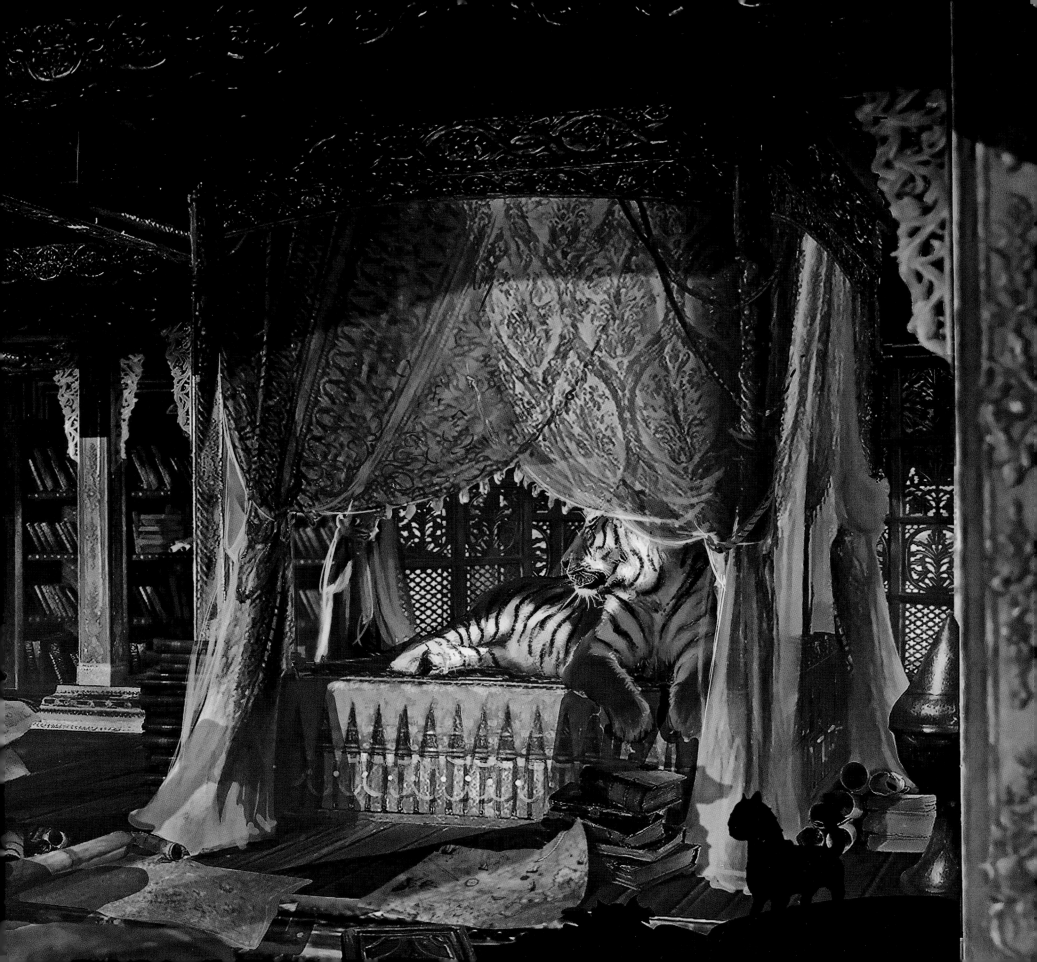

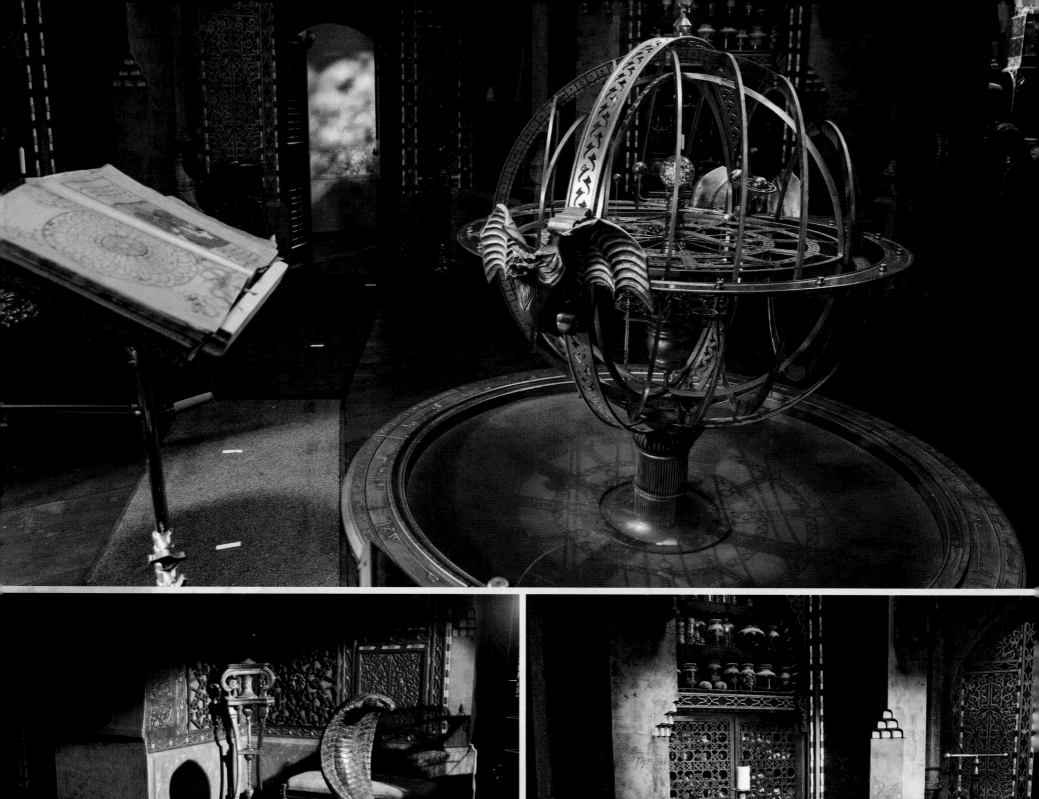

JAFAR'S STUDY

For Jafar's nefarious quarters, Jackson drew on a darker color palette. While the rest of the palace is constructed of warm wood tones and gold flourishes, Jafar's rooms are built from patterned carved stone and decorated with blues and dark reds. There's also a metal orrery—a model of the solar system—in the center of the room. The designs on the walls reference the character's obsession with sorcery and magic, and the team decorated the rooms with items that suggest Jafar's ill intentions.

"It's got a beautiful, dark, quite sinister sort of quality about it, and it has a feeling like it's tucked away in the palace," set decorator Tina Jones says. "It's an area where he does a lot of his magic. There's lots of references to possible potions, alchemy, and maps, and just great symbolism painted onto the walls."

Jafar's snake motif is present throughout his belongings and decor, and it eventually comes into play when he brings a throne into the palace as sultan. He is also the master of the dungeon, a dark, evil space beneath the palace where he brings his prisoners. The dungeon offers a sense that Jafar does wicked things, especially when he doesn't get his way.

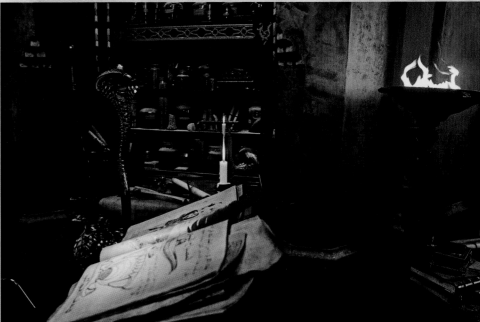

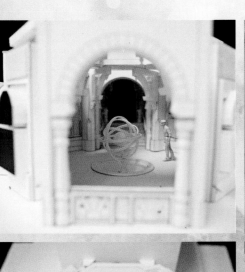

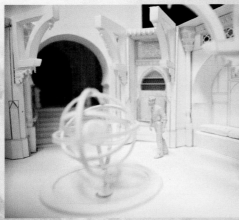

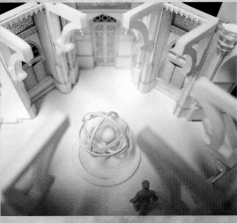

OPPOSITE TOP: A large orrery sits in the center of the study.

OPPOSITE BOTTOM LEFT: Jafar's snake motif extends to the decorations incorporated in the set design.

OPPOSITE BOTTOM RIGHT: Bottles and jars.

LEFT: A series of images showing the scale model of Jafar's study.

TOP: Jafar keeps numerous spellbooks.

ABOVE: Jafar's staff is seen propped up beside a book depicting the lamp.

THE CAVE OF WONDERS

The expansive Cave of Wonders was a seamless combination of Jackson's practical sets and the visual effects designed by VFX supervisor Chas Jarrett. "The Cave of Wonders has been quite difficult to do," Jackson admits. "There's no way I can design the whole Cave of Wonders in this day and age, where everyone expects so much more than just a cave. So what we're really doing is elements, but they're crucial elements and they set the tone for a lot. We've been using the colors of Jordan, and so there won't be a jump when you go to the interiors. They'll be the same textures and colors and aging."

Prop master Graeme Purdy manufactured rubber mats that look exactly like piles of gold and jewels, allowing Aladdin actor Mena Massoud to leap through the riches safely during action sequences.

Executive producer Kevin De La Noy explains, "We worked it out very systematically. Whereas in Agrabah, for instance, when you look around, it's real all the way around, [the Cave of Wonders] scene became a very strong visual effects sequence with a lot of blue screen and small footprints of set. The column where he climbs to find the lamp was real, and the lamp at the top was real, but everything behind him was blue screen and visual effects just dropped in. Essentially, if [Aladdin] touched it or walked on it, it was real. If he walked past it and it was more than twenty feet away, it was digital and blue screen."

"The world has learned to expect so much, visually, so you've really got to give them more than they're expecting and stun them and amaze them," Jackson adds.

PAGES 66–67: Aladdin enters the Cave of Wonders

BELOW: In this concept art, Jafar and Aladdin stand before the entrance to the Cave of Wonders.

OPPOSITE TOP: Jafar waits with Iago at the mouth of the cave in this concept art.

OPPOSITE BOTTOM: Concept art of Aladdin surrounded by treasure.

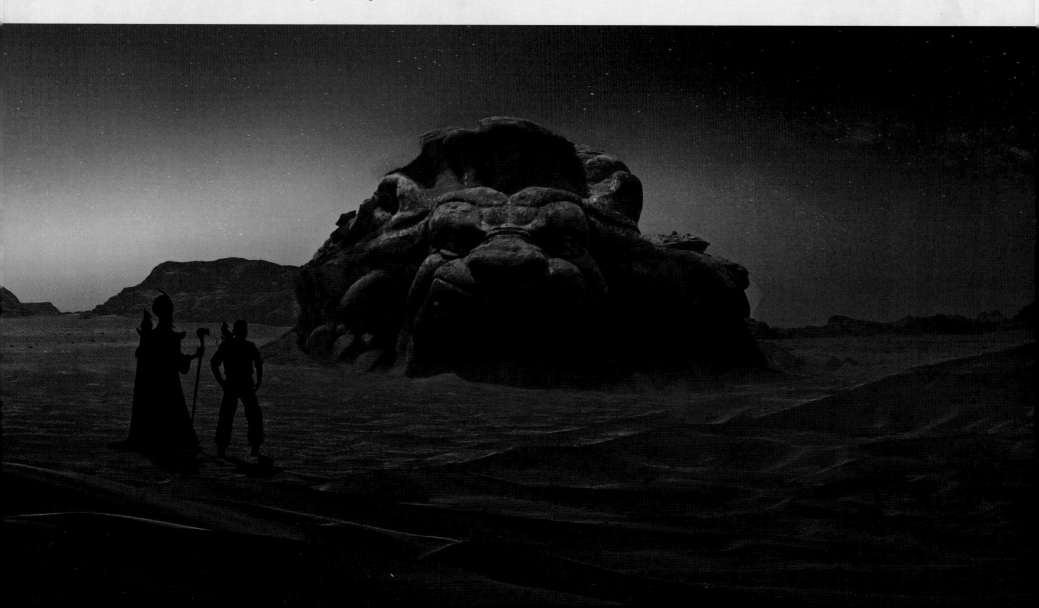

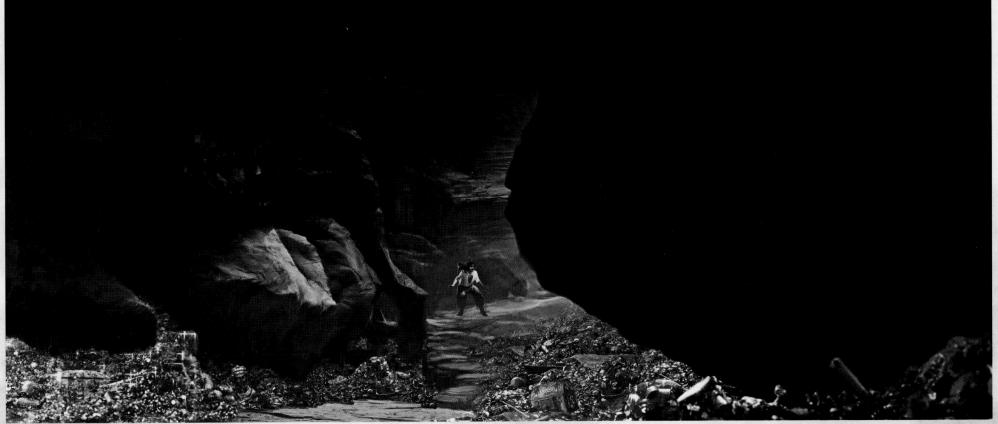

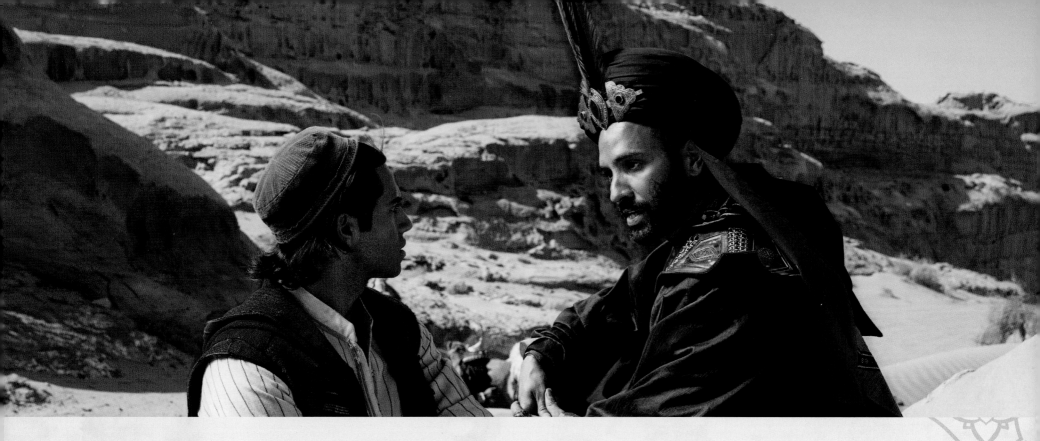

AGRABAH'S DESERT

To show the breadth and magnificence of Agrabah's desert, the filmmakers knew they had to take the production overseas. "We looked at various countries in the Middle East and North Africa," Ritchie recounts. "Jordan was the most hospitable and most aesthetically pleasing. It ticked all the requisite boxes that we needed, and they were also very accommodating and made us feel at home. Looking at the vast desert, you can really feel a sense of how epic the landscape is."

Production designer Jackson adds, "The desert was exquisite and really necessary to open the film out and give it that air, scale, and volume of looking across the Wadi Rum Desert."

The entrance to the Cave of Wonders was created from an existing natural rock formation found in the desert, with a giant arch framing the entrance. In the animated version, the Cave of Wonders arises from the desert, emerging as a massive tiger's head and then vanishing when the cave closes. In this live-action version, the entrance to the cave is more tangible, with a lion's head embedded in the rock formations.

"We didn't want it to become a huge visual effect, so our lion is in the mountain," De La Noy explains. "It had to be hidden, and we found this huge arch, and it provided a beautiful approach. The arch is very mystical because it's just a strange formation in this sea of rock and desert. What they ended up with was this extraordinary, surreal environment that grounds you at the beginning because you know it's real."

For actor Mena Massoud, it was exciting to shoot scenes in a landscape that felt so close to home. "I was born in Cairo, and I've been back there a few times," he says. "I've been to the desert before, I've been to the pyramids, but there's something really incredible about going back to a place that you feel like you're rooted in."

During postproduction, the cave's entrance was extended using footage that visual effects supervisor Chas Jarrett shot during the initial filming in Jordan, as well as during a secondary shoot.

"We went out to Jordan and filmed the exteriors of the cave on location, and we got some wonderful dunes," Jarrett remarks. "We took a helicopter unit down to Namibia and filmed shots of camels walking over dunes and things like that, and that gave us an incredibly huge scope. The mouth of the cave is entirely set in Jordan, but once you go down into the cave, we switched to a blue screen just because the scale of the set is just enormous."

ABOVE: Jafar speaks to Aladdin in the desert.

OPPOSITE: The film was shot partially in the deserts of Jordan.

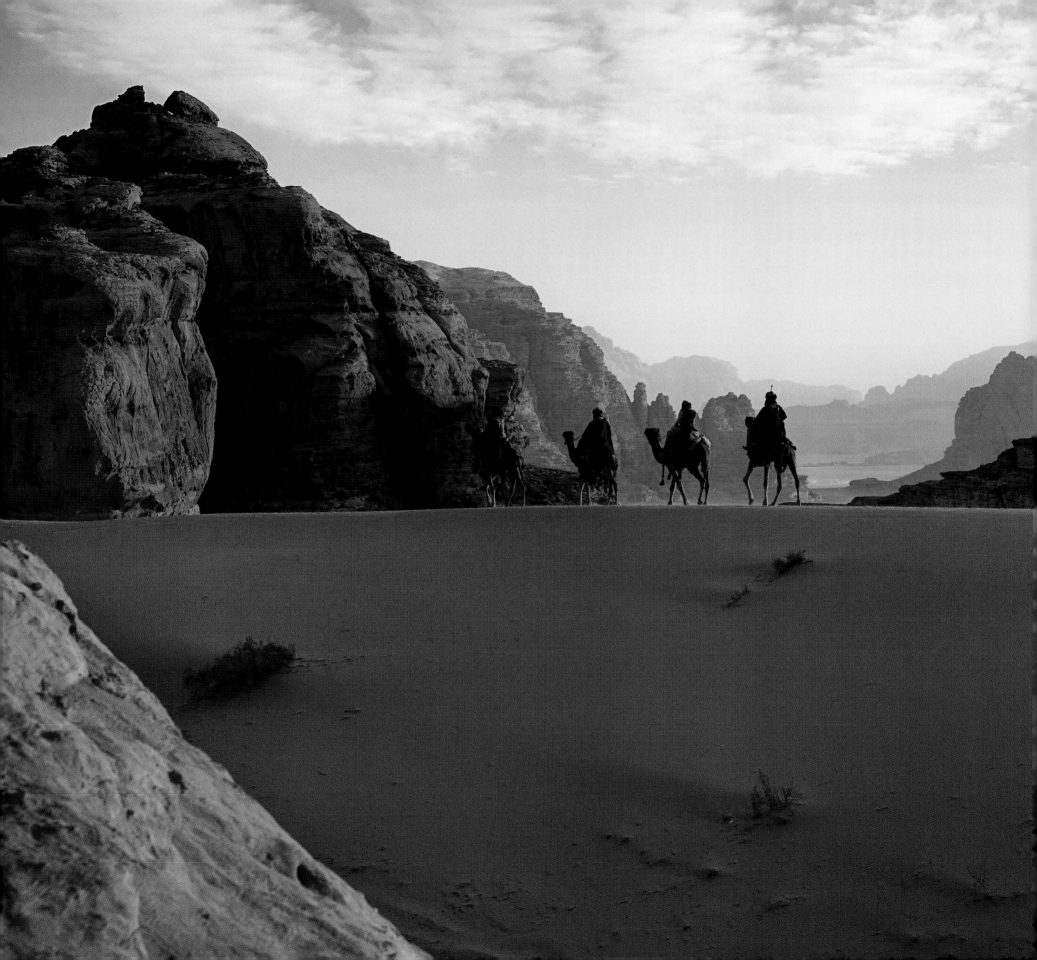

THE FROZEN TUNDRA

For the short scene where Aladdin and Abu are banished to a frozen wasteland by Jafar, the filmmakers used a combination of real locations and visual effects. To ensure they used real snow and ice, the team completed two days of filming at the indoor ski center in Milton Keynes, England, in freezing cold temperatures. The team later augmented the scene with snow machines on a studio soundstage to add in more blizzard-like effects.

The action takes place in a deep, rocky ice chasm, which Aladdin is forced to precariously descend. To create that effect, the filmmakers built two sides of the chasm on the back lot, each covered in blue to allow insertion of visual effects later, and had the character's stunt double scramble between the cliffs. Much of the background was created digitally but from real reference images.

"We did a helicopter shoot in Svalbard, in the Arctic Circle, for some of that and filmed some establishing shots," explains Jarrett. "When I was out filming those shots, I jumped out of a helicopter and took a lot of photography at ground level and from different mountains and so on. A lot of the backgrounds are constructed from those photographs. The particular ice crevasse that Aladdin scales down and jumps down to find Abu was created from scratch and is completely digital, but the environment itself is very much based on a real location in Svalbard."

RIGHT: Aladdin, still dressed as Prince Ali, is banished to the frozen tundra in this concept art.

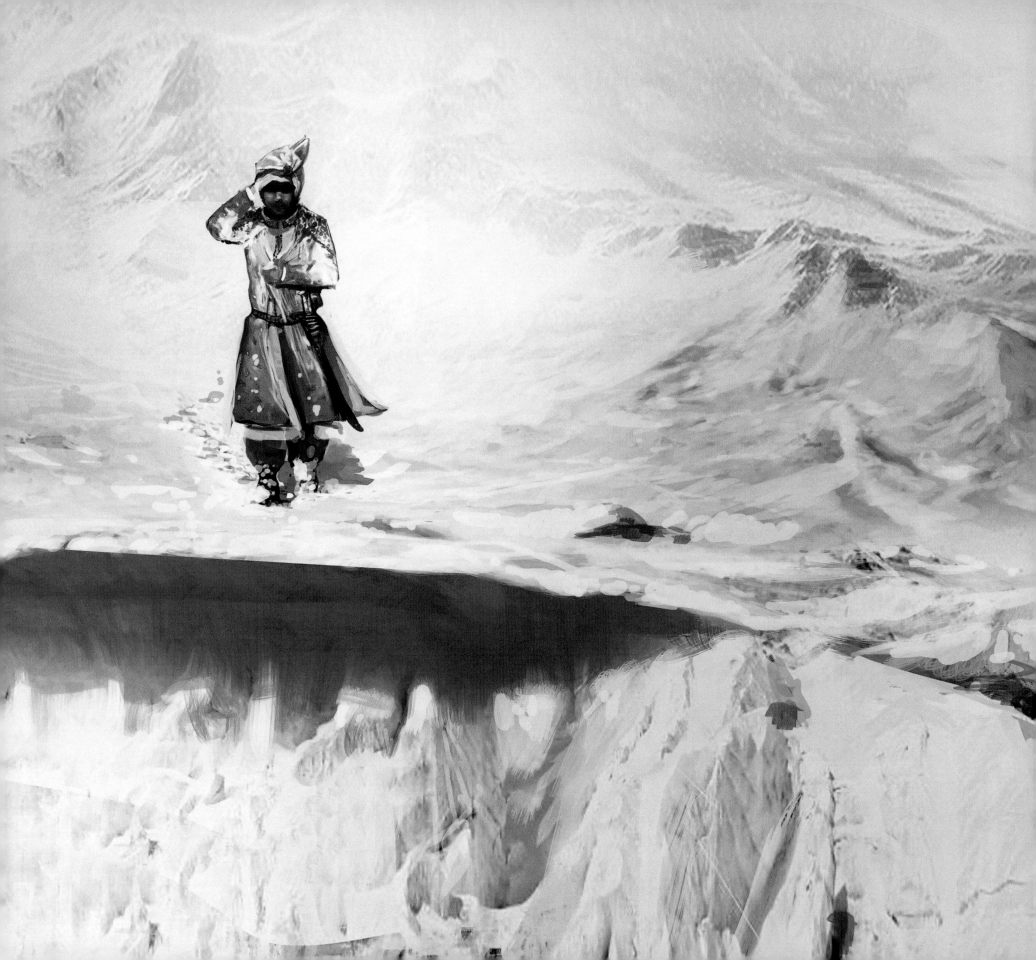

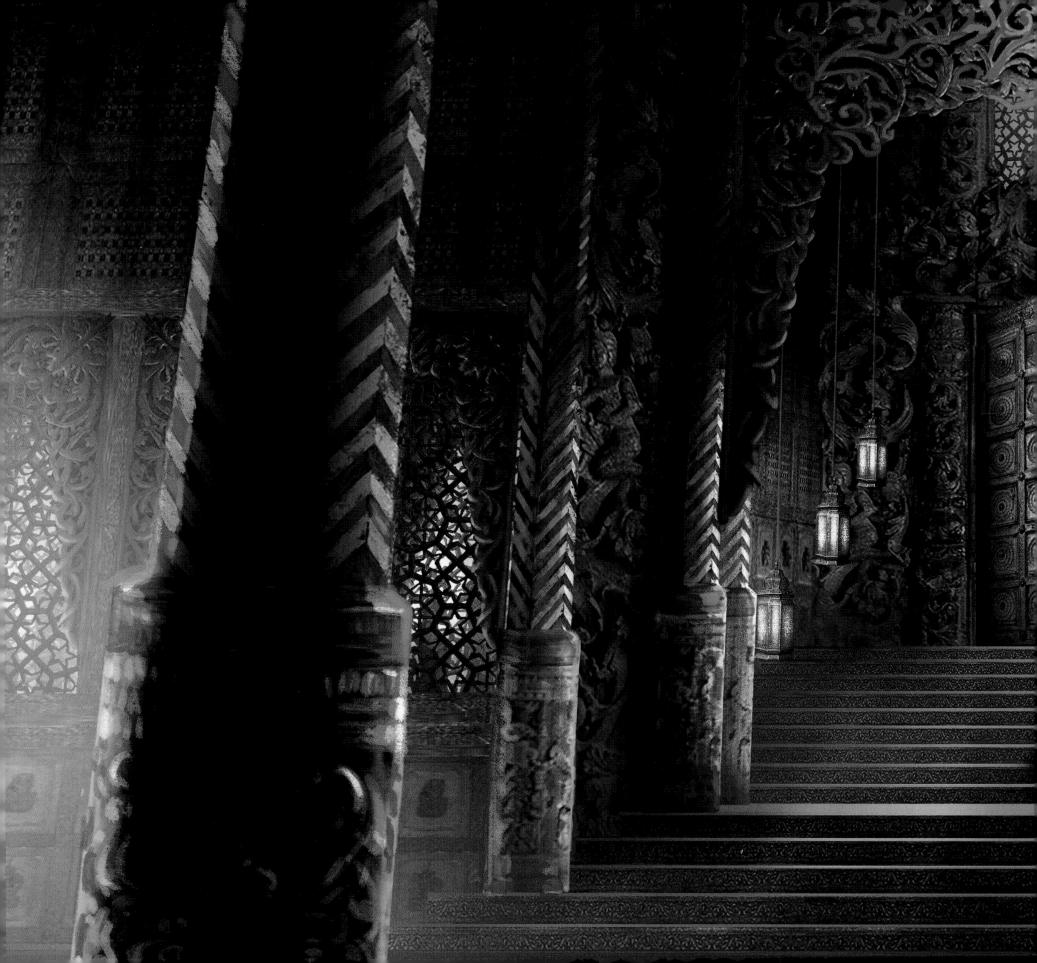

Chapter 4
COSTUMES

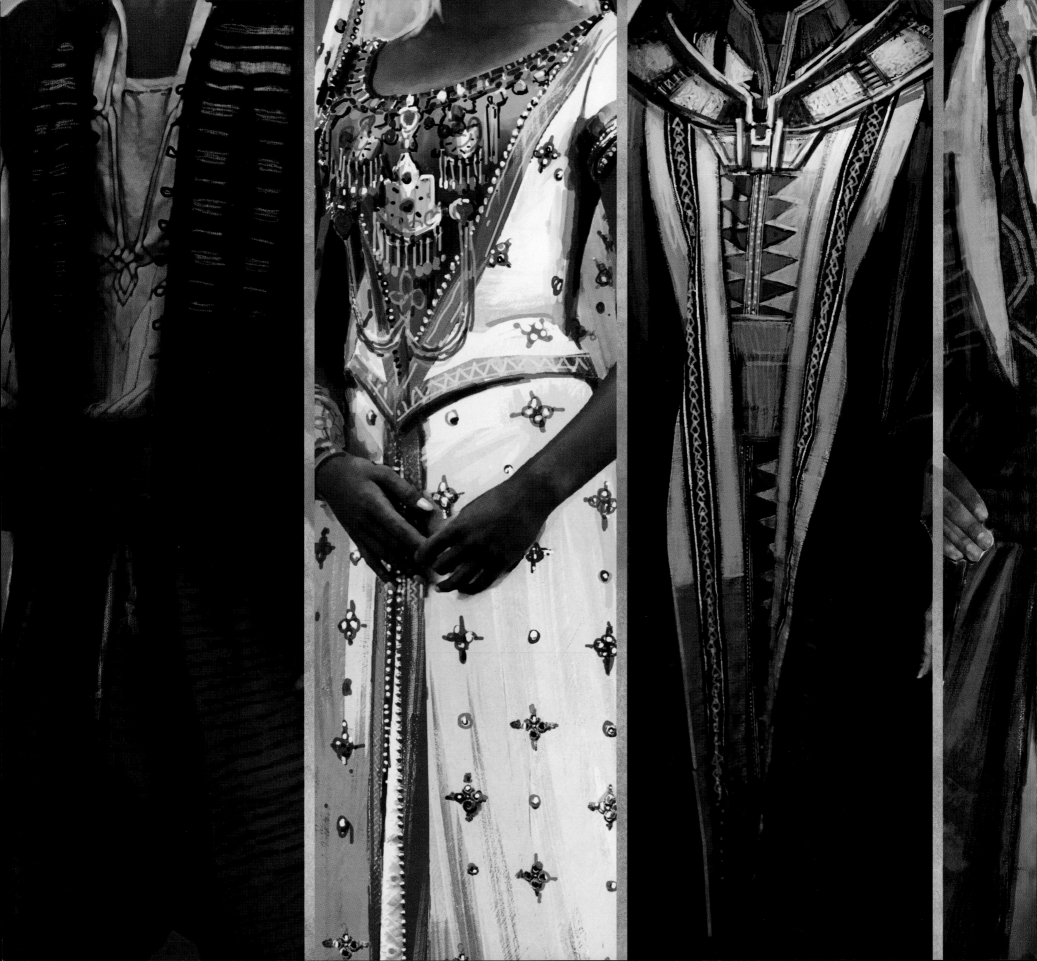

The costumes from the animated *Aladdin* were immediately iconic, with memorable colors and silhouettes. Costume designer Michael Wilkinson wanted to pay homage to the characters' classic looks while adding fresh, modern appeal. Because Agrabah is now a port city, with many cultures converging in its streets, the costume designer took inspiration from the Middle East and Morocco, as well as India and Turkey, to evolve each character from a flat animated image into a breathing being. "It was a fantastic challenge for me to take these two-dimensional characters and make them three-dimensional," Wilkinson says. "Costume is fantastic because it's an opportunity to tell the audience a little bit more about the background and the personality of these characters. I had fun using different textures and silhouettes and layers and things, just to give little subliminal hints to the audience about who these people are." He adds, "Hopefully the characters will leap off the screen and into the hearts of the audience."

In keeping with Ritchie's colorful, bold vision for the story, Wilkinson kept each look playful and vibrant. The authenticity comes from the narrative and the characters rather than a specific place in the world, so the designer was able to pull elements from various cultures, using real-world fabrics, patterns, and silhouettes to develop a new aesthetic. "Guy encouraged us to have fun with it," Wilkinson notes. "To be cheeky, and

find a balance between keeping things believable, authentic, grounded, and having preposterous flights of fancy and magic, embracing the fantastical elements of this story."

To begin, Wilkinson collaborated with production designer Gemma Jackson to develop a specific color palette that was bright and reflected the tones from the original animation. "Gemma and I wanted to give the audience a lavish visual experience—a real treat for the eyes," he says. "We were inspired by the rich, bold colors used in the paintings, textiles, and art from the Middle East, and we wanted to capture the surprising ways that the colors were combined together in the East—for example, orange with pinks or with greens. For the palace costumes, there were many metallic accents of gold, silver, and copper. In the town, the bright bursts of color in the costumes are tempered with rich neutrals and earth tones."

Wilkinson visited Morocco, Turkey, and India in search of fabrics and accessories that could work within the palace and on the streets of Agrabah. He found antique belts in Turkey, jewelry in Morocco, and silks in India, and he brought everything back together in London. "Since we were creating a fictitious Middle Eastern country, we tried to avoid anything that was too strongly associated with a particular country," Wilkinson notes. "Instead, we blended all of our favorite elements together to create a bold new world that was rich in associations but unique to the film."

PAGES 72–73: Concept art of Jasmine entering the Great Hall.

OPPOSITE: Concept art of various costumes for Aladdin, Jasmine, Jafar, and the mariner.

~ Aladdin ~

Aladdin has two distinct looks: "street rat" and Prince Ali. Although the film is not set in a particular time period, there is a sense that the story takes place hundreds of years ago, and Wilkinson wanted to ensure that Aladdin still felt young and hip in his attire when he's traversing the narrow streets of Agrabah. The designer reimagined the animated character's iconic vest, swapping purple for red and adding a hood and several pockets for concealing stolen goods. The vest is made of a strong, red-velvet fabric, which Wilkinson bought in Istanbul. Because the fabric was antique and rare, the team had exactly enough to sew the eight vests needed for the shoot. The final piece has side detailing made from striped wool that Wilkinson cut from an old Moroccan blanket. Aladdin combines the top with a pair of drop-crotch trousers, a red cap, and custom-made boots with a pointed toe. The shoes evoke classic motorcycle boots, but with a Persian flair, and the overall vibe suggests current-day streetwear without feeling overly trendy.

"It still has a timeless feel," Wilkinson says. "It could be ancient. It could be modern. We put together this silhouette for him that had a youthful, fresh, dynamic quality to it. We wanted it to feel like something the people in the audience might fancy themselves." He adds, "When I was drawing the concepts for Aladdin's shoes, I wanted something tough and with a bit of swagger. The boots were a hybrid—they have the pointed toe of a classic Middle Eastern slipper, but the toughness and sturdiness of a motorcycle boot. The full protection of a boot was helpful for all of the elaborate stunts and choreography that our actor performed."

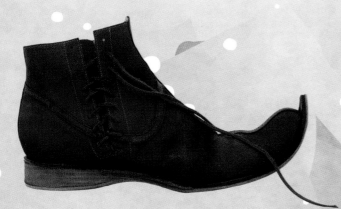

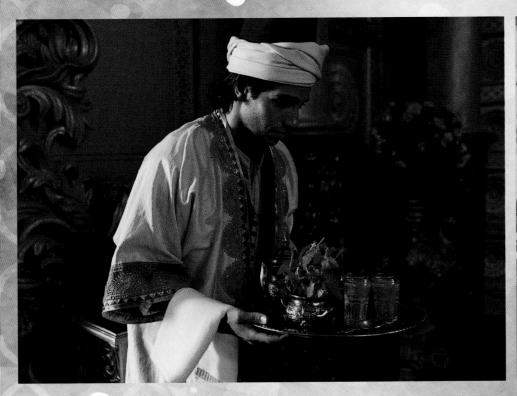

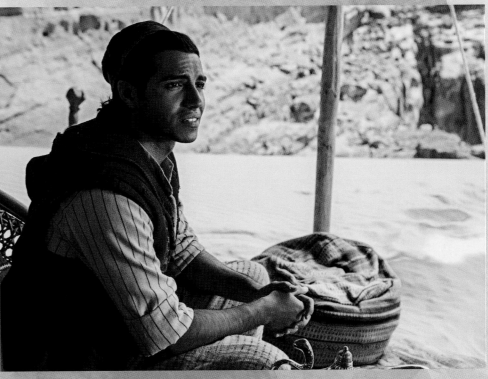

OPPOSITE LEFT: Detail of Aladdin's shoe.

OPPOSITE RIGHT: Aladdin in his "street rat" costume.

TOP LEFT: Aladdin disguised as a servant in the palace.

TOP RIGHT: Aladdin in the desert.

RIGHT: Various close-up images of Aladdin's costumes.

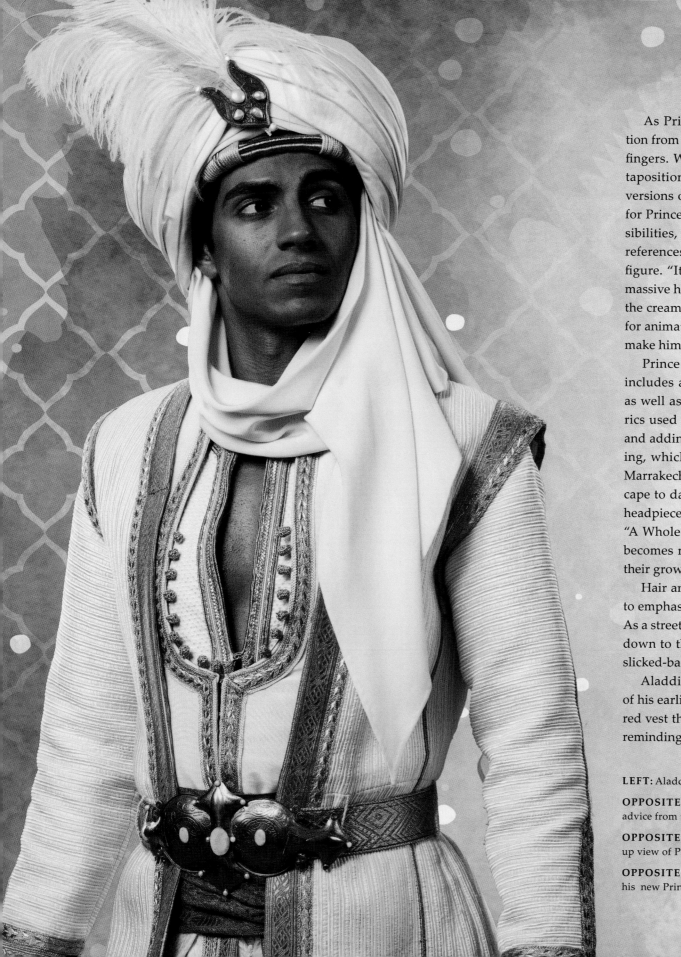

As Prince Ali, Aladdin undergoes a distinct transformation from street kid to majestic prince with the snap of Genie's fingers. Wilkinson wanted to ensure there was a strong juxtaposition in the colors, fabrics, and silhouettes for the two versions of Aladdin. Genie rolls through a variety of options for Prince Ali's ensemble, cycling through various color possibilities, and eventually settles on a creamy white look that references Lawrence of Arabia—and overwhelms Aladdin's figure. "It has a huge silhouette," Wilkinson says. "He has a massive headpiece with lovely regal detailing, and we thought the creamy color was both a nice nod to the original costume for animation and also a beautiful princely quality that would make him stand apart from all of those around him."

Prince Ali wears several versions of the costume, which includes a sumptuous cape re-created from a Syrian design as well as custom boots and belt. Wilkinson created the fabrics used for Prince Ali by printing them with metallic inks and adding gold foiling. He also brought in decorative braiding, which was specifically made for the film by artisans in Marrakech. During the Harvest Festival, Aladdin removes the cape to dance with Princess Jasmine, and later he shreds his headpiece and jacket as the pair soars through the air during "A Whole New World." These layers come away as Aladdin becomes more comfortable with Princess Jasmine, reflecting their growing connection.

Hair and makeup designer Christine Blundell also wanted to emphasize the differences between Aladdin and Prince Ali. As a street kid, Aladdin has facial stubble and hair that sweeps down to the sides, but as Prince Ali, he is clean-shaven with slicked-back hair.

Aladdin's final look at the end of the movie marries both of his earlier aesthetics. He wears a red and gold outfit, with a red vest that references his earlier look as a kid on the streets, reminding the audience how far he's come.

LEFT: Aladdin dressed as Prince Ali.

OPPOSITE TOP LEFT: Prince Ali gets advice from the Genie.

OPPOSITE BOTTOM LEFT: Close-up view of Prince Ali's ornate costume.

OPPOSITE RIGHT: Aladdin examines his new Prince Ali clothing.

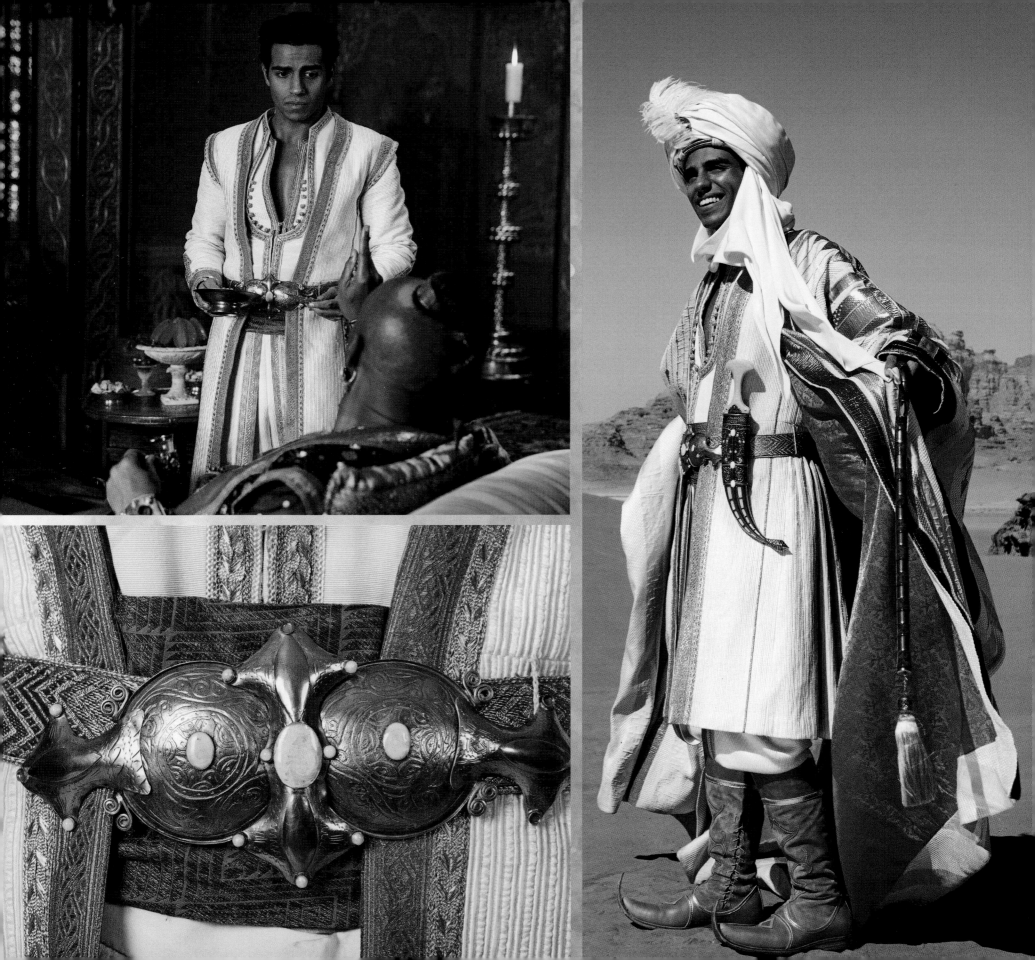

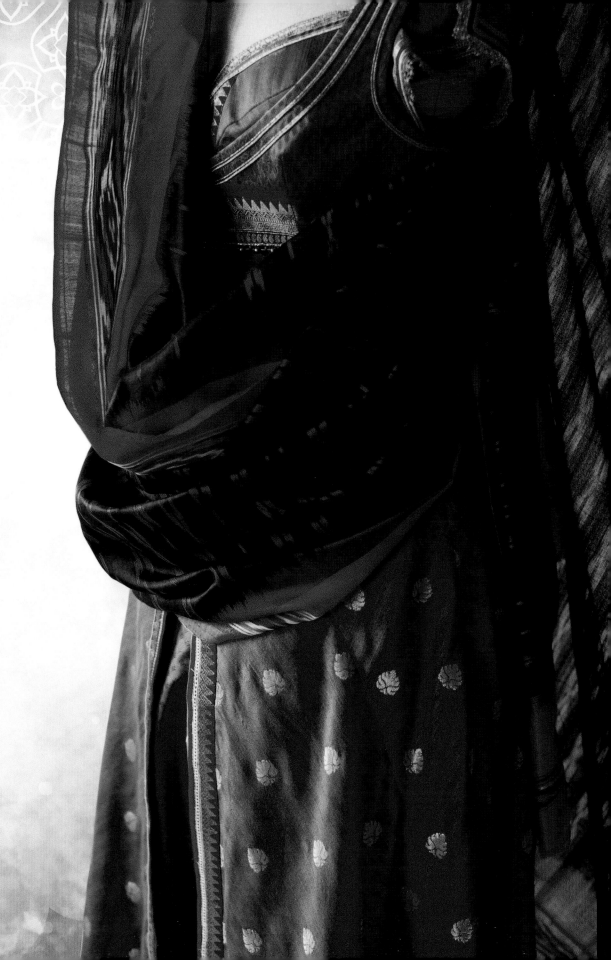

⚘ Jasmine ⚘

Throughout the film, Jasmine dons nine signature looks, all with strong colors to convey her personality and help her stand out from those around her. Wilkinson wanted the character's unique way of looking at the world to come through in her costumes, and he collaborated with Naomi Scott on each look. In the palace, Jasmine's looks are constricted with corsets and boning to reflect how constrained she is in royal life. Her looks in her private chambers and outside the palace are freer and looser. "Yes, she may be a princess, and when she's in those moments of duty, she has to be more poised, but she is also a normal girl," Scott notes. "What's so important to me is that she has to feel relatable. There are all these beautiful costumes, but at the heart of it it's about the character."

"We had a lot of discussions about how we wanted to present the princess in this live-action version, and we came to the conclusion that you see her in lots of different states in the film," Wilkinson says. "You see her public persona, which is when she accepts her duty as a princess, and we wanted her costumes in those moments to encase her and restrict her movements. Then we see her in more private moments where she's more at liberty to be herself. Her silhouette and her clothes are a little bit more relaxed and fluid, and she's able to move around the palace as a young, spirited woman."

Wilkinson wanted to pay homage to Jasmine's memorable looks from the original film but also give her more scope and more opportunities to express herself. "It was very important for us to show her as a very strong, intelligent woman who was the mistress of her own destiny and battling with this sense of responsibility and duty and her own vision of herself," Wilkinson says. "Describing those sorts of qualities in the way she dressed and how she presented herself to the world was a really interesting journey to explore with Naomi."

When Jasmine ventures out into the marketplace after escaping the palace, she wears turquoise silk leggings hidden by a more modest dress based on a Turkish design. The turquoise shade returns in her Harvest Festival ensemble, which reinterprets the character's classic animated look.

RIGHT: Jasmine's first outfit is a teal and fuchsia ensemble with a veil.

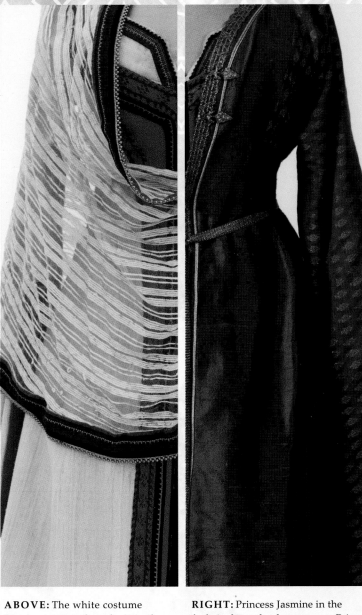

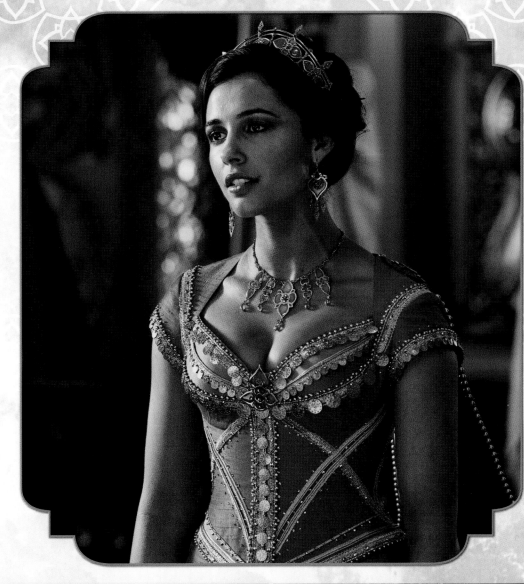

ABOVE: The white costume Jasmine wears when she is in the marketplace (*left*) and the green overcoat she wears over it before escaping the palace (*right*).

RIGHT: Princess Jasmine in the fuchsia dress she dons to meet Prince Anders (*top*) and two images showing the details of her costume (*right*).

BELOW: The treasured bracelet Jasmine wears that once belonged to her mother.

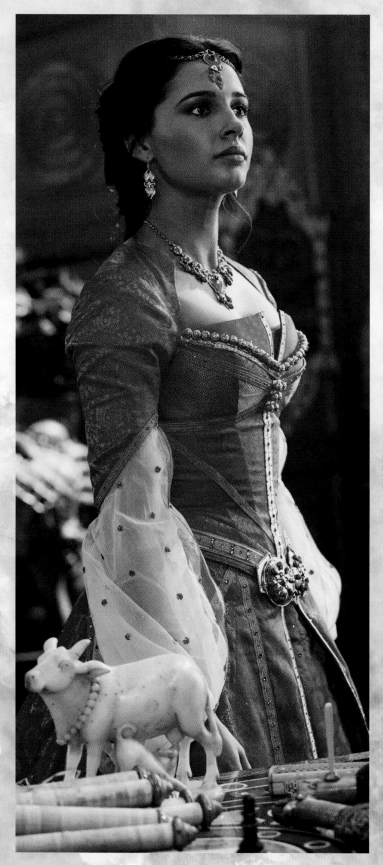

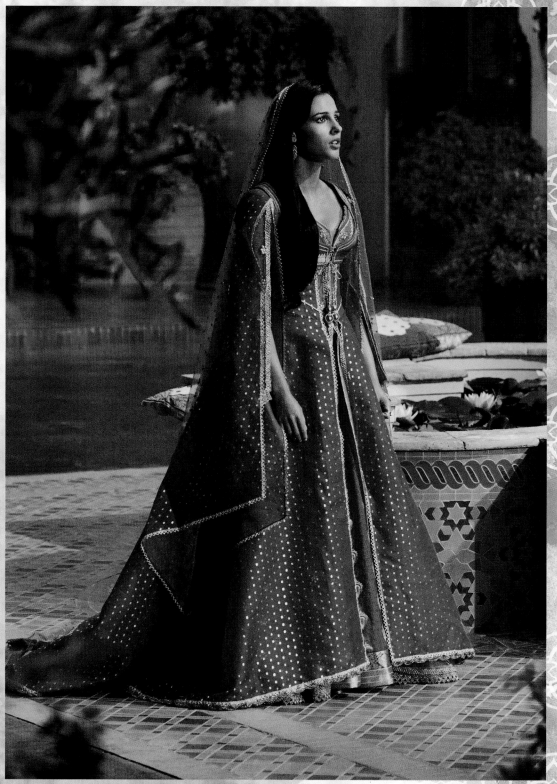

LEFT: Jasmine wearing her orange gown.

ABOVE: Jasmine in the palace gardens wearing a purple gown.

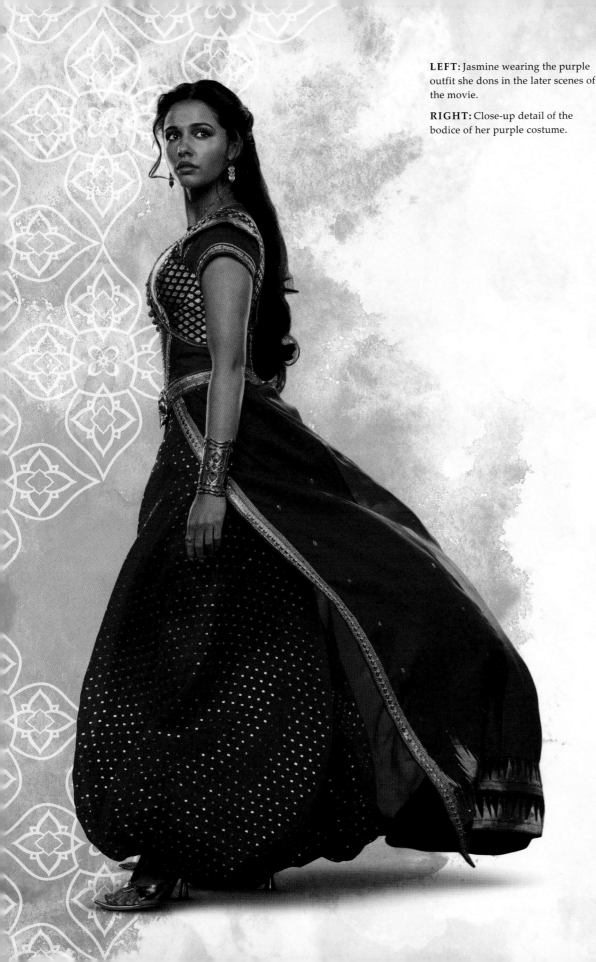

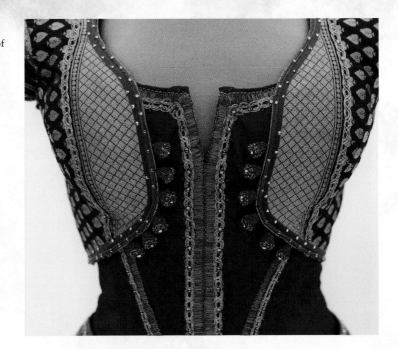

LEFT: Jasmine wearing the purple outfit she dons in the later scenes of the movie.

RIGHT: Close-up detail of the bodice of her purple costume.

In the action-packed finale, Jasmine wears an elegant yet functional purple and gold outfit with a long skirt overlaying billowing trousers. Jafar later forces her into a wedding dress, which Wilkinson designed specifically for the finale sequence.

"As a form of protest, the wedding ensemble that Jasmine wears to marry Jafar is not overly celebratory, especially when we compare it to the dress I designed for the film's joyous finale, which is a richly embellished creation of ivory organza and turquoise silk," the costume designer explains. "The costume for the wedding to Jafar consists of a deep purple waistcoat, blouse, and harem trousers, with regal gold accents. When she wears the costume, she has to leap onto a magic carpet and race through the town, so I knew the costume had to be unrestrictive in its range of movement—trousers seemed like the right choice."

For Jasmine's final look, Wilkinson brought back the signature turquoise trousers to show that Jasmine retains her sense of identity. The ensemble was created using sheer ivory fabric from India embellished with mirror pieces and silver embroidery, and Wilkinson added crystals as a final touch to give it a magical quality. The look is also decorated with tiny white enamel jasmine flowers, which appear on Jasmine's headpiece and around the neckline of her dress.

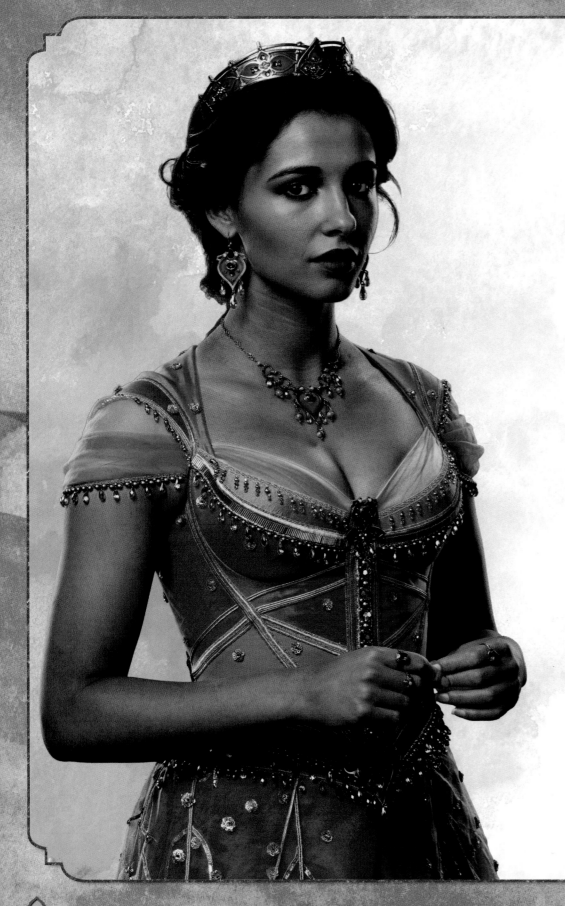

COSTUMING THE HARVEST FESTIVAL

For the celebratory Harvest Festival scene, Wilkinson designed dozens of costumes for extras and dancers, as well as for the lead actors. He used a color palette of oranges, pinks, and yellows with accents of lime green and turquoise, emphasizing opulence and style in the detailing. Gold, metallic, and mirror elements thread throughout the pieces to allow the costumes to really jump off the screen, especially during the dance number. Wilkinson's inspiration primarily came from Turkey, Africa, Pakistan, and China to reflect the global melting pot of cultures gathered in Agrabah. He explains, "At the festival, there would have been dignitaries from Arabia, from Morocco, from Shanghai, so we wanted to represent a wonderful mix of cultures and silhouettes and colors."

Jasmine's costume for the festival was particularly important. Her look is a reinterpretation of the iconic animated costume and features a vibrant turquoise with a beaded peacock cape, custom shoes, and a special tiara. She stands out alongside Prince Ali's luxe cream ensemble as he tries to impress her with his dance moves.

The costume features custom jewelry and shoes, a special tiara, and a beaded peacock cape—just one expression of a recurring peacock motif that Wilkinson included in many of Jasmine's pieces. "I wanted to honor that fantastically bright turquoise color that has become synonymous with her character," Wilkinson says. "We're at the festival, and there's dancing, so I wanted to create something that moved really beautifully. The peacock seemed like a relevant symbol for the princess—it is often caged in the palace, cut off from the real world, like Jasmine herself."

LEFT: Prince Jasmine in her teal outfit.

OPPOSITE LEFT: Jasmine's teal outfit features prominent peacock detailing.

OPPOSITE TOP RIGHT: Jasmine's teal costume features beautiful gold accents and jewelry.

OPPOSITE BOTTOM RIGHT: Prince Ali and Jasmine dance during the Harvest Festival.

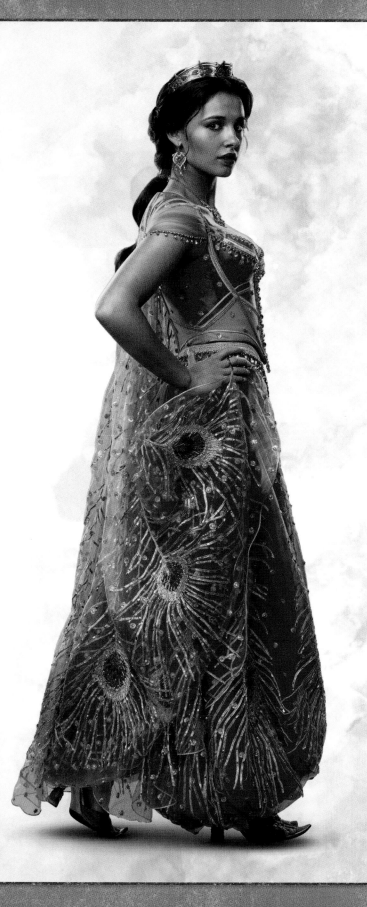

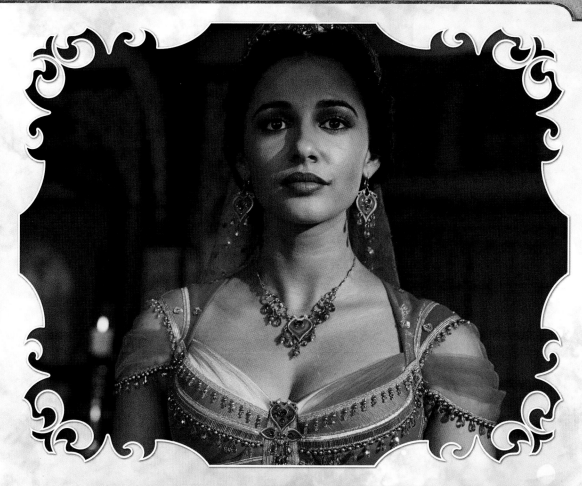

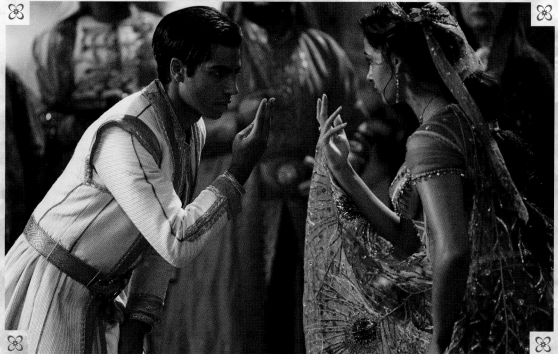

Genie

The Genie emerges in three distinct forms throughout the story. For the mariner, who narrates the tale, Wilkinson brought in colorful African and Arabic influences, and the overall look suggests a swashbuckler who has traveled all over the world. The character wears a loosely draped headpiece that harkens back to the animated Genie's headpieces.

Genie also transitions between Big Blue and human form, so Wilkinson had to work with the visual effects team on which elements would overlap between the real-life costumes

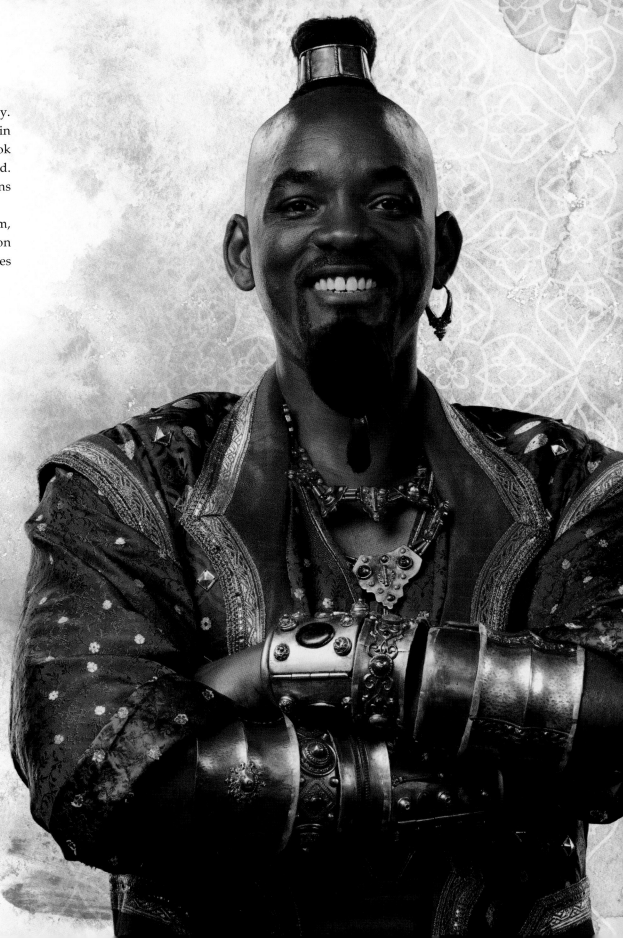

ABOVE: Detail shots of Genie's bracelets.

RIGHT: Will Smith as the Genie in his human form.

TOP: Details from the costumes the Genie wears in his human form.

and the special effects. Wilkinson created the original concept images for Genie with a team of illustrators as guidance. Both versions of the character wear similar jewelry elements, including Genie's signature metallic bracelets that he wears on each wrist. The layered bracelets evoke the gold shackles worn by the character in the animated film and provide a strong sense of Genie's history. "He's been a genie for thousands of years," Wilkinson says. "He's had many different masters, and he's collected bracelets from different masters and from all his travels around the world. When he's freed at the end, they tumble to the ground and he becomes a human again."

The character is unpredictable and fun-spirited, often changing his look on a whim. Ritchie and Wilkinson liked the idea that Genie often swaps between massive headpieces, particularly during the Harvest Festival scene.

"Guy had this very strong initial impulse for very big headpieces," the designer says. "He showed me all sorts of interesting research on Indian holy figures that had these huge headpieces with hundreds of meters of fabric wrapped in this layered, interesting look. So that was the starting point for Genie's character. When I researched headpieces from different cultures, I discovered that we could back up our designs with some very sizable references, from Indian sadhus to Ottoman dignitaries. Our milliner created a range of headpieces draped with silver chains and custom-designed pins. We have to devise complex inner structures to support the elaborate designs, keeping them as lightweight as possible."

Wilkinson scoured the globe for the best blue fabrics, looking for the "richest tones of blues," and designed custom earrings and necklaces to accompany Genie's headpieces. He created "outlandish" shoes that include a pair of blue suede slippers hand-embroidered in Spain. Genie's shirts and vests were embellished with cording, embroidery, and woven buttons from Morocco, as well as metal decorations. Genie and the mariner both have beards, a trait that Blundell decided after conducting numerous hairstyle tests. After toying with the idea of a Mohawk, she and Ritchie ultimately decided on a topknot for the Genie's hair, calling back to the original film.

Jafar

Jafar retains several of his signature elements and colors from the original animation, but Wilkinson wanted to include more references to the character's ambitions in his clothes. He kept the memorable reds, blacks, and golds, but reimagined Jafar's costumes with a more specific history.

"I always say villains get to wear the best costumes," the designer says. "When I met up with Marwan [Kenzari] and talked about the character, we definitely wanted to nod towards the animation, but we also wanted to take it in our own direction. One of the biggest points of change, I think, is the inclusion of armor in his look. We really wanted to hint at his military background, his militant aspirations of conquering different neighboring countries and turning Agrabah into a militant state."

LEFT: Jafar disguises himself to steal the lamp.

RIGHT: Jafar wields his staff.

OPPOSITE TOP LEFT: Jafar looms menacingly in the Cave of Wonders.

OPPOSITE TOP RIGHT: Jafar speaks to Aladdin in the desert.

OPPOSITE BOTTOM: Jafar and Prince Ali face off.

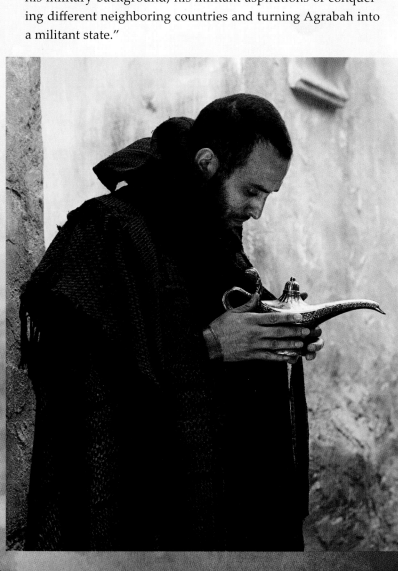

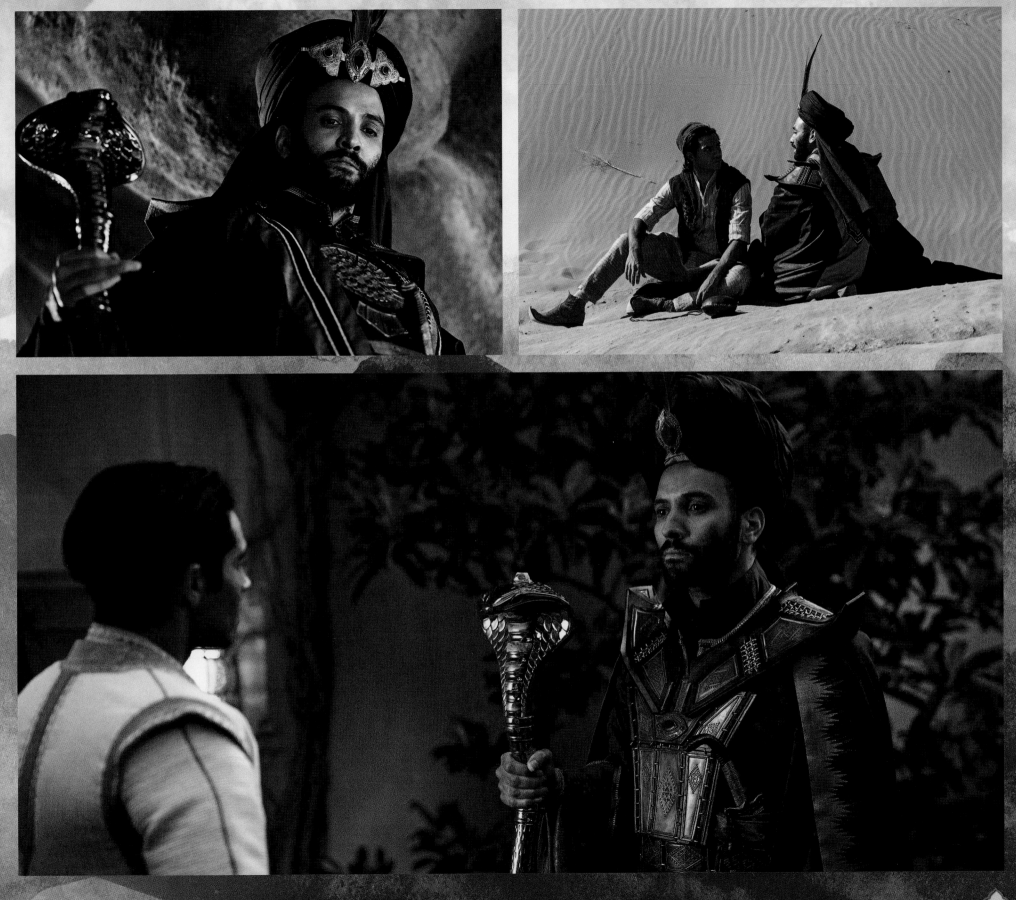

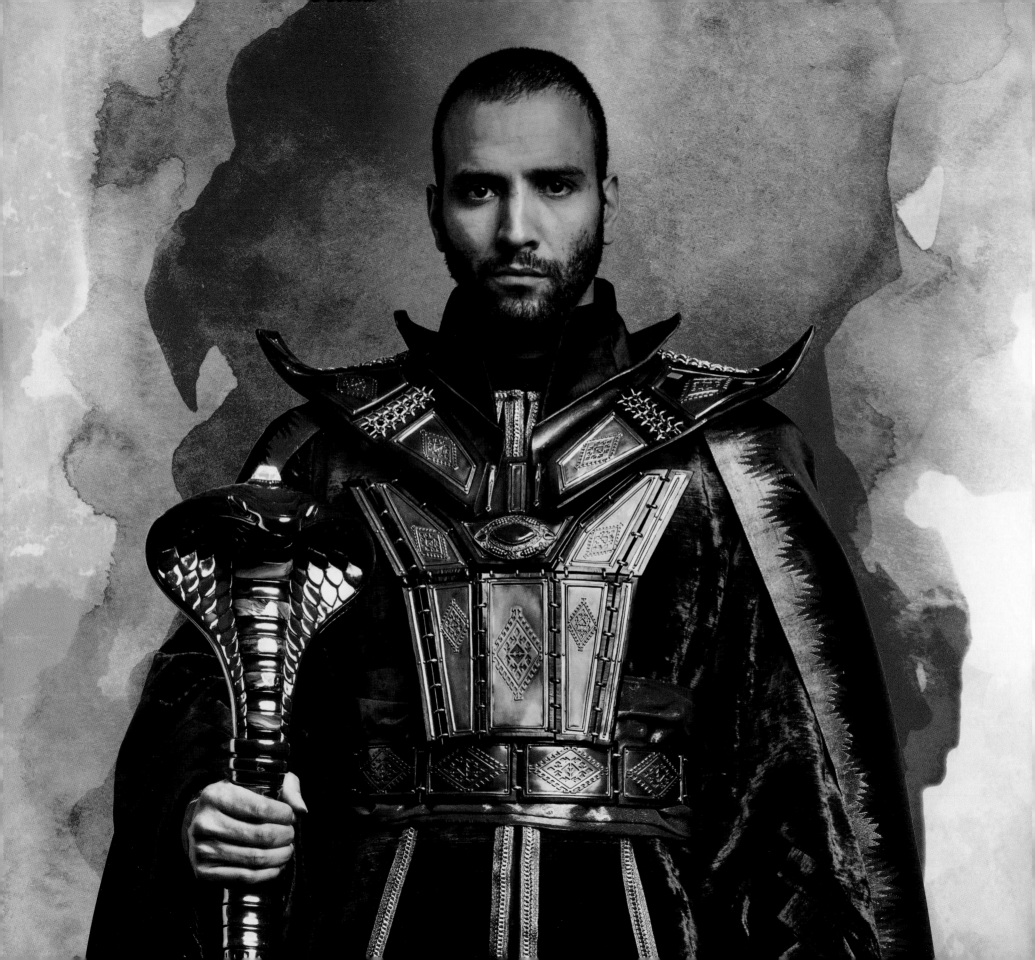

Jafar's sharp, angular look includes an armored breastplate made with sculpted leather and brass chainmail, as well as a headpiece that comes directly from the animation. He wears several sprawling capes, including a red velvet cape and a black satin cape. Wilkinson chose Indian fabrics with bold patterns to give graphic motifs to each cape, and the character's signature snake symbol recurs in the clothing as well as in his trusty staff.

"In the animated version of *Aladdin*, Jafar has a great look," Wilkinson says. "We wanted that to be our starting point but then to leap off into our own version. With our actor, we created a tall, iconic headpiece shape, draping together Jafar's red and black tones, accented by a jeweled headpiece pin and a feather that took the silhouette even higher. Jafar has ambitions to be the most powerful person in the room, and we wanted to hint at that with his intimidating costume. The snake motif is used in his staff to work together with the language of the costume."

Jafar's costume shifts as he transforms into the new sultan, then into an evil sorcerer, and eventually into a genie himself. The deep reds, blacks, and golds recur in each look, as do Jafar's pointed shoulder pieces, an important shape that filmmakers retained from the animation.

OPPOSITE: Jafar in his palace vizier costume.

TOP: Jafar's ring.

RIGHT: Jafar's sorcerer costume.

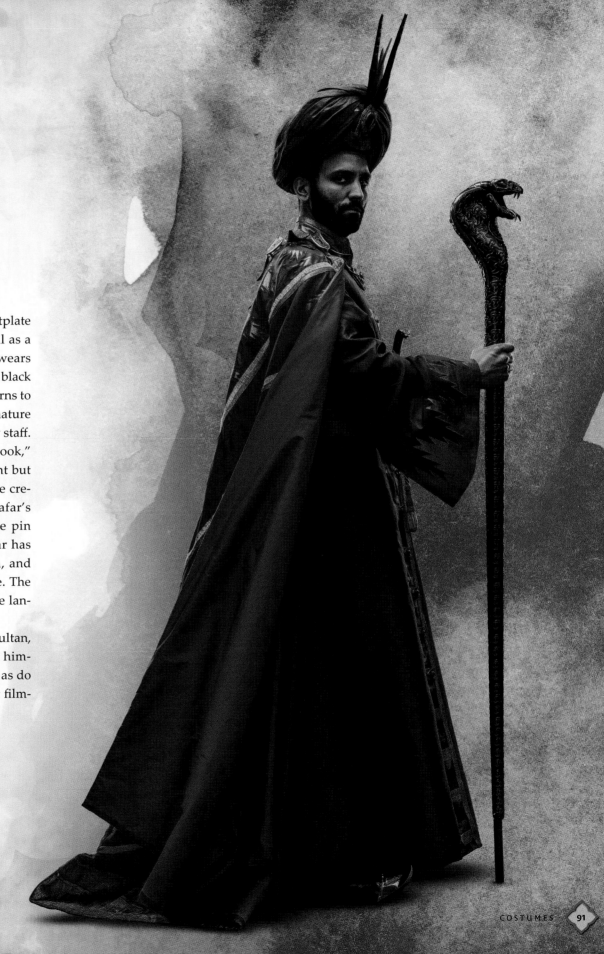

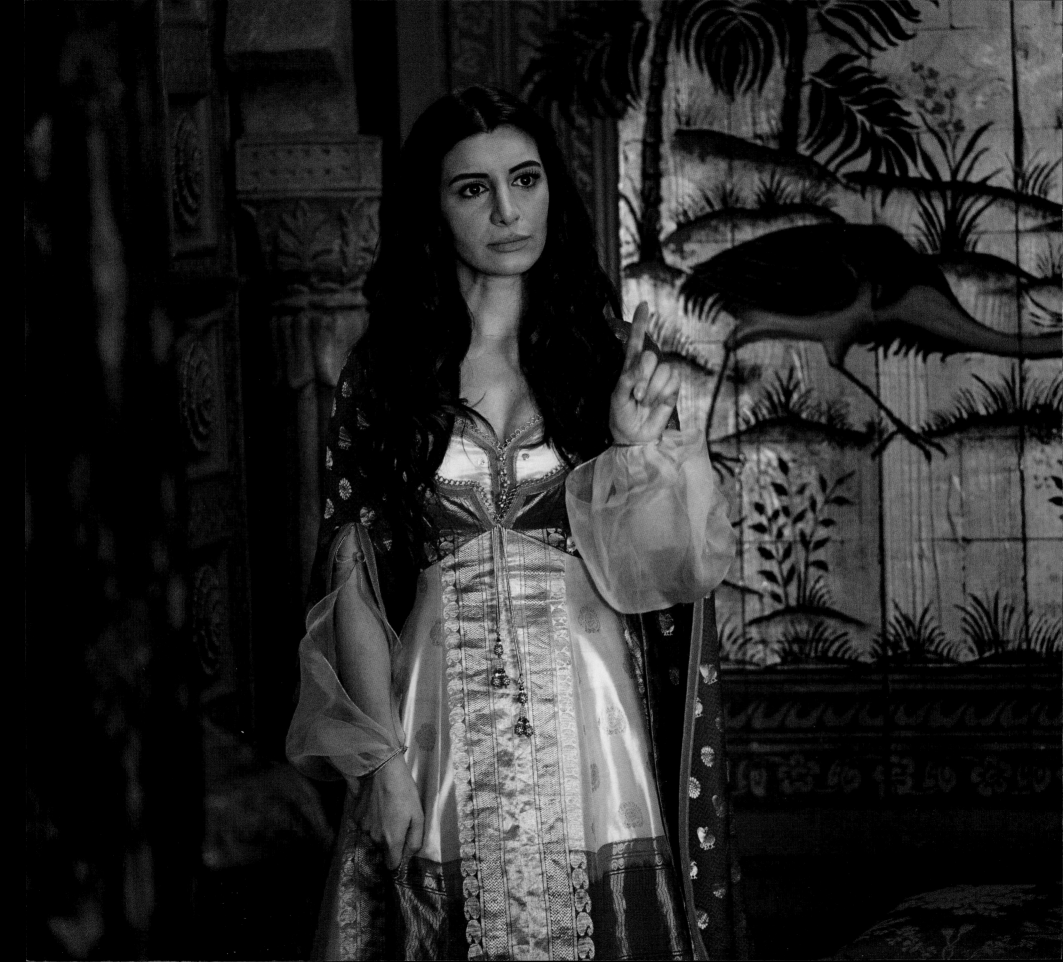

‎ৎ• *Dalia* •ৎ‎

Dalia appears in several costumes both as Jasmine's handmaid and later as the mariner's wife. As the mariner's wife, Dalia wears an embroidered overcoat, custom jewelry, and a veil to reflect the couple's worldwide travels. Wilkinson took the fabrics in Dalia's costume from Turkey and India and sought a global aesthetic for the character.

In the palace scenes, Dalia wears simple outfits with a cream, burgundy, and gold color palette, as well as custom jewelry. Wilkinson created a special belt for her, with small tools hanging at the ready, including a small sewing kit for in-the-moment repairs.

"Dalia's costumes had to convey the fact that she was a part of the royal household, but a lower level than the princess," Wilkinson says. "At the beginning of the film, Jasmine realizes that if she swaps her own richly embellished royal clothing for Dalia's simpler costumes, she would be able to blend in more with the people of Agrabah when she escapes from the palace. So Dalia's costume was made in more basic fabrics, with some simple folksy embroidery and braids—still lovely, and appropriate for a handmaiden, but less exotic than Jasmine's clothing. As someone who longs for a more constructive, practical life, we wanted Jasmine to be envious of Dalia's simpler, less constrictive clothing."

LEFT: Dalia wearing her Harvest Festival costume.

OPPOSITE: Various details from Dalia's first outfit featuring cream and gold pants with a red tunic and gold belt.

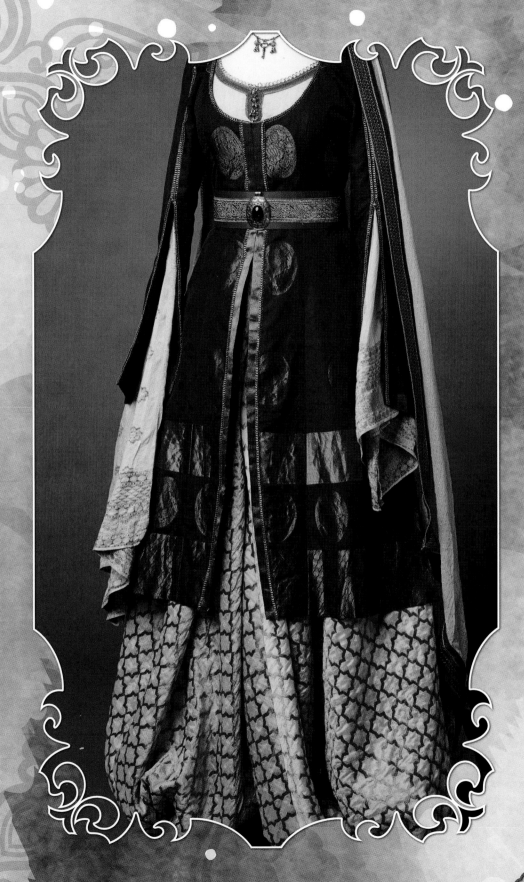

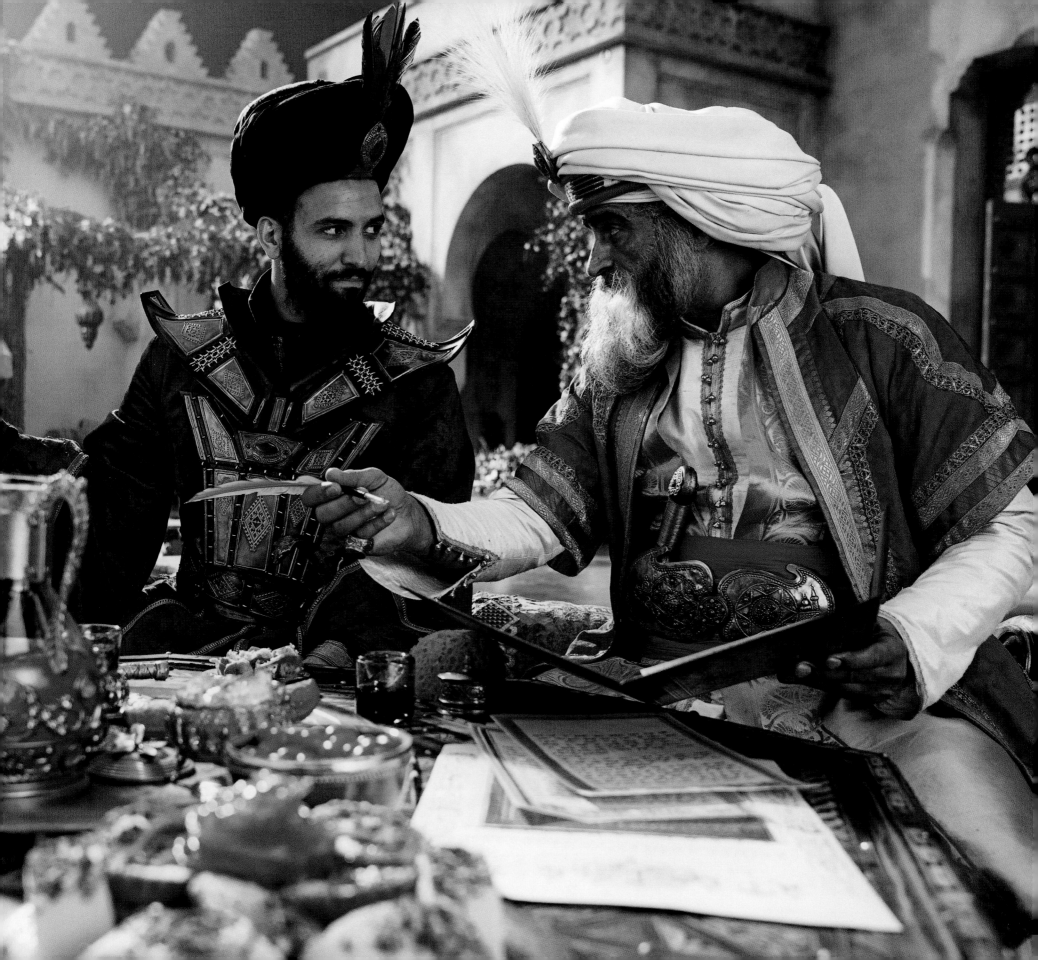

✤ Sultan ✤

The Sultan wears several looks throughout the story, each inspired by how he appears in the animation. Wilkinson primarily used cream and gold fabrics and of course included the character's iconic headpiece. The layers of luxurious detailing and beautifully textured fabrics lend a rich appearance to the Sultan, who has more seriousness and gravity to him here than in the animated film. The bold details come in brilliant shades of yellow, green, and red, giving the character a powerful sensibility that resonates through his clothing.

"We wanted the starting point for the Sultan's costume to be the beautiful creamy tones from the animated version of *Aladdin*, but to then add in all the wonderful design elements from our research into sultans from various cultures and historical eras," Wilkinson says. "I loved the idea of lavish layering of rich brocades and velvets, and the unusual and striking color combinations—turquoise and salmon pink, burgundy and orange, and more. I found incredible full-bodied silk brocades with large-scale patterning that I combined together into elaborate ensembles. Navid Negahban carried them all off with a wonderful mixture of elegance and fun."

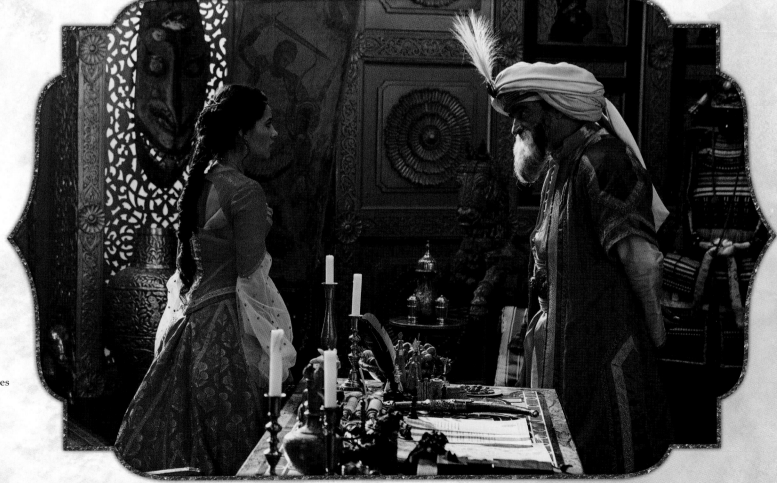

OPPOSITE: The Sultan's costumes featured numerous textures and colors.

RIGHT: Jasmine and the Sultan have a serious conversation.

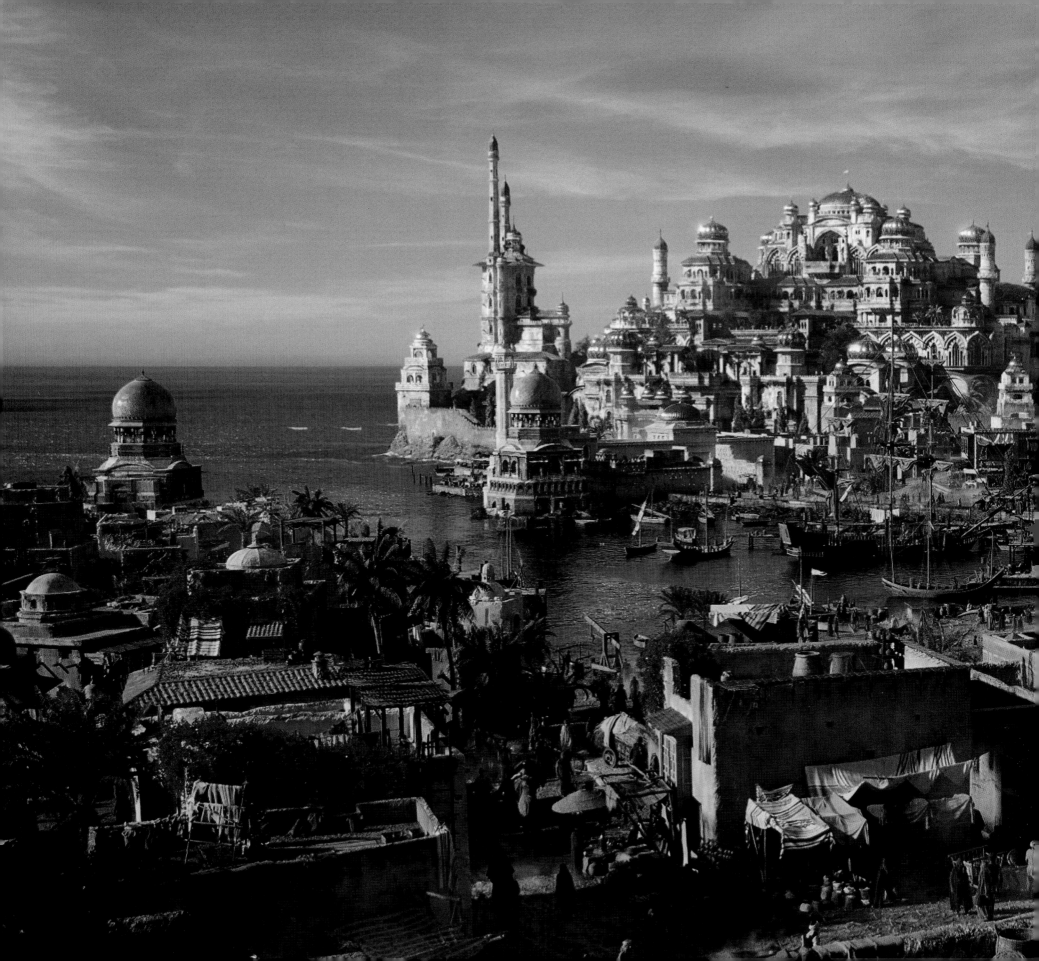

Chapter 5

VISUAL EFFECTS

While *Aladdin* brings the magic-filled Agrabah to life in live action, a number of elements could not be physically constructed, and visual effects were essential to complete this detailed world. The stunning visual effects seen throughout the movie were complex and had to be incorporated seamlessly. Five characters—Genie's Big Blue form, Abu, the magic carpet, Raja, and Iago—are entirely digital creations, adding another layer of complexity to the process. Each character needed to look real, have an individual personality, and fit within the scene.

Disney enlisted visual effects supervisor Chas Jarrett as well as a team at Industrial Light & Magic (ILM) led by animation supervisor Tim Harrington to visualize the world and characters of Agrabah. The filmmakers continually referenced the original film, especially during the computer animation process, while also developing the live-action movie's own aesthetic. From the beginning of the process, concept artists helped shape the filmmakers' visions, drawing different versions of the characters and locations. "We were all quite clear early on that we didn't want to stray too far from characters and scenarios that people already knew and loved," Jarrett notes.

"Each element had its own different challenge," says animation supervisor Tim Harrington. "Will Smith being a realistic human as the Big Blue Genie was a big challenge, and creating the realistic animals was also important. We wanted to make sure everything was super high quality, believable, and appealing. With Will, we wanted to make sure that when people saw

PAGES 96–97: A final render of the palace and Agrabah.

BELOW: Concept art of Agrabah showing some of the marketplace and port.

BELOW LEFT: A sequence of images showing the development of Agrabah and the palace exterior, which was created digitally.

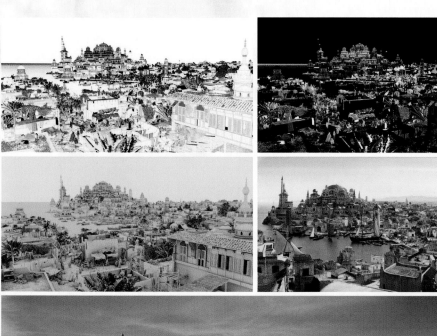

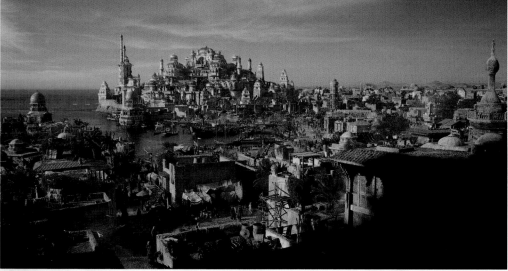

him, they thought, 'Oh, that's Will Smith,' and then went along with it. Same with the animals. We don't want anyone to be distracted by the illusion."

While Agrabah's streets and palace rooms are real sets built by the production design team, wider shots of the city are digital creations. The filmmakers again used concept artists and scale model makers to imagine the palace overlooking the city and the expanse of Agrabah and its port. Production designer Gemma Jackson worked with the visual effects team to design the complex, winding city as one visually cohesive world.

"We took out drones to fly over cities so we could scan them from the air for particular bits that we liked," Jarrett says. "And then we would bring all of that material back—huge amounts of material that we acquired over months and months around the world that we thought were relevant. We would bring that back to London and then sift through it with Gemma and together pick out the things we liked and things we didn't like. [We had] endless conversations about the conceptual and philosophical aesthetic of the film, and then we would go away with all that information and essentially design and build environments from that."

The VFX team also worked closely with the special effects and photography departments. Ritchie was careful to ensure that the crew focused on a realistic version of the Middle East in all aspects of the filming. "It was a very collaborative effort," Jarrett says. "One thing Guy was certain about from the very outset was that it was to be a very faithful rendition of the—albeit fictionalized—Middle East. It's a very authentic-feeling environment and character."

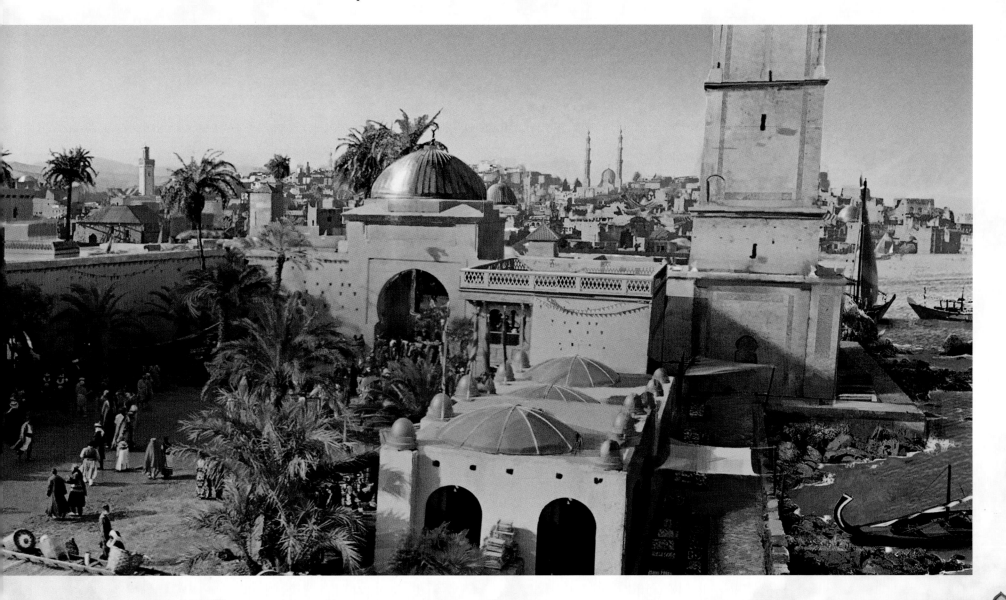

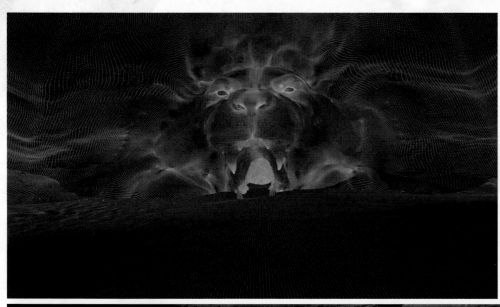

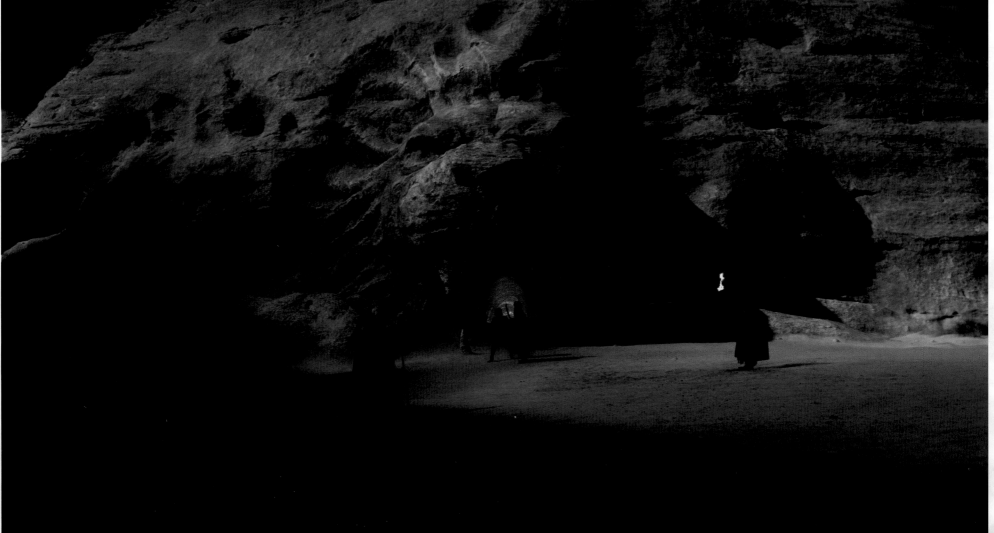

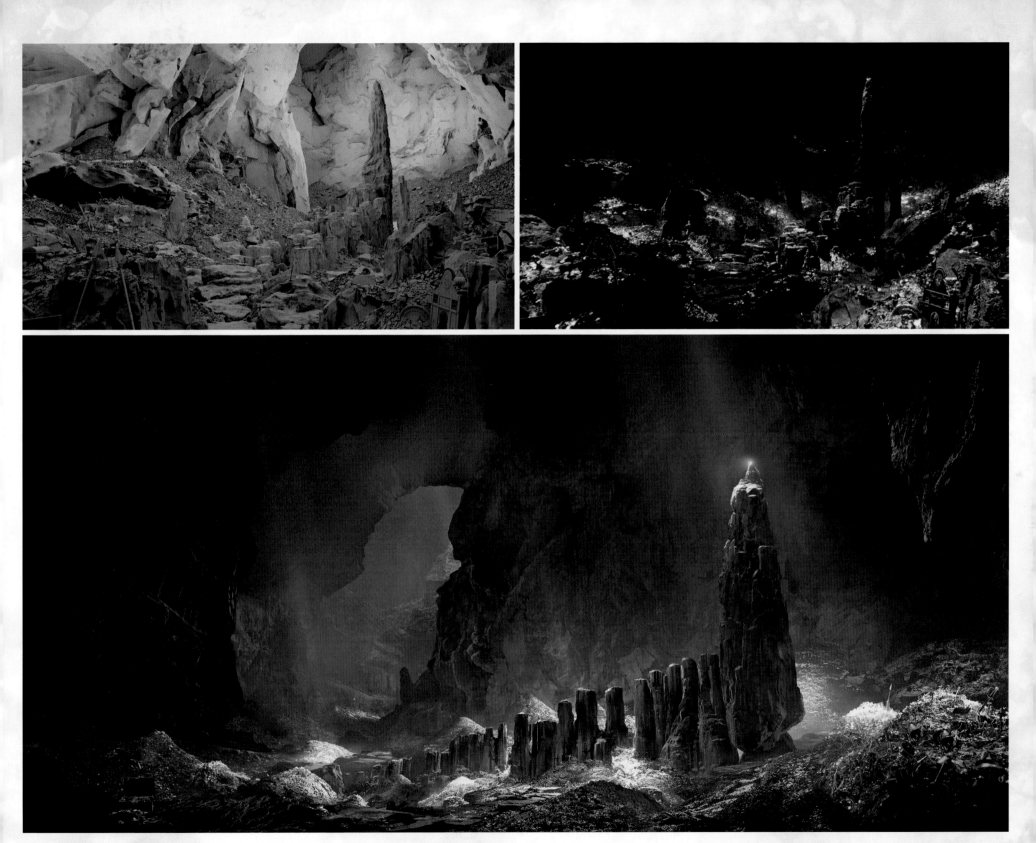

OPPOSITE: Images showing how the exterior lion head of the Cave of Wonders was modeled.

THIS PAGE: A series of images showing the development of the path to the lamp in the Cave of Wonders.

ABOVE: This sequence of images shows the progression of visual effects design for the Cave of Wonders.

RIGHT: Aladdin reaches for the Genie's lamp.

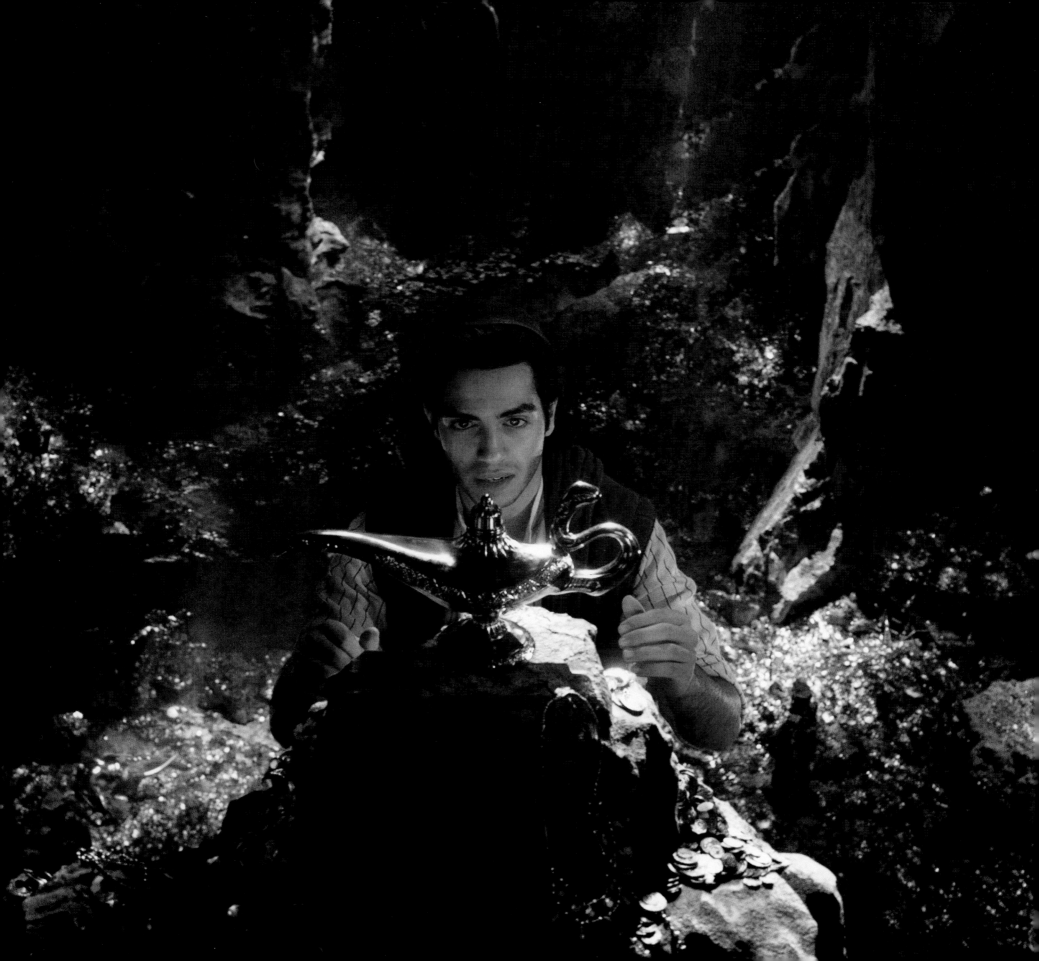

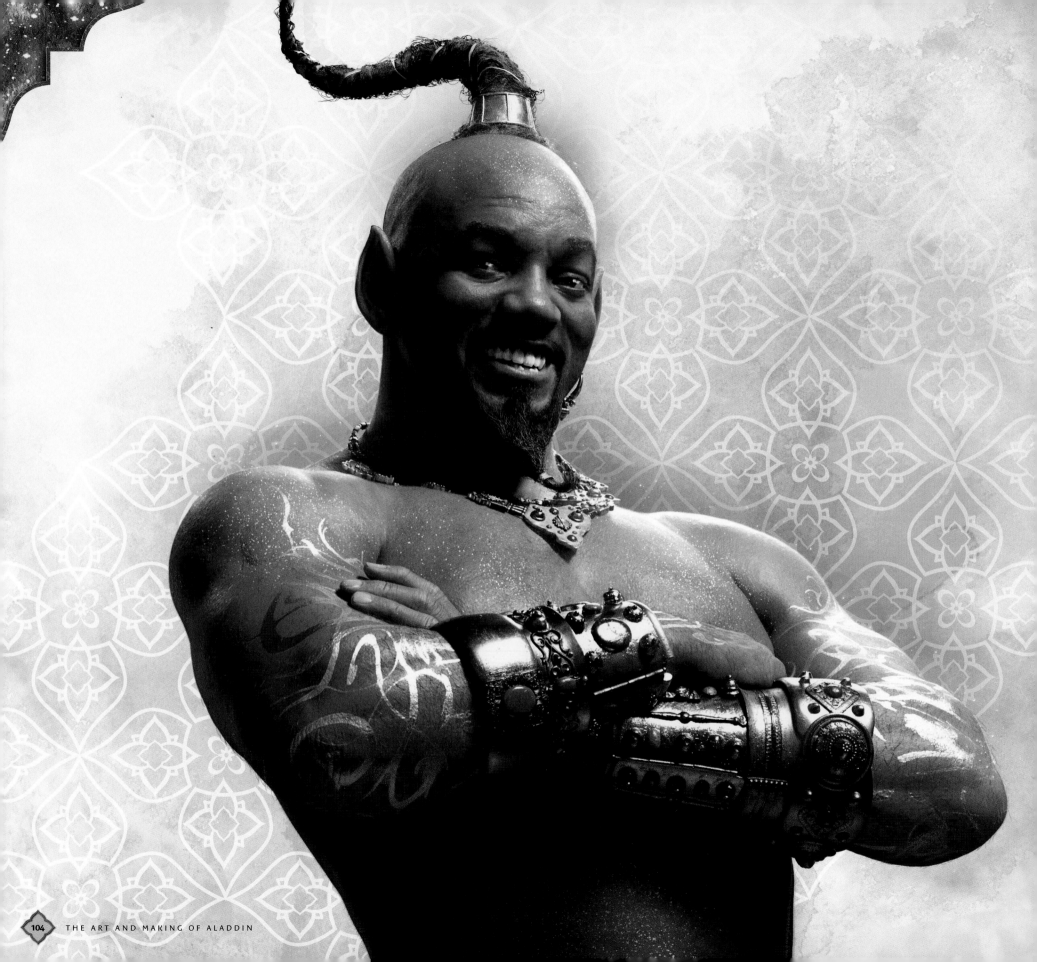

Genie

During the process of making *Aladdin*, the Genie proved to be the most challenging VFX element. The fast-talking, whimsical character needed to look real enough to be believable, but he also needed to look fantastical. As Big Blue, Genie is an entirely digital creation, and Will Smith worked with the VFX team to generate the physical performance for the character. As the process went along, it became clear that Genie should reflect Smith's actual face and performance, even in his magical form.

"We have this big-name actor, and we want the audience to be able to identify him and know right away that it's Will Smith," Harrington says. "We tried some caricatured versions, and the more we delved into it, the more we realized that Will's an appealing actor and there's nothing wrong with his face, so it didn't make sense to distort his face or caricature him when he's playing Big Blue. So when you see the Genie, it's pretty much Will."

Disney Research developed a new motion-capture system called Anima, which allowed the team to capture Smith's facial performance with high-resolution cameras surrounding the actor's head and apply the performance to Big Blue with high fidelity.

"You're essentially in a big, black box surrounded by cameras," Jarrett notes. "You're not surrounded by other actors. You're not on a set. So it's quite a tough environment in some ways for an actor to really come to life in. So, although capturing his face in so much detail was a really key part of the performance, we also brought Will on to set and filmed him standing with the other actors even knowing that we'd have to digitally remove him from the shots."

His presence on set allowed the other actors to react to his performance, but the Big Blue version of Genie in the film was added digitally afterward. To help create the body of Big Blue, Harrington put Smith in a motion-capture suit called an Imocap suit to capture his body movements as well as his facial movements in a less constricted environment than Anima. Big Blue can accomplish a wide range of magical movements, from growing and shrinking in size to separating his hand from his body and more. But because this is a live-action film, the filmmakers didn't want Genie's antics to be too extreme.

"Those types of playful staging gags were really fundamental to the original film, and we still felt they're very important to our character—they are very much part of his character and certainly [part of] the way Will played it," Jarrett says. "But we're challenged in a way because we're not just 2D. His skin actually looks like skin, because you believe his body actually has bone and muscle and all those things that look and feel real. If you start contorting those things—skin and bone—in such extreme ways as the 2D animation did, it begins to get very creepy, very quickly. It just doesn't feel right. So we've really had to tread this fine line between cartoony and playful, but also being true to the physical weight of a being."

The greatest technical question during the process was how to handle Genie's smoky blue tail. The team designed the character's upper body in a naturalistic, muscled way but needed to determine how he would float and where his tail would appear. Jarrett and the animators tested out various versions before settling on the final look, which gives Genie a more grounded appearance. "It's easy to draw, but very hard to make look real," Jarrett says. "So that's been a real challenge."

The original version of Genie's tail was simply blue smoke, but the filmmakers felt that there needed to be a magical element to its appearance. The animators experimented by adding sparkles and by looking at images from outer space. "It took a long time to arrive on the tail that we have," Harrington says. "We literally tried everything, like, 'What if we give it a little bit of blue? What if we give it a little bit of red? What if we have a nebula in there? What if we add more sparkle?' Finally we arrived at the ingredients that everybody thought looked good. But it took a while to find that."

To move seamlessly between Big Blue and the human version of Genie, the VFX team worked closely with costume designer Michael Wilkinson. Many of Genie's costume elements appear both in tangible form on Smith's body and in digital form on the Genie. To do this, Jarrett scanned each costume into a computer and created digital renders. "A number of costumes in the film only ever appeared digitally—we never see them on live-action characters—but we still obviously went to Michael for the designs of those," Jarrett notes. "He would find and reference the right types of material, or he'd completely design a costume for us, and then we would scan it, and it would just be within the visual effects realm."

OPPOSITE: Genie in his "Big Blue" form.

❧ Abu ❧

Although a live monkey wasn't used on the set, Jarrett and his team did cast a real capuchin monkey named Fidget to help create Abu. Fidget was scanned digitally using a 360-degree scanning booth technology called Clear Angle to create a computer 3D model using over one hundred cameras. They scanned Fidget in several poses. "It's an unpredictable animal, so she would look off to the side, but we did the best we could," remarks animation supervisor Harrington. "We scanned Fidget, and we got four or five pretty good scans out of that, and then we used that data to actually build the model that's anatomically correct."

The ILM digital animation team also spent time with Fidget to see how she interacted with humans and how she moved. They watched hours of footage of monkeys in the wild as an additional resource, as Fidget was more used to people than the average capuchin. In this film, Abu is funny and often silly, but he stays true to real-world animals rather than being overly anthropomorphized.

"It took us a little while to find the right sort of character for Abu," Jarrett says. "He's obviously Aladdin's best friend and they spend a lot of time together and he's quite habituated to people as a character and they talk, but they never communicate with each other in a way we might with a dog. We didn't want to think of him as a trained monkey—we wanted to think of him as a monkey that we had an infinite amount of time to film with on set. He does respond to Aladdin, but he's not like an acting monkey. He's just a monkey being a monkey. It would be almost too easy to animate Abu being like a little person and responding like a small person would. In a traditional cartoon, that works really well. I think in a live-action feature it feels odd and it doesn't resonate true."

Finding the right range of facial expressions for Abu was also challenging. The character needed to be cute and react in a pleasing way but also seem realistic. "We went through a phase where we thought, 'Maybe we need to make him a little bit more human in his facial expressions and push it a little

RIGHT: Final image render of Abu.

OPPOSITE TOP LEFT: Abu in Aladdin's tower.

OPPOSITE RIGHT AND BOTTOM: A series of images showing Abu's development.

bit further,'" Harrington notes. "We created a model sheet of facial appearances for Abu based on human expressions: smile, laughter, joy, serious. We started sprinkling that in and people started responding to it, and it was good. But then I think maybe we went a little too far that direction and we had to pull back to find the right balance of realistic versus cartoony."

Costume designer Michael Wilkinson designed Abu's costumes, which reference the animated classic. The monkey's first look includes a vest and tiny hat, paying homage to Aladdin's own attire, and later Abu gets a more luxurious ensemble to wear in the palace when Aladdin transforms into Prince Ali. Wilkinson researched circus monkeys from around the world when designing the look. Abu's miniature vest is detailed with small sequins to give him a little extra flair. Jarrett's team scanned each look to use in the CGI rendering of Abu. "Even though the character is entirely digital, Chas requested a real physical costume that he could scan and re-create in the computer," Wilkinson notes. "My team loved constructing a tiny waistcoat and fez, embellished with vintage braids that we found in a market in Calcutta."

The physical costumes also dressed a "pocket" version of the monkey that was used on set to help the actors visualize Abu's location. "The actors would occasionally have puppeteers, either with a puppet sitting on the right-hand shoulder or just simply using the puppeteers' hands to apply weight to Aladdin's shoulder so that the actor would respond as though this creature was really sitting there," Jarrett explains. "Abu is a monkey. It's not like they're big monkeys—he's a capuchin—but he weighs as much as a small dog, and if that was sitting on your shoulder, you would react in a certain way to that. We're very conscious of getting that sense of interaction."

Harrington adds, "If Abu had to climb up an actor's arm and sit on his shoulder, we would rehearse it with the puppeteers so that the actors spatially knew where the character was going to be and they knew where to look. They had something to rehearse with, and then once they got the beats down, we would take the puppeteers out of the scene and shoot it without them. That was the first time I'd done it with that approach, which I thought was very successful."

After the initial filming, Jarrett had a small team of traditional animators that went through the film and sketched in rough versions of the digital characters using a process they called "2D postvis" to draw in sketched versions of Abu, Iago, the carpet, and the Genie over the original film footage. This storyboard-like process allowed the filmmakers to determine each character's size and how each would move throughout the scene before the digital animation took place. "It's just a rough drawing, but it's appealing and it tells a story," Harrington notes. "It was a really handy process for blocking and for quickly figuring out creative ideas."

ABOVE: Finished visual effects shot of Abu in the Cave of Wonders.

Iago

In Ritchie's version of *Aladdin*, Iago has been reimagined as a more traditional parrot, one who acts as Jafar's eyes and ears around Agrabah and reports back by mimicking what he's heard. He was modeled on a green-winged macaw. To create Iago, the team enlisted a real macaw named Britain, who was brought into the studio for 3D modeling. It took thirty-seven tries to scan the perfect open-wing pose, but ultimately a 3D computer render of the character was created. They later added in malicious-looking features to the parrot's visage, with details around the eyes to make him look more evil. "We needed to push the character a little further, especially in the face," Harrington says. "So they did a pass of some art on top of the real parrot where they added little eyebrows to the eyes, just to make him feel a little bit more devious. It's not over the top, but it's just enough that when you see the character you're like, 'Oh yeah, he's a devious character.'"

RIGHT: A sequence of images showing Iago's development and design.

BOTTOM: Concept art of Iago showing his nefarious look.

ᔔ• *Raja* •ᔕ

In the original film, Raja was a playful tiger who acted as a sweet companion to Princess Jasmine. Here he remains her loyal friend, but Ritchie and his team have reimagined Raja as a wise, older tiger who has grown up alongside Jasmine, and the visual effects team wanted to make him look mature and regal. They based him on a Siberian tiger and added some gray to his muzzle and beard to help age him. While ILM couldn't scan an actual tiger, real tigers were used as reference, and the visual effects animators viewed footage of the way the animals move and interact with each other. The team went to the London Zoo to observe and videotape the tigers there. They were able to capture small details and micromovements, like how tigers twitch their eyes or move their muzzles. They looked at footage online as well and accumulated thousands of hours of reference. This came in handy every time ILM needed to animate Raja doing a specific movement.

"We'd find a piece of reference that's the closest thing we could find to that action, like, 'Here's a shot of a tiger jumping up on a platform and then sitting down,'" Harrington explains. "If the next action Raja does is plop down and sit on the bed, then we'll go through the footage and we'll find something close. We found different ways that tigers sit. There's a

BELOW: A finished shot of Raja.

BOTTOM ROW: In-progress effects showing Raja's development.

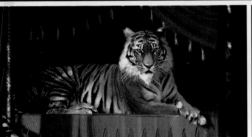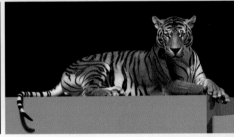

specific way that they drop their hips down before they drop their chests down. Sometimes we would do a reference pass, blocking in the scene with a picture in picture of the reference."

This version of Raja differs from the playful, spirited tiger in the original animation. "One of the things we decided from the beginning was that the animals in the film should really look and feel like real animals," visual effects supervisor Chas Jarrett says. "Raja we imagined almost as a godfather figure to Jasmine. Like a slightly elder statesman—quite regal, poised, and calm in his demeanor. All of our animation for him is about trying to emphasize those qualities. We gave him slightly a bigger mane than a tiger would normally have to just give his face a certain weight that felt very fitting for that character, but it's still completely within the bounds of a real tiger."

It wasn't possible for the filmmakers to use an actual tiger on set because of the nature of Raja's close interaction with the characters—at times he playfully jumps up on Jasmine and Aladdin and even licks their faces. On set, the team used puppeteers to help fill in the space where Raja would be in each scene. The puppeteers used a stuffed-animal-like version of the tiger's head to help set the actors' eye lines and show them where to react. The puppet was then digitally removed during postproduction and replaced with the CGI version of Raja. "We had a full-size Raja head that could be puppeteered to the scene, and Jasmine could interact with him," Jarrett notes. "She could stroke its head and look directly at it just to help with the believability."

TOP: A final VFX shot of Raja.

ABOVE: Concept art of Raja (*left*) and various in-progress shots showing the development of Raja's mane (*middle images and right*).

Magic Carpet

The magic carpet was a digital creation, so the VFX team spent a long time determining how it would act and move. They wanted to retain the puppy-dog-like enthusiasm from the original film and give it real joy, qualities that needed to come through in each of its motions.

Visual effects supervisor Chas Jarrett notes, "Everything about the carpet's life is fantastic. It's super enthusiastic about everything that it encounters. It loves Genie and loves everything Genie does. It's just happy to be near him, and that general positivity gives it a real warmth that makes it great fun. It's also a great foil for Abu. They might be vying for Aladdin's affections. So there's this great kind of rivalry between the two of them. The carpet is always nothing other than the most innocent and joyful and playful character."

The challenge for the filmmakers was to convey all these emotions with a giant rectangle of fabric. The team looked at the original film for reference on how Carpet took on various shapes to communicate its feelings and how it used its corner tassels as "hands" and "feet." They liked many of its original poses, which helped make it feel more alive. Here, though, the carpet also needed to move, flop, and crease like an actual piece of woven fabric. While the team often went back to the original animation for reference, it was essential that the live-action Carpet didn't look overly cartoonish. Instead, Jarrett wanted the audience to feel like there was a physical carpet on the screen. The team had a few genuine woven carpets created to provide references for how light bounced off the surface of the fabric and how it folded and creased. "We had a carpet made, and we used to move that through the scene after we filmed with the actors," Jarrett says. "They'd move out, and that's when our team would move in and film lots of reference."

The real challenge came during the digital animation process. Harrington created two different animation rigs for Carpet: one for when he was walking around with the other characters and one for when he was flying. The team at ILM built in custom controls for each version to ensure the movements felt appropriate to the scene at hand.

"There's an energy and an innocence to the classic character that everybody wanted to keep," Harrington says of Carpet. "So that was our starting place. As far as actually technically creating it, it was probably the hardest character to rig because there's no real-world anatomy that we can base it on, like a monkey or a parrot. We added real-world physics to it, with flapping and draping and wrinkling just to ground it in reality and to take it beyond what the classic character did."

OPPOSITE: Three images showing the development of the magic carpet.

RIGHT: Additional images of the carpet's development.

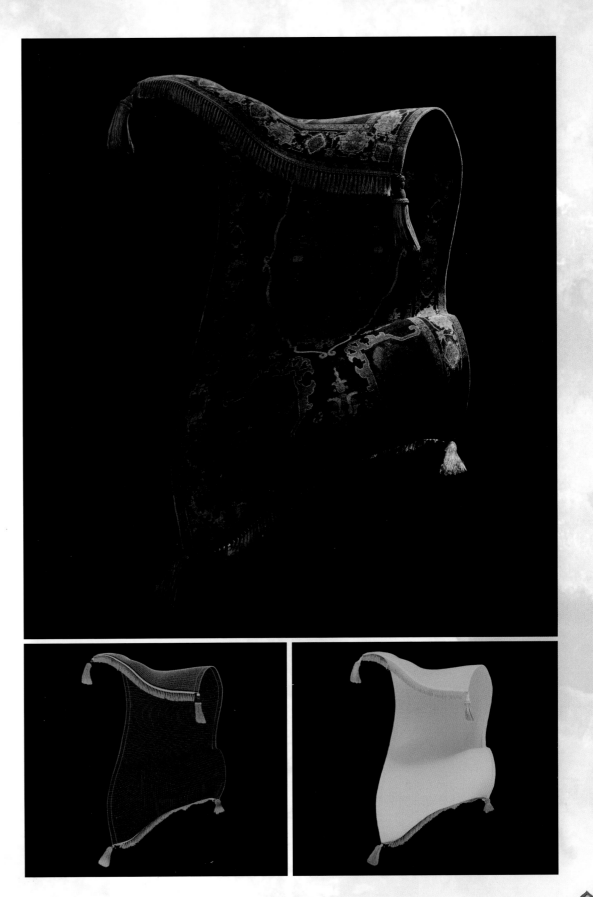

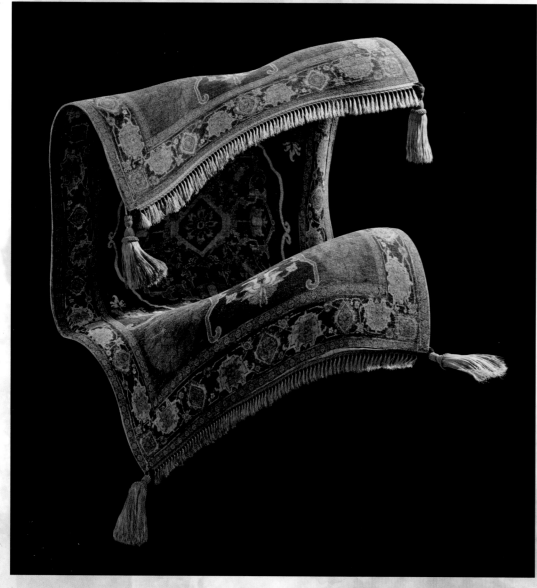

The carpet's visual design is largely based on the animated version, but the design is far more intricate, as it would be in the real world. Set decorator Tina Jones and prop master Graeme Purdy worked carefully to both reference the original and also ensure the magic carpet fit within the world Ritchie built.

"We also took a lot of our design pieces from the original cartoon," Jones notes. "We took a rough design from that and then made it far more intricate. But essentially that's where the idea came from."

When it came to filming scenes with the characters riding the magic carpet, the crew needed a physical magic carpet to stand in for the digital version. The team built a giant mechanical rig in the studio to generate the motion of the flying carpet for several scenes. Hundreds of connected rods allowed the rig to roll and move as if it were an actual fluttering flying carpet, and the rig itself could pitch and dive. Producer Jonathan Eirich describes the structure saying, "The rig was a new piece of technology for this film which allowed the carpet to be constantly moving while changing speeds, shifting the light source, and making it appear as if the carpet was always responding to the wind around it. This allowed our actors to naturally react to the carpet's movement within these environments to create a sense of realism."

The actors were strapped in during filming so they wouldn't tumble off the rig, which could be hoisted as high as twenty feet in the air. The filmmakers created previsualization and storyboards for the two sequences in which the characters ride on the magic carpet and planned exactly how the carpet and the actors needed to move to work within the scene. The team built the machine, spent months programming it, and then shot for two weeks, including "A Whole New World" and the finale carpet chase sequence.

"The actors were physically holding onto a carpet that was really moving," Jarrett says. "It was essentially a computer-controlled carpet surface, so that took a great deal of preprogramming, predesigning all the shots, where and what the movement should be."

LEFT: Three images showing how the carpet had to fold and flop on itself.

OPPOSITE: The filmmakers created a printed version of the carpet for on-set reference.

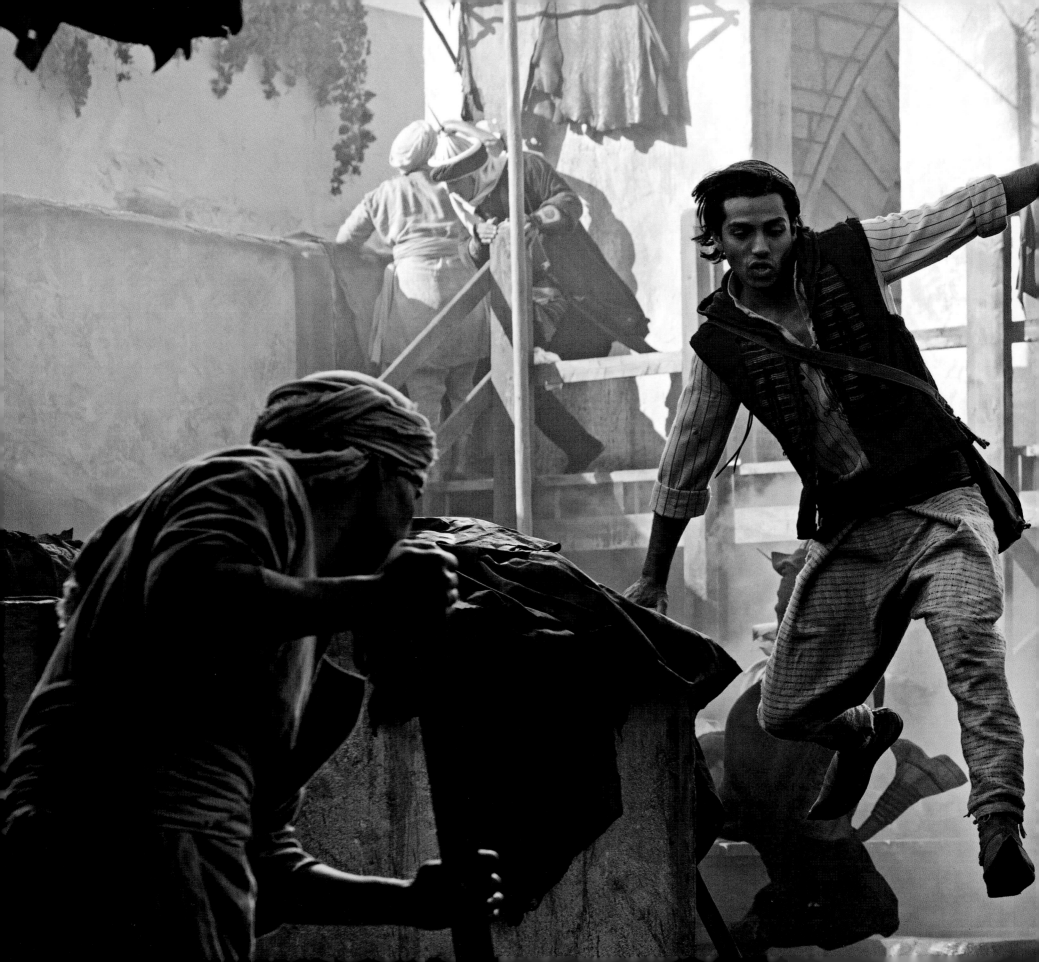

Chapter 6
STUNTS AND ACTION

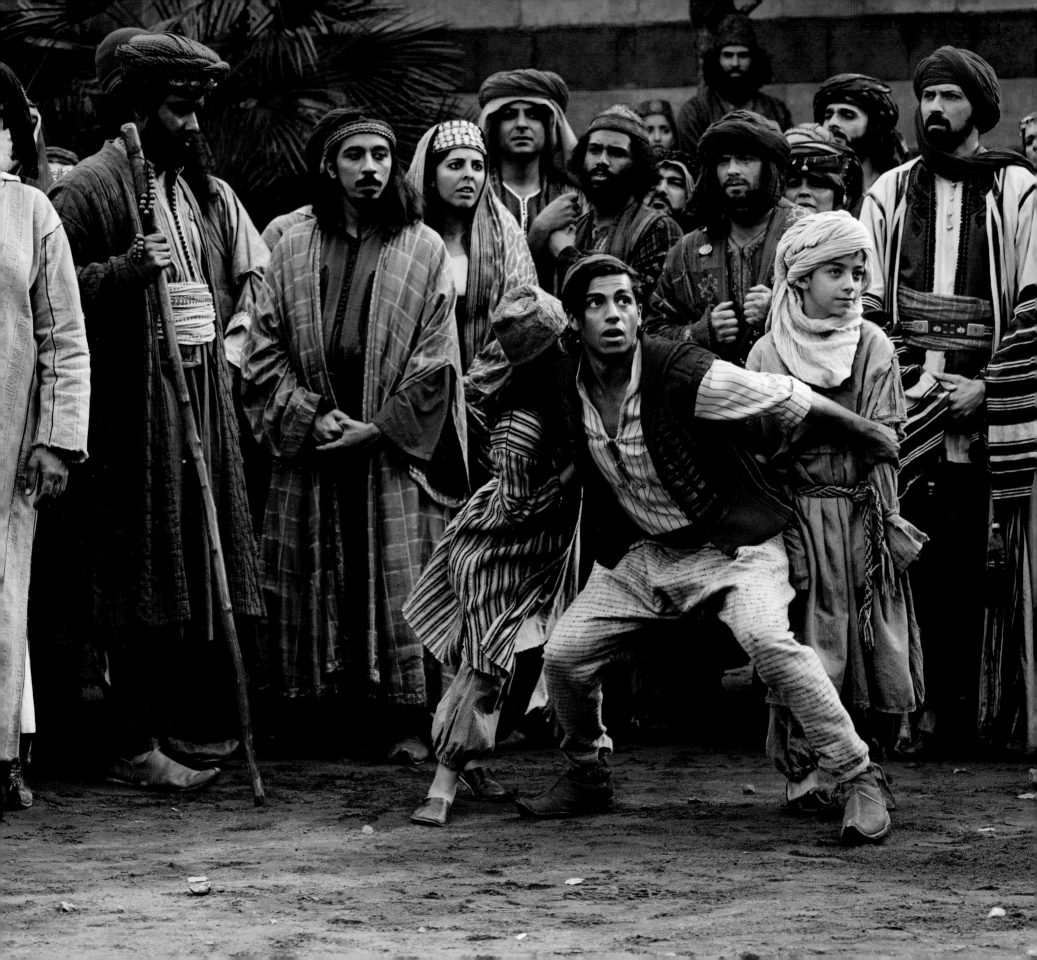

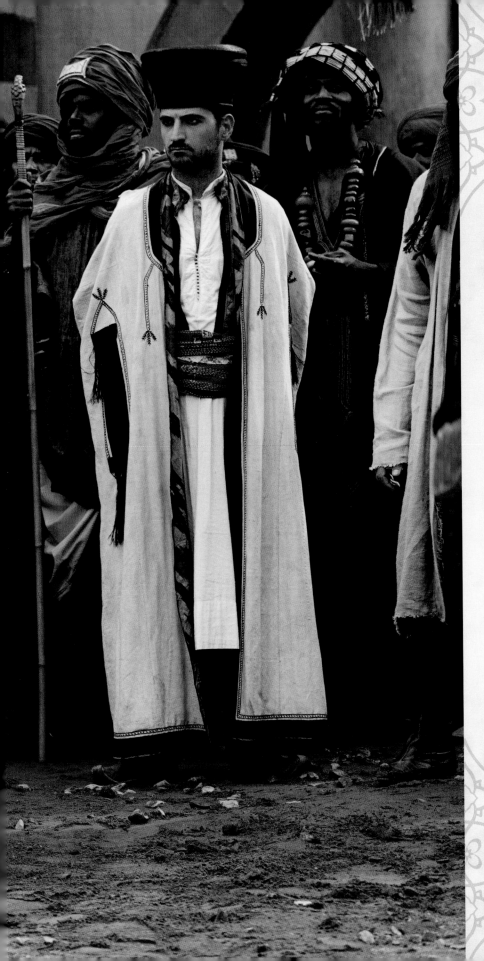

Aladdin is packed with action and high-energy stunts, a hallmark of Guy Ritchie's filmmaking. The director wanted to create a sense of dynamic movement, especially as Aladdin dashes through Agrabah's marketplace with Jasmine in tow during the memorable song "One Jump Ahead." Ritchie enlisted stunt coordinator Adam Kirley to bring these sequences to life on-screen and ensure that all of the action stayed true to reality as much as possible.

"He was very keen on the idea that it needs to look real and not too fantastic and too superhero-ish," Kirley says of Ritchie's vision. "It really needed to feel like it was achievable—that a human being could do it. We added a little bit extra to make it spectacular, but anything that happened needed to be survivable or actually humanly possible. [Aladdin] just had to look like a very athletic human. So he wasn't flying a hundred feet into the air and surviving. But he was doing things that were realistic. He was strong, but he was still a human being the whole way through the movie."

Kirley worked closely with the other departments to ensure that the stunts worked well alongside the sets, costumes, VFX, and dance choreography. He and Ritchie wanted the action to feel seamless within the story but also feel bigger than in the animated classic. "The cartoon is just a slight template to know what we needed to do, and we just embellished everything," Kirley notes.

Ritchie has imbued *Aladdin* with his signature energy and action throughout the film. "*Aladdin* is one of the most fun titles of the Disney canon," president of production Sean Bailey says. "Guy brings such a tremendous kinetic energy. He has a huge twinkle in his eye and a little bit of mischief about him. He's not afraid to sort of be audaciously fun and thrilling. His filmmaking style is energetic, it's dynamic, and I think you're going to feel that in the movie."

PAGES 116–117: Mena Massoud as Aladdin leaps through Agrabah's marketplace during the "One Jump Ahead" musical sequence.

THESE PAGES: Aladdin pushes a small child behind him for safety as Prince Anders's horse (out of frame) rears up.

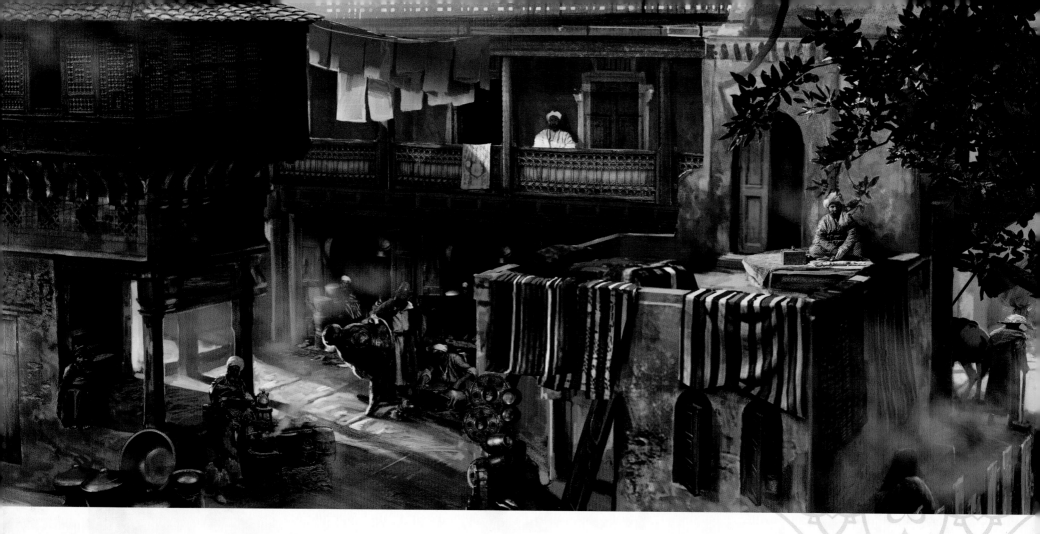

"ONE JUMP AHEAD"

In the "One Jump Ahead" musical sequence, Aladdin and Jasmine are chased over the rooftops of Agrabah. The scene proved to be one of the most challenging for stunt coordinator Kirley. The movement of the characters was timed with the music, and it took several weeks to shoot the scene and ensure that every single detail came together correctly. It was an extremely complicated sequence, but the extra preparation time allowed everything to be seamless when cameras rolled.

"The set was built to our requirements," Kirley explains. "So we had to get there fairly early and had to work with set design. We found where we wanted each line to be in the song, and then we designed the action and the journey around that. Aladdin was jumping from roof to roof and swinging from things, so everything was built to [Mena's] specifications."

Before constructing the city's marketplace, production designer Gemma Jackson started with small models of the buildings, which could be moved around and rearranged to test

various layouts. Because the filmmakers chose to build Agrabah's marketplace from scratch, the team didn't have to deal with the many constraints of an existing city. The action could be filmed in a continuous sequence, with the movements choreographed working in conjunction with the set and vice versa.

"This way we could design [the sets] for dance sequences," executive producer Kevin De La Noy says. "When you control where the levels are and where the buildings are, it's much easier. We got a real synchronicity of dancing, choreography, and set design."

Jackson adds, "The characters could go any which way they liked at any time, into a tannery, into the marketplace, into the side streets. There was this lovely little alley like you see in Morocco, where the buildings almost lean toward each other, and we created this space where Aladdin could go. We even had scaffolding that went flying. It had every trick in the book, and it was a real joy to put it together."

ABOVE: Concept art of one section of the marketplace.

OPPOSITE TOP: This concept art of the marketplace shows the density and diversity of the city.

OPPOSITE BOTTOM: Concept art of the tannery, a location seen during the "One Jump Ahead" sequence.

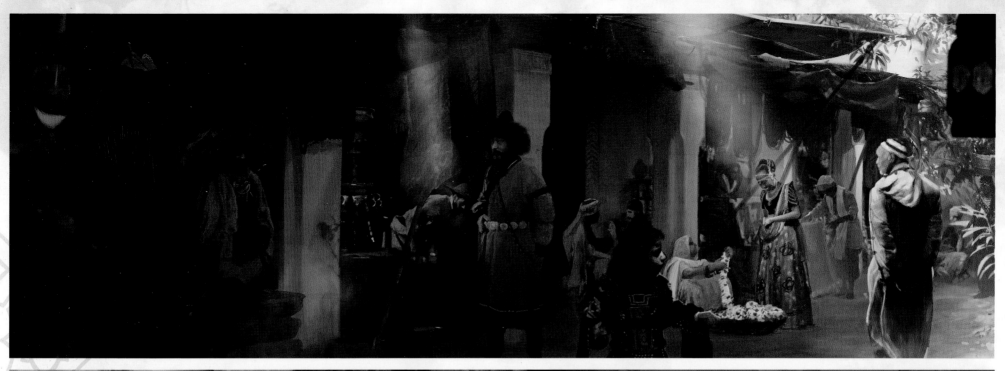

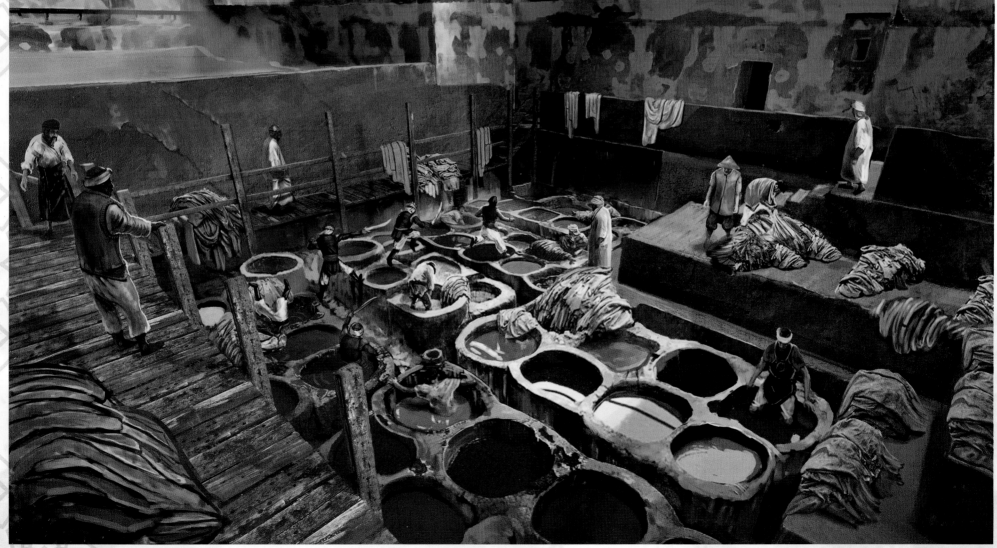

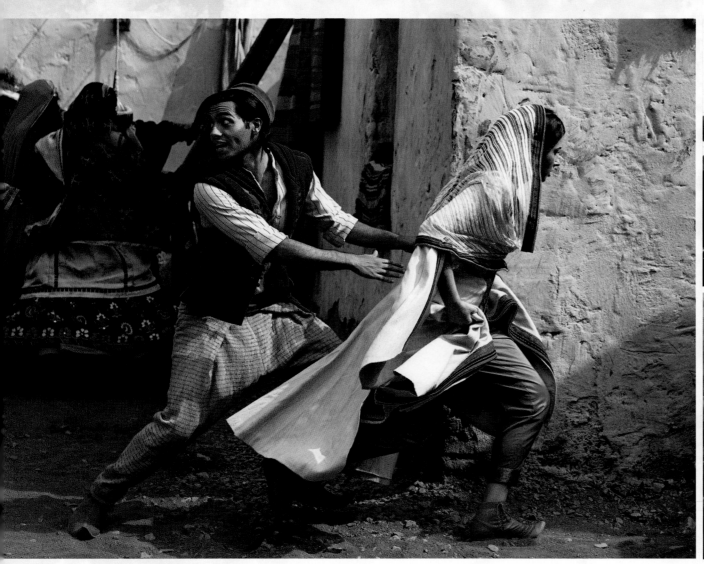

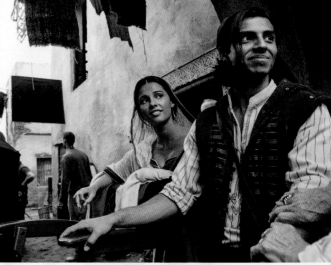

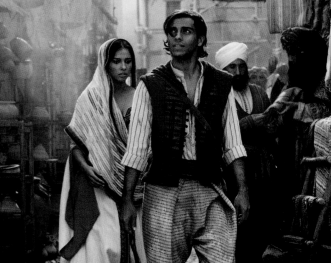

Kirley used the set models as well as a 3D digital model of Agrabah to map out Aladdin and Jasmine's journey through the city's alleyways and across its rooftops. Small changes were made to the set buildings once Kirley had determined what would and wouldn't work with the action. "Sometimes making a wall six inches or a foot higher makes our stunt look much better, and they were very receptive to making that happen," Kirley says. "[Production designer] Gemma and her team were fantastic."

Once the crew had determined the layout of the set and how the scene would play out, Kirley worked with Massoud and Naomi Scott in stunt rehearsals to ensure they were comfortable with the movements. Choreographer Jamal Sims was also part of the process, as the scene combined stunts and dancing. He helped ensure that each beat of music was hit correctly with a movement. "We were there to make the stunts feel smoother

than just a regular land-and-go," Sims notes. "We finessed some of the moves, but it was always created to be an action sequence, a stunt sequence."

Ritchie was also clear that he wanted everything to feel nonstop, as if the characters were actually on the run. "The animated version comes across as lots of little vignettes," Kirley says. "You see Aladdin doing something, you cut to the guards. Whereas Guy had a very specific vision. He wanted much longer takes and almost to feel like it was all in one shot because it was a big number, and he wanted us to be along for the journey while they were being chased. So we tried to cover the action and not cut away as much."

Once it came time to film the actual scene, the filmmakers were ready. They used on-set playback of the song to help with the timing and allow Massoud to lip-synch the lyrics along the way while also performing the majority of his own stunts.

ABOVE LEFT: Aladdin and Jasmine race through the marketplace ahead of their pursuers.

ABOVE TOP: Naomi Scott and Mena Massoud between takes.

ABOVE BOTTOM: Princess Jasmine and Aladdin in the marketplace after Jasmine has escaped from the palace.

"'One Jump' was a very complicated scene," Kirley reflects. "There were a couple of times where we shot at different frame rates. We would shoot at a thirty-six-frames-per-second range at some points where the music was playing much faster, or it's playing much slower, so Mena would have to change his movements in order to match time. It got quite complex at different times."

Game for the adventure, Jasmine joins in on the action. "She's watching him do all these crazy things, and she's running after him and also doing really cool things herself," Scott says. "That's where the adventure begins. She's thrust into this crazy world and it's an adrenalin rush." Scott did many of her own stunts, although the team elected to use a stunt double for a moment when Jasmine pole-vaults between two buildings.

The scene is impressive, with nonstop feats reminiscent of parkour-style action, as Aladdin leaps and bounds through the city with apparent ease. Still, the filmmakers didn't want Aladdin to be too perfect. He's human, which was an important theme for Ritchie throughout the film.

"Initially it started off that Aladdin was going to land perfectly, perfect this, perfect that," Kirley says.

"If Aladdin is too slick, if every jump he makes in 'One Jump' is too perfect, all of a sudden you stop liking him," producer Jonathan Eirich notes. "All of a sudden he's a little too perfect for who we think this street rat is."

"We had to get the stunt double or Mena to act as if they had only just made a jump. We had to work in a little bit of imperfection so some of the movements were happy accidents and things like that. That was actually more challenging than doing it perfectly, to be honest," Kirley adds.

Eirich continues, "You want enough of those moments to feel like, 'This guy is cool, this guy is aspirational,' but add just a few stumbles and just enough of those moments that it feels like, 'Okay, this guy is us.'"

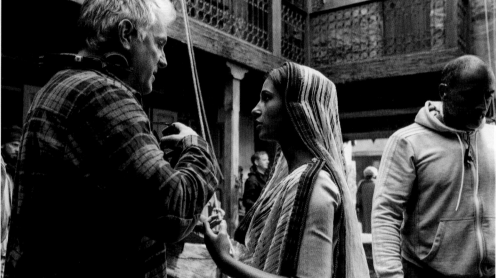

TOP: Mena Massoud during filming of an action sequence.

MIDDLE: Naomi Scott prepares for a scene.

BOTTOM: Mena Massoud and a cameraman filming in the alleys of the marketplace set.

THE CAVE OF WONDERS

Fans of the animated classic will remember the action-packed chase sequence through the Cave of Wonders after Aladdin grabs the magic lamp. In the original, there's a frenetic dash to escape the cave, with lava roaring in from all sides, and the animators could really stretch their imaginations to create the most dangerous and dramatic scene possible. In the live-action version, the filmmakers were tasked with building a chase sequence that placed an actor in a part-practical, part-CGI environment. Production designer Jackson designed parts of the cave, and the filmmakers constructed anything Massoud needed to directly interact with.

"When [Aladdin] gets into the Cave of Wonders, it is a wondrous environment and he does jumps and leaps, but he still feels grounded in a surreal landscape," De La Noy notes. The scene took roughly a week to film, and the team constructed a rock wall set for Massoud to scale as he reaches for the lamp.

"He had to climb up a series of very high steps that took him up to about thirty feet, and then he had to climb up a twenty-five-foot rock face to find the lamp," Kirley explains of the challenging sequence. "When the Cave of Wonders starts to collapse, he then runs, sprinting down these big steps which are basically big spikes of rock. We had one of them collapse with a stunt double grabbing onto one of them, and as it's collapsing, he jumps onto another one."

Kirley worked closely with the VFX team to ensure that Massoud knew how to move and where to look as he was running and jumping. As the scene played out, visual effects supervisor Chas Jarrett helped call out what was happening on each blue screen, which were placed 360 degrees around the action. It was important to make it look like Aladdin was in a real space, even though the Cave of Wonders was imagined later in the VFX process. "We used the blue screen because the scale of the set is just enormous," Jarrett says. "It's just huge. And in the final movie, some of the sets have been replaced entirely—the floor they were walking on. So actually the characters are in a completely digital environment."

"The Cave of Wonders is quite extraordinary," Jackson adds. "What's fantastic about us all working together is we can create all these fabulous worlds. All of it stitched together very seamlessly."

OPPOSITE: Concept art of Aladdin standing at the top of the pathway into the heart of the Cave of Wonders.

BELOW: Concept art showing the interior of the Cave of Wonders.

CREATING A MAGIC CARPET RIDE

When Aladdin and Jasmine take off on the magic carpet following the Harvest Festival, singing the iconic duet "A Whole New World," they sail through the skies. The carpet soars around Agrabah, revealing vast deserts and up-close looks at the cities throughout the region. It's not just a feast for the eyes—the scene is also deeply emotional and essential for the love story between Aladdin and Jasmine.

Massoud says, "When you see [two people fall in love] on camera, it's amazing. It was great in the animated film, but at the end of the day they're two animated characters that we're seeing do this thing. I'm excited about really bringing these characters to life as human beings."

Although taking flight on a magic carpet is fantastical, the filmmakers wanted to ensure there was still a sense of reality throughout the scene—requiring some very specific stunt work.

"The one thing that we all understand and that is really important to Guy is that this does look real," Eirich says. "While on the one hand this is a fairy tale world of magic, we still had to deliver on both the visuals and the emotion of the story, and that requires creating an environment that's immersive that the audience can buy into."

In order to create that sense of reality, the actors were placed on the magic carpet rig created by the special effects and visual effects teams. Naomi Scott and Mena Massoud were secured to the rig by the stunts team, often up to twenty feet in the air. The filmmakers had planned and storyboarded each of their movements to coincide with where the carpet was going and how it was moving through the air. The carpet was surrounded by blue screens so the VFX team could later insert backgrounds based on real locations from throughout the Arabian Peninsula. Visual effects supervisor Jarrett shot footage around Namibia and Jordan of sand dunes and other desert environments, and the team also used preexisting photography.

"We wanted something not fantastical, but more realistic," Jarrett says. "We created a lot of digital backgrounds for that sequence. They're all based on real photography and real places that exist."

LEFT: This concept art shows one of the locations Aladdin and Jasmine fly through during "A Whole New World."

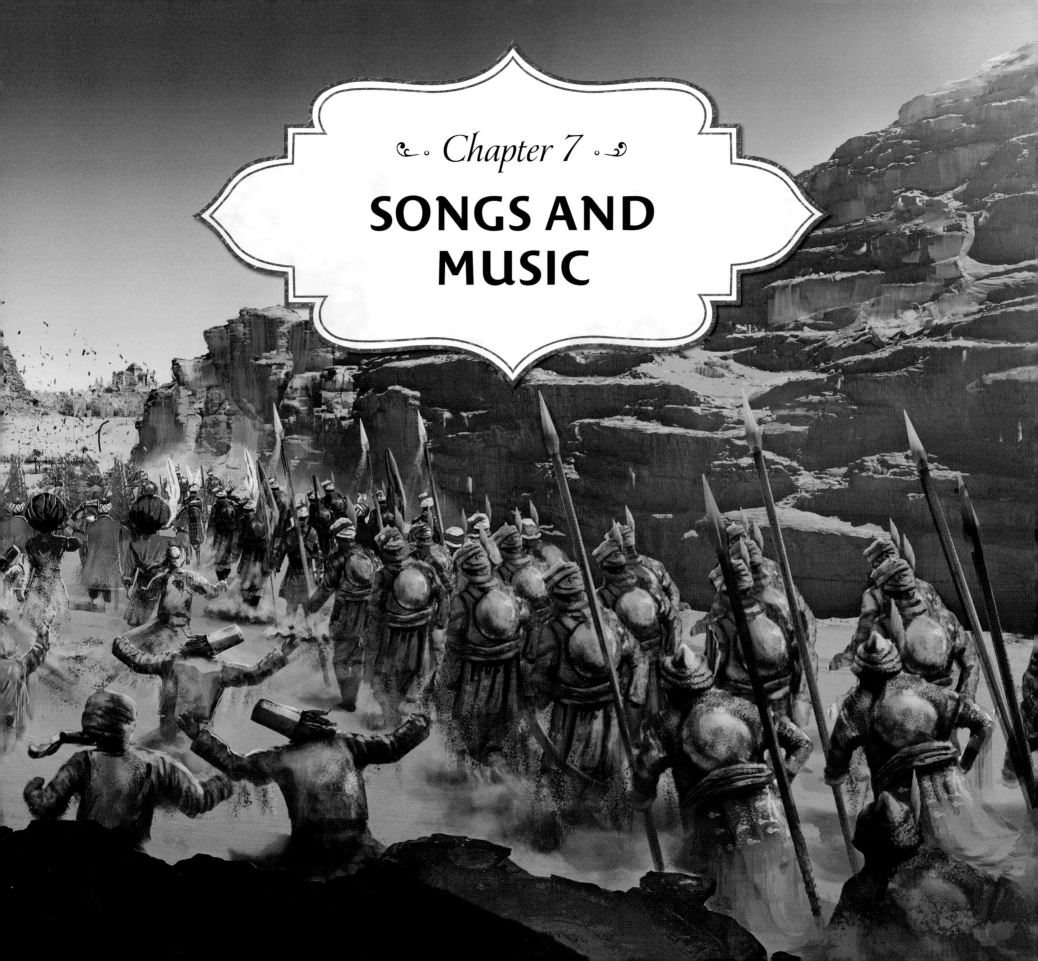

Chapter 7
SONGS AND MUSIC

The iconic music and lyrics of *Aladdin*'s original songs are etched forever in the memories of the 1992 film's longtime fans. For Ritchie's reimagining of the story, the filmmakers wanted to highlight composer Alan Menken's unforgettable musical compositions and Howard Ashman and Tim Rice's compelling lyrics, while also introducing new songs and sounds. Menken returned to create new pieces, and the producers also enlisted Benj Pasek and Justin Paul, a song-writing team, to pen the lyrics to a new song. They worked with music supervisor and producer Matthew Rush Sullivan and music editor Christopher Benstead to infuse the film with memorable music that will become the favorite soundtrack for a whole new generation of Aladdin fans.

Before production, Sullivan met with Ritchie to discuss the director's vision for the film's music. "Guy and I had many conversations about music in general, before we started talking about each song from the original movie," Sullivan says. "We then played each song, and asked, 'Okay, how do we feel about this song? What changes, if any, do we want to make to make it fit into the fabric of our new film?' It was really helpful. And when you have songs like 'Friend Like Me' and 'Prince Ali' sung by Will Smith, you instinctively know what direction to take them. You really want to re-envision them for Will Smith and what he brings to the Genie character.

For the animated film, Alan Menken and lyricist Howard Ashman looked to find a musical style that would take the score somewhere unexpected. "Having Harlem jazz as a medium for the Genie was a real game changer for *Aladdin*," Menken notes. "Going for [a sound like that of] Fats Waller, Cab Calloway, and that whole genre of backstreet jazz really made it a compelling score and made it a fun ride for people."

Ritchie didn't want to lose the spirit of the original songs, but he did feel the music needed to be a bit more rhythm-forward, with more robust percussion and more diverse instruments. "While he doesn't necessarily have a background in musicals, what mattered was that he could be really precise about what was and wasn't working for him in the songs. We never lost anything that felt essential from the original and it was important to Guy to not lose the feeling audiences remember and love from growing up on those songs—but it was really just about, 'How can they feel like the Guy Ritchie versions of these iconic songs?'"

Menken was part of the preproduction process and was very involved with the development of the new song "Speechless," as well as with rearranging the original songs. Each decision was run through the composer to ensure continuity between the 1992 movie and this version. "Alan's certainly the guardian of the music and lyrics," Sullivan notes. "He really keeps a close eye and is making sure that the audience won't feel like we've gone too far or strayed from the original material."

"You never want people to come to see something and feel like it's a cut and paste from a previous version of a score," Menken adds. "You always want it to feel fresh and new. So there isn't one song that doesn't have some new arrangement elements in it."

The team went through a long process to focus in on the right version of the songs for Ritchie's vision. The director provided numerous notes for Sullivan and Benstead, who worked on the music for five months ahead of shooting.

"The biggest challenge was updating the original music to work with a modern live-action film with very real sequences whilst still retaining the fun and magical heart of the animated classic," notes Benstead.

The team also wanted to bring in the sounds of Middle Eastern instruments. "We did a lot to add Middle Eastern authenticity to the score," Menken says. "It's the same thing we did on *Beauty and the Beast*, where we wanted to insert more of eighteenth-century France in the story so you really had a sense of reality. Even though *Aladdin* is a fantasy, everyone on the creative team wanted to give it a stronger a sense of time and place, as well as the feel of the Arab world. We did that by using authentic instruments—wind instruments and percussion instruments and string instruments—then

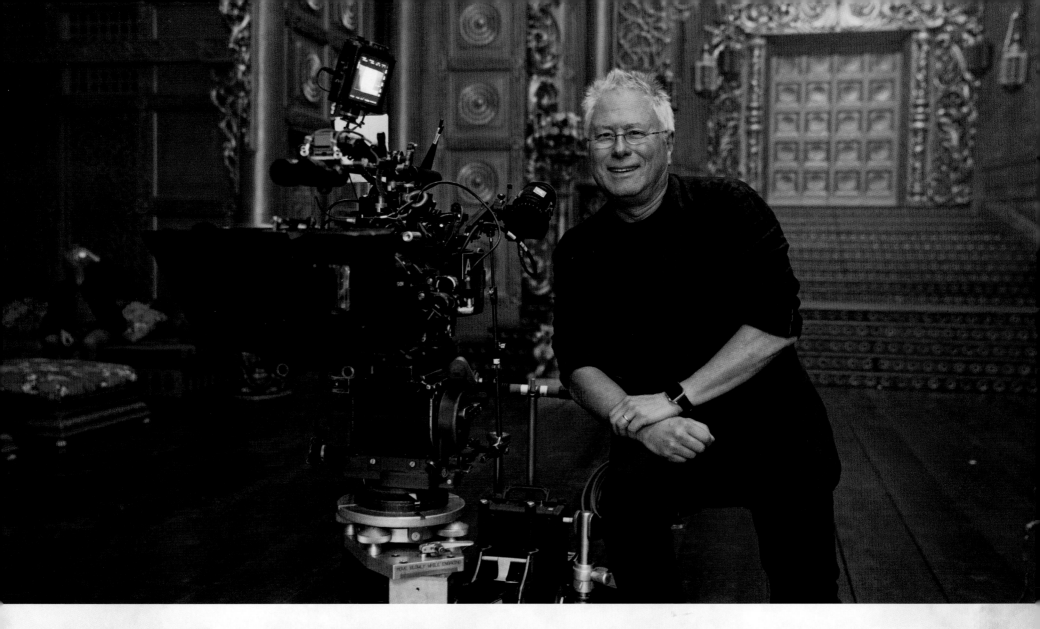

PAGES 128–129: Concept art depicting the "Prince Ali" parade forming in the desert before heading to Agrabah.

ABOVE: Alan Menken, seen here on set, is the composer of the original *Aladdin* score. He returned to pen new songs.

supporting them with traditional Western sounds or pop sounds, but integrating those authentic sounds into the arrangements."

Some of the Middle Eastern instruments that are featured in the score include the oud (a type of guitar), the *quanun* (a harp), and the rebab (a bowed string instrument). Benstead notes, "[Those instruments] feature heavily, along with a wealth of percussion instruments from the region—some of which are showcased on-screen in 'Prince Ali.'"

Sullivan and the actors recorded most of the vocals in a room at Longcross Studios outside London ahead of production. Mena Massoud, who doesn't come from a musical background,

took four singing lessons a week and worked hard to catch up with his more experienced cast members. Smith required almost no preparation and did most of his vocals unrehearsed in Sullivan's production room.

"We set up a full, operating recording studio in our production office," Sullivan says. "It was a big room and we created a studio vibe with couches, curtains, rugs, and lamps. Actors liked to come and hang out and just listen to music as well as work and record. That's where I did pretty much all of Will's vocal recording. He was so creative and well prepared. He came in with new ideas, new ad-libs, and together we discovered many magical moments in his performance."

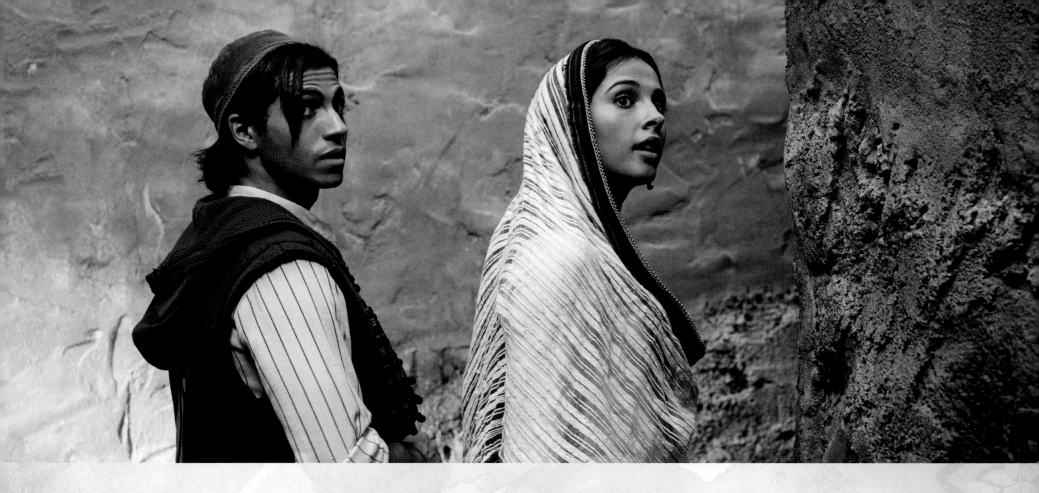

"ARABIAN NIGHTS"

In the original film, the introductory song "Arabian Nights" is sung by an old merchant known as the peddler, who sets the scene for the magical world of Agrabah. Lyricists Benj Pasek and Justin Paul wrote new lyrics for the song to reflect the change in who was singing the song.

"It was not someone who was living in Agrabah; it was someone who was coming to this fabled city," says Paul. "We were tasked with giving the audience a visceral, stimulating vision of what this film's Agrabah is: a sort of meeting place of cultures. We wrote lyrics about the spices, the people bartering, and the bazaars because we wanted to color the experience for viewers as they're being welcomed into the world of *Aladdin*."

"With new lyrics from Pasek and Paul, 'Arabian Nights' is now twice as long as what is in the original movie," notes Sullivan. "As soon as we played the new instrumental track for Will, he yelled, 'This is the way I wanna open all my concerts!' It's just so bold and cinematic."

"ONE JUMP AHEAD"

The filming for "One Jump Ahead" proved to be a challenging sequence, as Aladdin sings the words to the song as he leaps through the alleyways and over the rooftops of Agrabah. Because it is heavily choreographed, the sequence required a significant amount of coordination between every department so each note of the music matches with the action and the stunts.

"We couldn't just keep adding music to create room for a stunt. That interrupts the musicality and flow of the song," Sullivan says. "We had a constant back and forth collaboration, asking ourselves how can we incorporate all the exciting action but keep Aladdin's singing going through the whole sequence. We spent a lot of time rehearsing on the set. It was a complicated process."

The music also needed a propulsive element to match the action. "The original version of the song was a bit more Broadway jazz," Sullivan says. "[For this version] we wanted more of an Arabic influence, so we're using a lot of Arabic percussion and instruments like the *duduk* and *ney*—Arabic woodwinds—and many others. Creating the tracks with those instruments automatically gives it a new desired direction."

ABOVE: Mena Massoud and Naomi Scott filming in the marketplace during the "One Jump Ahead" song.

"FRIEND LIKE ME"

One of the biggest shifts in Ritchie's version of *Aladdin* was making the Genie's songs reflect Smith's sensibilities as a singer and rapper. The filmmakers wanted to give the actor the freedom to bring his own style into songs like "Friend Like Me," a show-stopping number that acts as an introduction to Genie and his fantastical skills. Sullivan and Benstead reworked Menken's tune to have a stronger hip-hop flair by keeping the original big drums and brass. The team played the track for Smith at Longcross, and the actor immediately got behind the microphone to test out some lines. He eventually decided to add a section of beatboxing into the song.

"It has all the hooks and the brass and the Cab Calloway feel that the original had," Sullivan says. "But Will Smith is able to take it and rap it a little bit more. The very first time he came into the office, he got behind the mic and we just started recording. We recorded his vocals with a nice AKG mic, but sitting off to the side I had a stage mic, which can be used for beatboxing. I just had a feeling he may want to do some. He looked over and asked, 'Is that for me?' And I said, 'Yep, that mic's for you.'"

Smith also made a few lyrical shifts, although ultimately the song stays very true to the original. "Will did a lot of his own ad-libs over different parts of the songs, that's in addition to the original lyrics," Sullivan notes. "He did a very small amount of updating on a lyric or two, but it's really just about making it more Will Smith and creating his own version of the character, owning it more."

Menken adds, "Will brings a hip-hop quality, he brings his personality. There's always been an irreverent quality to our Genie, but now there's a new kind of irreverence. I love the fact that he jumped in with both feet and felt the creative freedom to make [the songs] his own."

After the initial track recordings were completed, Smith performed the song again in the motion-capture studio. Sullivan adds, "Since the Genie is partly a CG character, we prerecorded Will Smith's vocals. Later, when we shot [Smith's] visual effects motion capture, Will sang both live as well as to the playback in order to capture his exact facial and body performance. The performance that you see is all Will."

"PRINCE ALI"

For the over-the-top parade sequence that stomps into Agrabah to introduce Prince Ali to the world, the music team stuck to the original lyrics sung by Genie. But the music takes a slightly different tone. "In live action we automatically knew it needed to feel much more authentic," Sullivan says. "We have real live players performing on camera with many of these Arabic drums. Therefore, we leaned into Prince Ali being a big percussive song, compared to the 1992 movie."

Smith's isn't the only voice in the song. The background actors are also meant to act as a chorus in the track, but the composers hadn't recorded that aspect of the song when it came time to shoot the scene. Instead, Sullivan used the background vocals of the original song on set as a placeholder and later rerecorded them for the new version. While that was initially done as a time consideration, using the original sounds also gave the team the opportunity to experiment with the composition.

Sullivan explains, "In preproduction we temporarily used the 1992 Broadway-style background vocals for our 'Prince Ali' track, which was quite the juxtaposition from Will Smith's Hip-Hop approach. We loved the marriage of those two worlds. When we recorded the final background vocals, we took the same classical approach."

"Mixing in some hip-hop production elements along with the exuberant brass from the original songs proved a great and unique-feeling recipe," agreed music editor Benstead.

The filmmakers also hired a percussion group to be part of the parade. Sullivan worked with choreographer Jamal Sims on crafting each aspect of the spectacle to fully highlight the musical choices. "We wanted to feel that big Arabic percussion," Sullivan notes. "What the instruments were and what they look like and creating a symmetric visual for the camera of what instruments are placed where."

The song ends with a big group chant, with everyone in the massive crowd singing along with Smith's Genie. In the original film, Abu, as an elephant, kicks open the palace door for the track's finale, but here, the entire parade takes place in the streets of Agrabah. The team had the idea to have the parade participants sing one final note, but Smith took things up a notch, according to Sullivan. "Will came in and said, 'I like that idea, let's stretch it out. And we just kept on stretching it, so it's a big moment. It's a lot of fun.'"

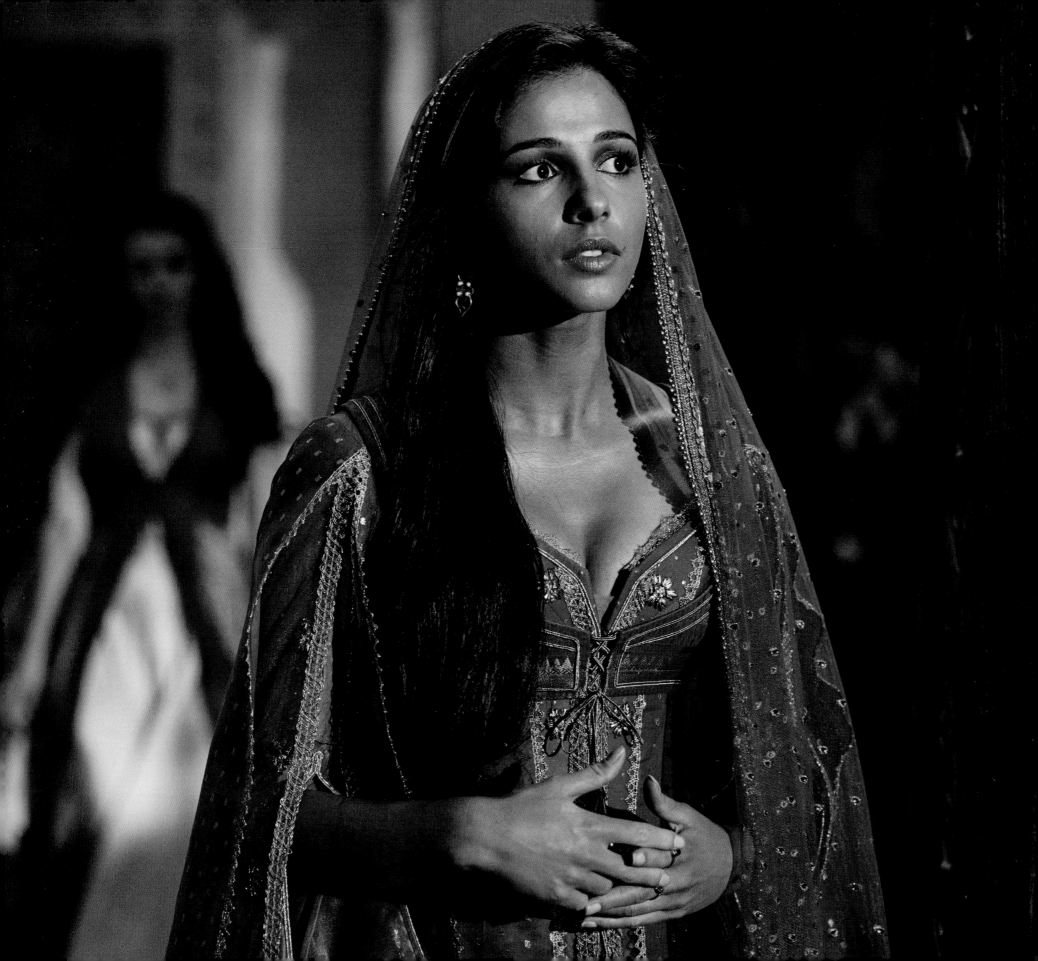

"SPEECHLESS"

One of Jasmine's biggest moments in the film comes in the form of a new song written by composer Alan Menken and lyricists Benj Pasek and Justin Paul. Frustrated by being silenced, Jasmine unleashes a powerful ballad that allows her to find her voice again. The songwriters came up with the idea while working in Menken's studio and went through a few versions before landing on the final arrangement.

"We've been playing with arrangements a lot," Menken says. "We had a very pop-oriented arrangement initially, which I think works beautifully, except that it didn't feel in keeping with the fabric of the rest of the score. Instead, we've gone with a more orchestral version. It'll feel much more like a piece of the score, and I think it's that much more integrated."

When they finally played the song for music supervisor and producer Matthew Rush Sullivan and music editor Chris Benstead over the phone, the impact was immediate. "As soon as we heard it, we thought, 'Wow that's it, that's it,'" Sullivan remarks. "She's been told, growing up, she should be seen and not heard. She finds her voice throughout the movie, and at the end she puts her foot down, and says, 'I'm not going to go speechless.' It's one of the biggest, strongest moments of the movie."

Alan Menken adds, "We really had to work with the book to plant the seeds of her feeling intimidated and feeling like she's not allowed to speak her mind, and have the song come at just the right moment when she says, 'No, I will not remain speechless anymore.'"

"We were really inspired by the original movie," Benj Pasek notes. "The 'aha' moment for us was when we went back to the source material. Jafar says condescendingly to Jasmine late in the film: 'You're speechless, I see. A fine quality in a wife.' It felt right for her to make a declaration that she would not be subjugated in that way. It was a real opportunity for her to stand her ground and sing about those philosophies, and felt like a natural extension of this very strong, powerful, and determined Disney princess. I think people gravitate to Jasmine because she is such a strong female character, and we were inspired by that and aimed to give her a song, and a moment, that matched her power."

While the team did prerecord the vocals for the scene, Sullivan also prepped actress Naomi Scott to perform the song live on set. "We really wanted to capture Naomi's best performance on the set and give her the flexibility to deliver a performance that is true to the emotions that she's feeling in that very moment," he notes.

"All the crew had goose bumps when she sang 'Speechless' on the stage," executive producer Kevin De La Noy says. "All of us just looked at each other thinking, 'We just witnessed history.' It took everyone's breath away. Everyone just knew that that was extraordinary. And it's not just the lyrics of the song—they were great, and the music is great—it's what she then did with it."

Scott was able to tap into Jasmine's intense emotions during the evocative, empowering musical number, accurately demonstrating this major turning point for Jasmine.

"She's shut down by Jafar throughout the movie, and she really wants to lead, and she's trying to persuade her father to see her in that light," Scott says of Jasmine. "This song is an expression of her just not taking it anymore. It's that moment of realization of who you are. That actually, as a woman, you already hold so many amazing qualities and skills that are strong. Having feminine qualities is really strong and amazing and actually makes you a better leader and actually helps you see the world in a different and a better way."

OPPOSITE: Princess Jasmine in the palace courtyard garden.

"A WHOLE NEW WORLD"

"A Whole New World" is the center point of Aladdin and Jasmine's courtship. As the pair sails through the night sky, singing a duet, they fall in love. The team wanted to retain the sense of beauty and emotional heft that came with the original version, but Ritchie also felt the track needed a more contemporary vibrancy. "He wanted to feel like we were really flying and soaring and feeling the energy," music producer and supervisor Sullivan says. "We modernized it a little bit and moved away from the instruments that were used back in the '90s, like the electric piano. The song is updated, but it's very much the same song and same melody lines, it just feels more modern."

"I love the changes in arrangement that we've made," Menken adds. "I think it's got a real sensuality to it and a floating, dreamlike quality that is great."

The song was prerecorded before filming to ensure the actors wouldn't be distracted by singing live while managing the complicated filming onboard the magic carpet. Sullivan worked closely with visual effects supervisor Chas Jarrett during the shooting process to help guide Massoud and Scott on how to react musically as well as emotionally.

"Mena and Naomi worked really, really hard at telling their characters' story during 'A Whole New World,'" Sullivan says. "At the start they're thinking maybe they want to date each other, and at the end, 'Is this love? What's going on here?' It's a two-and-a-half-minute song, and we have a lot of story to tell. It's really up to them to emote to each other, and emoting through song is probably one of the most beautiful things that you can do, especially on camera."

LEFT: Aladdin and Jasmine soar through the sky in this concept art of the "A Whole New World" musical number.

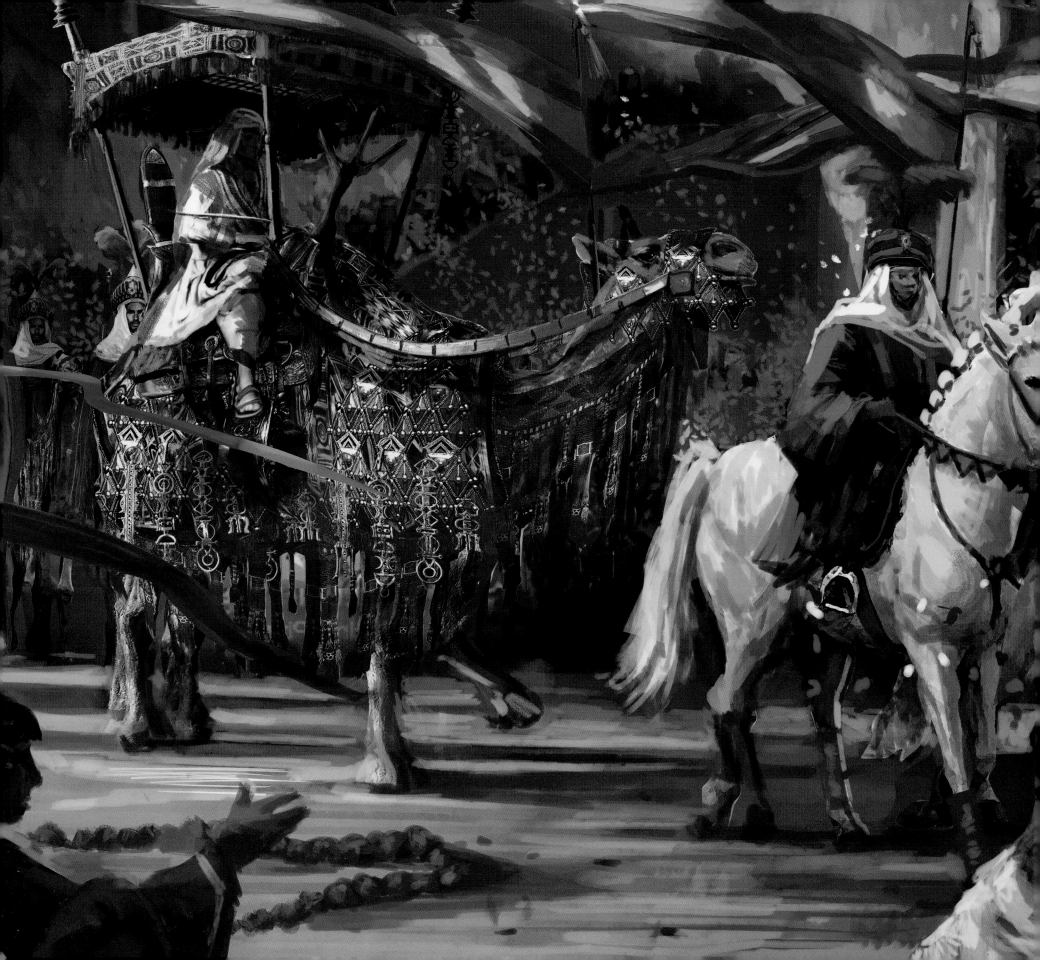

CHOREOGRAPHY AND DANCING

Chapter 8

When working with animated characters, the sky is the limit when it comes to performing physically demanding dance moves. With live-action movies, actors have to be able to actually perform the steps, which is why Ritchie and the producers brought in choreographer Jamal Sims to create high-energy dance numbers to accompany the classic songs. Sims, who grew up with the original film, had an immediate reaction to the tale that helped him shape the characters' motion.

"Aladdin's a street kid," Sims says. "I grew up as a dancer without any formal training, so that was something I connected to instantly. People just count you out if you don't have formal training, so it's cool to be able to do something like this and work with a character like Aladdin, where, sometimes, you never know what's inside of us. I instantly connected to that story."

Sims allowed the story and the music to act as a roadmap for his choreography, approaching each sequence with intention and an eye for details. He wanted every single movement to have a thought behind it. The choreographer looked to dance styles from around the world for inspiration, with many ideas coming directly from the Middle East. Because Agrabah is a fictional place, Sims was able to combine various styles in a fresh way.

"I wanted to take a lot of the different dance cultures from [countries like] China, India, Egypt," he says. "I wanted to mix it all together with what we know in Los Angeles as current and contemporary dance, and I've taken pieces of everything and molded it together. That's what I was excited about because I feel like if we were just to stick to a typical jazz or hip-hop number it probably wouldn't read well. So I took elements of

PAGES 138–139: Early concept art of Prince Ali's entourage entering the city.

ABOVE: Prince Ali rides a camel through the streets of Agrabah on his way to the palace in this concept art.

all the things that people currently know and mixed them with all of the different cultures of dance. It's cool to create and do something that has never been done before."

Sims wanted to bring the high-energy feeling from the dance numbers in the original film without compromising naturalism. He worked with each actor to develop a specific signature movement style for individual characters.

"I wanted to keep a sense of who we are and how we move as humans," Sims says. "With Mena, he's not dancing in every number, but the way he walks down the street, the way he may take a coat from a guard, it all has to be smooth and have a dance element to it. I tried to give each character their own movement vocabulary, and I think that helps with them as actors as well."

Besides working closely with the main cast, Sims also had to audition and rehearse the hundreds of background dancers who appear in the "Prince Ali" sequence. To help with the process, Sims hired Nicky Andersen as both his assistant and Massoud's dance double. Costume designer Michael Wilkinson also collaborated with Sims.

"I knew that the movement of the fabrics was going to be a huge factor working on this musical," Wilkinson notes. "So when I was making my selections, I was sure to keep that in mind. I often chose fabric that looked rich but had a lightness that would really complement Jamal's amazing choreography. I designed sleeves, veils, petticoats, paneled garments, and other elements that would move well and create wonderful shapes with the dancing."

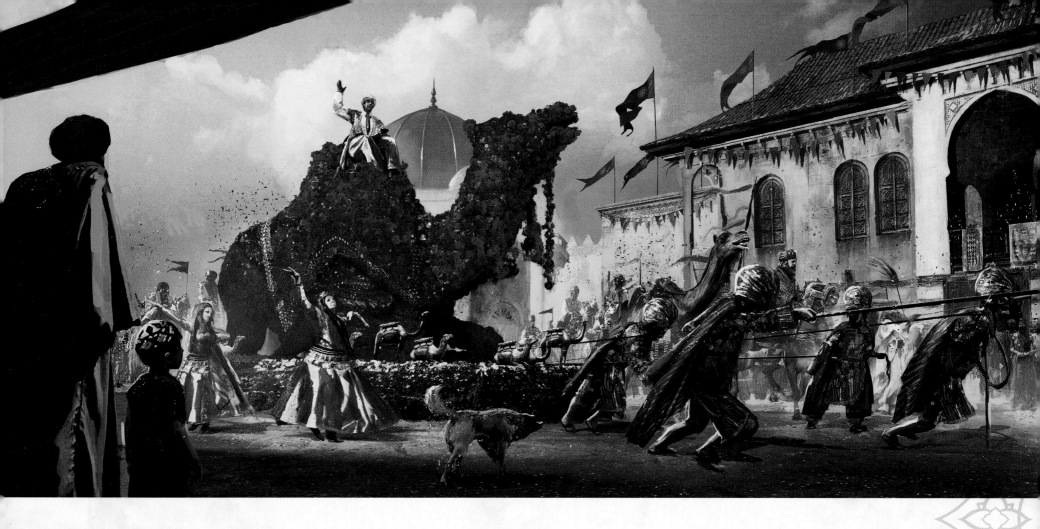

✎• ALADDIN •✎

When it came to Aladdin's stylish dance moves, Massoud had to start from scratch. The actor had almost no dance experience, so Sims spent time discussing the various sequences with Massoud and helping him internalize how Aladdin might stand or move in different situations until the movement became a natural part of the actor's performance as Aladdin. "We developed a language that is Aladdin," Sims notes. "I'm excited to see [Massoud's] growth from the very beginning—which was really from nothing—to now where he's doing all of the choreography, which is really cool." Massoud adds, "You surprise yourself if you just give yourself a chance and push yourself, you know?"

While the "street rat" version of Aladdin has some decent moves, the character really showcases his skill when he transforms into Prince Ali. At Ritchie's direction, Sims imagined that it is the Genie who gives Aladdin his skills as a dancer.

"The challenge for me was to make Aladdin look like he can't dance but then really quickly learn how to dance through the Genie's magic," Sims says. "You don't want anybody to look like they're a bad dancer, but sometimes we had to simplify the dancing for Aladdin so when he does dance well, we understand that it was the Genie who took him there. Through a little magic, we made that work."

Much of Aladdin's style was inspired by contemporary street dancing, which lends a modern flair to the film. Ritchie wanted to utilize dance styles that feel relevant instead of the traditional styles expected in a musical.

"I remember him saying that we've seen a whole bunch of jazz hands in a lot of musicals before," Sims says. "But [street dancing is cool now,] so it made sense to me, and it follows through with what he's done through the whole film—taking things that are happening in the world and making them fit into the story and making it digestible for everyone."

ABOVE: This concept art shows the camel made of flowers that appears in the movie.

ℰ • JASMINE • ℰℐ

Although Naomi Scott has a background in both singing and dancing, the actress still had to train for Jasmine's dance scenes and learn choreography for several big moments, including the Harvest Festival and her performance of "Speechless." "That girl is a mover," Sims says of Scott. "She's a performer. You just give [the moves] to her and she's got it. She's locked in."

"I'm not a trained dancer, but I can dance and I love learning choreography; it was definitely my favorite part of rehearsals!" Scott adds.

For the Harvest Festival, Scott was adamant with Sims that she could learn anything he brought to the table. Originally, the scene didn't have Jasmine dancing very much, but Sims wanted to flesh it out, giving Aladdin and Jasmine a moment of connection on the dance floor. The choreographer even added in something special for Scott.

"Naomi came into rehearsal and she killed it," Sims says. "And we put some belly dancing in there and she took right to it. [She's] pretty phenomenal in her dancing skills."

BELOW: Prince Ali asks Princess Jasmine to join him on a magic carpet ride in this concept art.

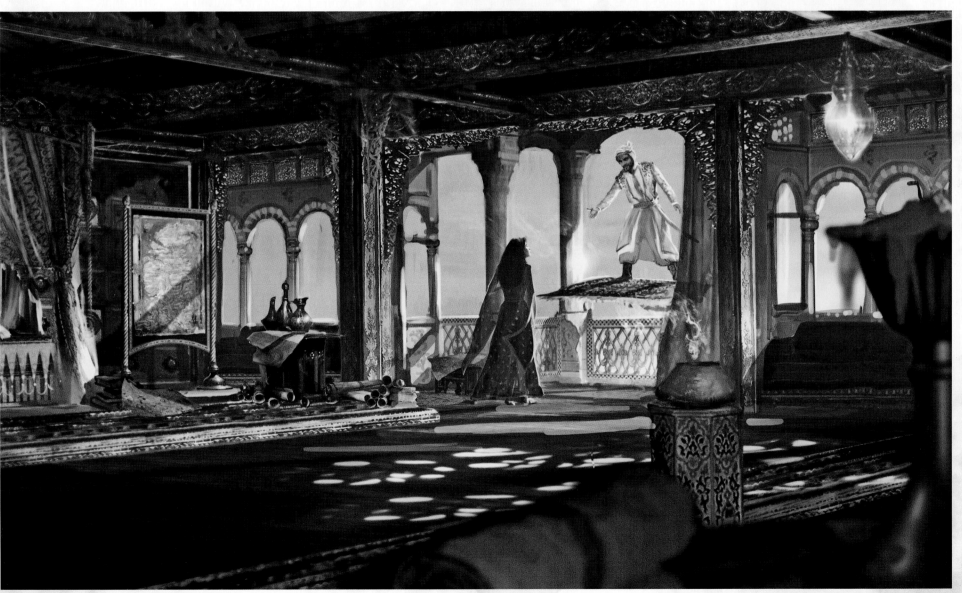

GENIE

As a performer, Will Smith is the whole package: singer, actor, and of course, dancer. Much of Smith's background is in hip-hop, so Sims wanted to adapt Genie's dance sequences to the actor's strengths. Genie has two big moments: the first when he shows off his magic to Aladdin in "Friend Like Me" and the second when he leads the "Prince Ali" parade through the streets of Agrabah. Sims wanted to be sure that Smith's moves were right for each song, especially "Friend Like Me."

"Will added the beatbox section which, you know, just totally came as a surprise," Sims notes. "It was a chance to put little old-school grooves into the sequence, a little break dancing."

Sims was surprised by how quickly the ideas for "Friend Like Me" came together. "When I think of *Aladdin*, I think about 'Friend Like Me,'" Sims says. "I don't care how many times I've heard this track, I've never gotten sick of it. Especially now that Will is on it—he has taken this song and taken it to the next level. I asked for maybe two or three weeks to prep 'Friend Like Me,' and it was choreographed from top to bottom in two days, which is rare for me, because I like to take my time. This is Genie's time to shine. He's over the top, and not all the time do we get a chance to do that. So I think that it was just the opportunity to really smash it."

Sims found Smith exceptionally quick when it came to learning the choreography, and his aptitude shines through on-screen. "All I have to do is tell him one time," Sims says. "You know, I could probably show it to him one time, and he'll say, 'I got it.' And I'll walk away thinking, 'He probably doesn't have it.' And then the cameras will roll, and not only does he have it, but he's put the character into it and added a little bit extra. I've never been more impressed with somebody, and I

am really not just trying to blow smoke. I really have never seen anybody be able to take movement and make it their own really quickly like Will does."

While Smith did most of Genie's dancing himself, Sims also worked with visual effects supervisor Chas Jarrett on the "Friend Like Me" sequence. In the scene, Genie is showing off, building a spectacle of magic and color that allows the character to move in fantastical and unexpected ways. Sims kept most of Smith's choreography grounded in reality but was able to combine some of the real moves with VFX to create the illusion that Genie can do crazy things with his body.

"The dancing can't move out too far because there's visual effects that have to go in between," Sims says. "But Chas has also given me an amazing gift, which is, 'Anything you could think of, we can do. We can do it with visual effects, you know?' And I'm like, 'Anything?' He's like, 'Anything.' It's been really challenging, and you just have to have faith in Chas that he's going to be able to bring it."

Jarrett combined Smith's live dancing with visual effects to create the final sequence. "For that sequence, we had a team of much more traditional animators—drawing animators—during the preproduction phase, and we designed the sequencing [for "Friend Like Me"] with drawn animation. It was a really interesting process, actually, for us," Jarrett says. "We tend to work with graphic artists, but these guys brought a great deal of understanding of traditional animation and the fun things you can do and also had real respect for the original film as well. Films like these are what inspired these guys to become animators. So for them to kind of work on this film and actually have an input and to evolve this film into the next generation's version of it is really, really exciting for them."

RIGHT: The Genie, seen in his human form in this concept art, sings as Prince Ali approaches the doors to the palace.

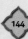

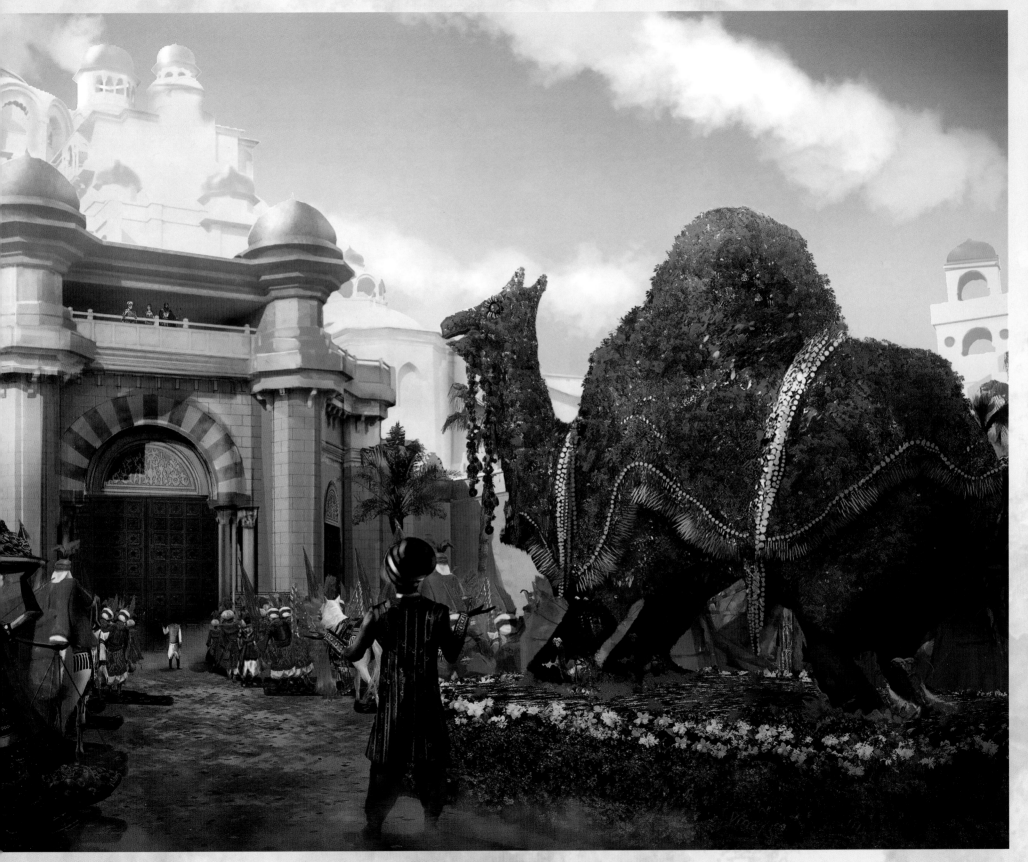

Chapter 9

CREATING THE FINALE

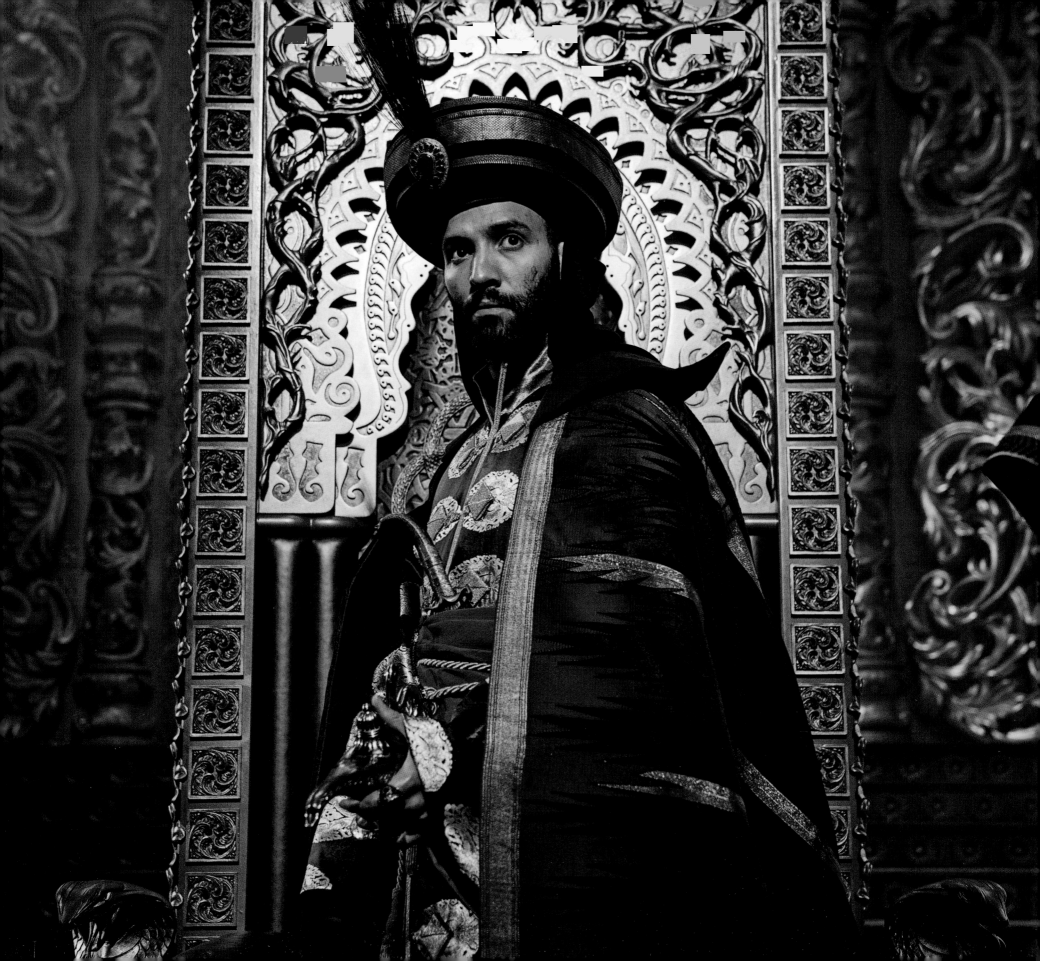

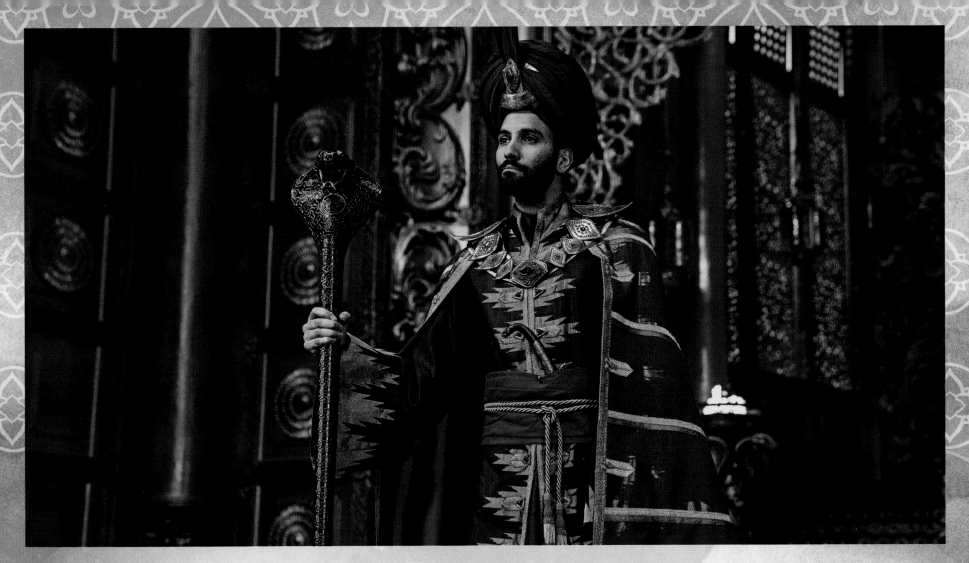

Aladdin may end with a happily ever after, but it takes an action-packed finale to get there. While the animated version confines its climactic ending to the palace, Ritchie wanted to create an even grander spectacle. Here, the evil Jafar still wields his influence to become sultan, then an all-powerful sorcerer. But this time, Jasmine and Aladdin leap into action to steal the magic lamp back from Jafar, and a thrilling chase ensues as the couple soars through Agrabah to save the day, with Iago on their tail.

To create this daring scene, the filmmakers used the mechanical rig built for "A Whole New World" and planned out exactly how Aladdin and Jasmine would move and react while rapidly flying through the streets of Agrabah. A second camera unit shot point-of-view footage to create the backgrounds as the duo zips through alleyways and over buildings.

"If it's their point of view and you're on the carpet with them and they're flying through market stalls, we had to have a camera fly through market stalls to get the background for what was happening," executive producer Kevin De La Noy says. "And if it was interactive, if they had to duck under a branch, we had to have the branch in camera and then bring the two together so that they ducked under something that wasn't there. We had a second unit work for six weeks shooting flying carpet point-of-view shots with a camera flying through market stalls, through arches, and up in the air, so that we had the backgrounds. And then that went into an edit, and then when we were doing the flying carpet chase on the flying carpet, we could call up those backgrounds, and we could do a poor man's comp; we could put the two together just to see if it works."

"A Whole New World" allowed Aladdin and Jasmine to sail peacefully through the skies on Carpet, but the action-packed chase sequence meant moving at a breakneck speed with dives and leaps. Before filming the actual chase, the team gave the actors a few tries at slower speeds so they could get used to the movements and choreography.

PAGES 146–147: In this concept art, the Great Hall is transformed to Jafar's preferences once he obtains the lamp.

OPPOSITE: Jafar holds the Genie's lamp after wishing to become sultan.

ABOVE: Jafar uses the lamp for his second wish and becomes an almighty sorcerer.

"We tested quite heavily to make sure each move that we did obviously matched what we wanted visually, but then also was safe," stunt coordinator Adam Kirley says. "So it was fairly rehearsed once they got there, and we let them have a few warm-up sessions. We could do a 20 percent version so they can really feel it. It builds up and builds up. It's a very safe process. I mean, they were fifteen feet in the air at some points, but they both seemed very comfortable with the heights and felt very safe."

Most of the scene was filmed on a stage in front of blue screens, ensuring that every movement was safe and carefully planned. Other elements came in later, including the visual effects, which make it look as though the pair is being chased through a stormy Agrabah. As Jasmine, Aladdin, and Abu rush off with the lamp, Jafar uses his newfound powers to transform Iago into a giant creature that pursues them.

"He's still got feathers. He's still got a parrot shape. But everything about his features is much more pronounced, much more jagged," visual effects supervisor Chas Jarrett says of Iago's new form. "His beak is jagged-edged, and the color of his feathers blacker, more inky and oily. It's definitely a magical transformation."

In evolving Iago from a small parrot into a monstrous creature, animation supervisor Tim Harrington studied how flying changes based on an animal's size. "So animation-wise, we had to be very careful about making sure that he felt heavy," he

BELOW: Images from the final sequences in the movie.

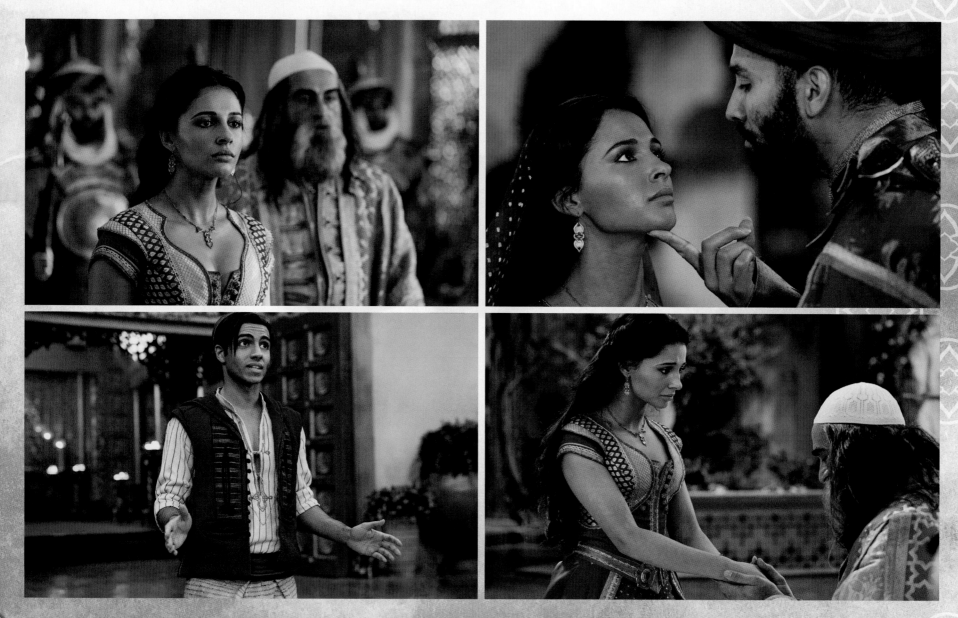

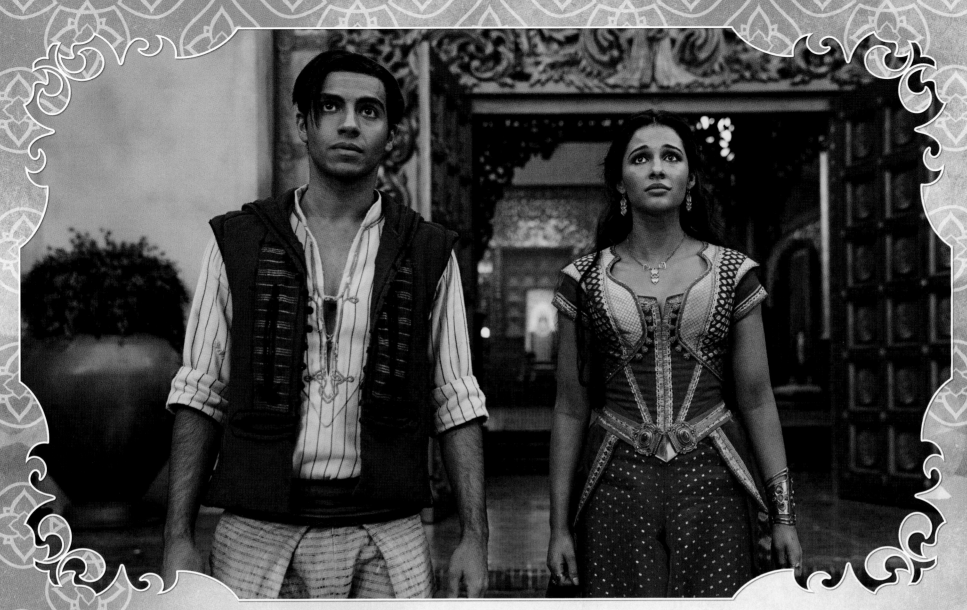

recounts. "The frequency of his wings flapping when he's flying is more high-frequency when he's a smaller bird. Once he becomes the bigger bird, it's this slow and laborious action that gives him more weight and presence. It makes him feel heavier. That was probably the biggest challenge, just making sure that the physics were believable because when he's up in the sky, there's not a lot of scale to use next to him. You have to make sure his movement feels really heavy."

Ultimately, Jafar is defeated after Aladdin tricks him into wishing to become a genie himself. The evil villain grows into a massive genie before being sucked into the confines of a magic lamp. The filmmakers wanted to ensure that every magical action made sense within the world of *Aladdin* instead of simply replicating the animated version. "Action involving the

real, physical set is governed by physics; action with genies is governed by your imagination because it's not real," De La Noy notes. "[There was] a consensus on what these mystical creatures can and can't do, and some of that is stemming from the animation. But most of it you work out as you go along—it feels right."

This new chase scene offers an added layer of excitement to the story, and for director Guy Ritchie, it was important to bring the action out of the palace and into the streets of Agrabah. "It felt like we needed to get out of the city—or at least out of the palace," Ritchie notes. "And I knew Jasmine needed to be involved with that sequence. This came organically because we needed something that could work within the live-action world rather than the animated world."

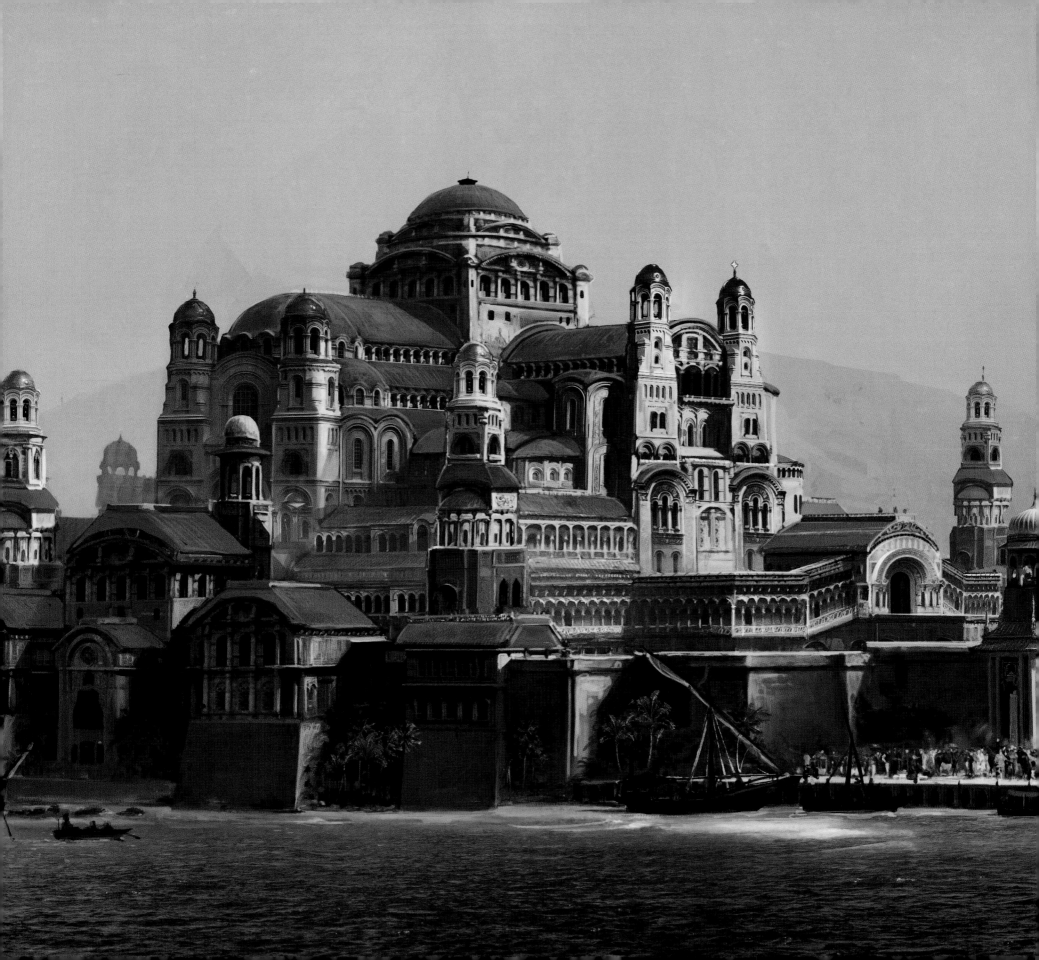

CONCLUSION

With its action-packed, high-energy scenes and emotional core, Guy Ritchie's *Aladdin* brings the tale into the modern era. By paying homage to Disney's beloved original film, which showcased dynamic magical animation and memorable songs, Ritchie has given the story and its characters a new and vibrant life. This live-action version is notably more contemporary with an emphasis on diversity, inclusion, and gender equality. The filmmakers have given viewers a relatable hero with Aladdin and a refreshed version of the Disney princess with Jasmine, inspiring audiences to grab hold of their own futures and never go speechless again. And Will Smith's Genie is a seminal entry into the world of *Aladdin*, a fresh take on an iconic character who guides the journeys of those around him. The film has humor, heart, and a real sense of whimsy.

"It is a film that has you smiling and laughing for such a long time throughout its duration," executive producer Kevin De La Noy says. "What's so impressed me with Guy is he brings the humor in right from the beginning, and it does not stop. It's just such a fun movie."

With its fantastical costumes, immersive sets, and vibrant visual effects, *Aladdin* emerges as a revitalized classic for viewers of all ages and demographics. Its reimagined narrative, new characters, and updated songs make it current and fresh, while the preservation of memorable scenes and the core original music reminds us why this story is so essential and beloved.

For Alan Menken, this version of *Aladdin* offers yet another entry point into the world of Agrabah. "The new movie is its own thing," Menken says. "Just as the original animated one is and as the Broadway show is its own separate piece. They're like spokes on a wheel. It's not like one leads to the other. All three of these mediums go back to the source material and then go in different directions."

Lyricists Benj Pasek and Justin Paul have been fans of *Aladdin* for their entire lives and credit the Disney Renaissance in the late 1980s and early '90s, which included *Aladdin*, as the reason that their generation loves musical theater. "It was the thrill of a lifetime to try to write in the lyrical voice and tone that [original lyricist Howard Ashman] created," says Paul.

"We were influenced tremendously by Howard's work and endeavored to honor that style and tone," Pasek adds. "*Aladdin* is something that is in our DNA because we really grew up with it—it raised us. We honestly wanted to be as invisible as possible and just try to serve the music and honor the incredible film that we grew up loving and that has served as an inspiration for us to do what we do now."

The actors, too, feel that *Aladdin* will resonate strongly with audiences around the world, as it has with them. The film is a reminder of the power of on-screen visibility for viewers of all cultures, genders, and backgrounds.

"I was such a huge fan of the animated version growing up," says Nasim Pedrad (Dalia). "There weren't many portrayals of Middle Eastern culture in Hollywood at the time, so to see that as an Iranian-American girl and identify with it was hugely impactful. I think the new version of the movie takes everything we love about the original and brings it into the modern era. Jasmine is resilient and independent. She's a leader who wants to feel connected to the people of her kingdom and do right by them. The world of *Aladdin* is so rich with colors and textures, so it's amazing to see the spectacle of it all come to life."

OPPOSITE: Concept art of Agrabah's beautiful palace.

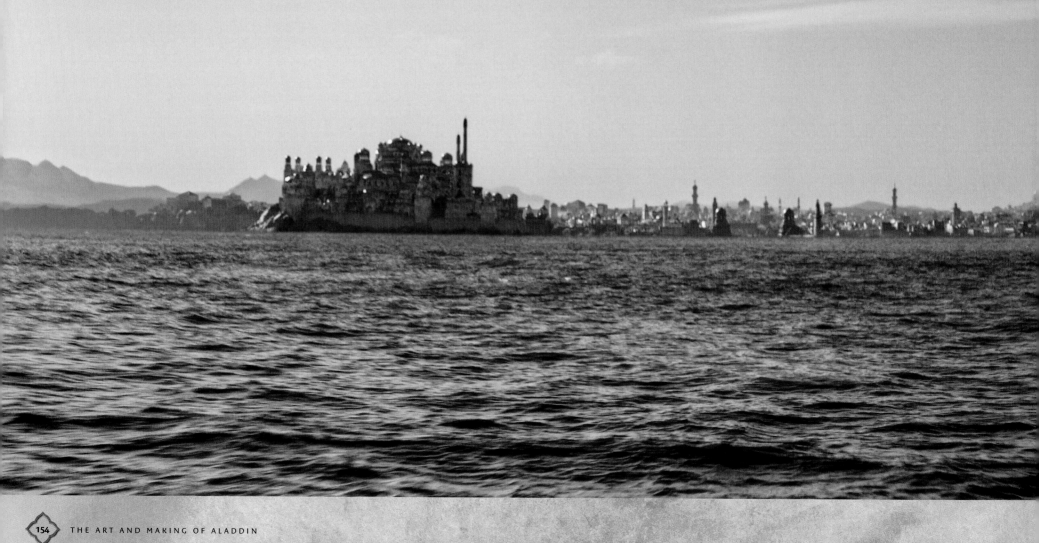

Aladdin is a love story for the ages, one that reminds us that you don't have to come from the same background to be meant for each other. Viewers can connect to the romance of the lead characters and to the colorful world they inhabit. Agrabah is now infused with real human beings. "This is a new piece because it's got beautiful, gorgeous people dancing, breathing, loving, crying, and all those things, but at the same time, the original animation was always a point of reference," production designer Gemma Jackson notes. "It's just a passionate and beautiful love story."

Guy Ritchie's first musical film is an exhilarating ride that marries Ritchie's fast-paced style with the magical world of Disney and leaves the audience thrilled. It's also the perfect film for viewers of all ages and backgrounds. "It's pretty much the world that I intended to create within the first five minutes of a meeting with Disney," Ritchie notes. "It's fun to make a film that you know you can sit down and watch with the whole family."

Ultimately, Ritchie is proud of the movie he created and the world built by his filmmaking team and cast. "I see myself as the viewer," he says. "And essentially, you make a movie for yourself and your family. I find that to be my North Star, which helps me get through all of the smaller battles. I feel confident that, as a director, if I am able to push through any creative or practical challenges, then it stops being work and just becomes pleasure, and if everyone enjoys the final product then, for a filmmaker, that's a job well done."

LEFT: The beautiful, sprawling city of Agrabah.

INSIGHT EDITIONS

PO Box 3088
San Rafael, CA 94912
www.insighteditions.com

Find us on Facebook: www.facebook.com/InsightEditions

Follow us on Twitter: @insighteditions

Published by Insight Editions, San Rafael, California, in 2019.

Library of Congress Cataloging-in-Publication Data available.

ISBN: 978-1-68383-682-7

Publisher: Raoul Goff
Associate Publisher: Vanessa Lopez
Creative Director: Chrissy Kwasnik
Designer: Evelyn Furuta
Senior Editor: Amanda Ng
Editorial Assistant: Maya Alpert
Senior Production Editor: Elaine Ou
Senior Production Manager: Greg Steffen

ROOTS of PEACE REPLANTED PAPER

Insight Editions, in association with Roots of Peace, will plant two trees for each tree used in the manufacturing of this book. Roots of Peace is an internationally renowned humanitarian organization dedicated to eradicating land mines worldwide and converting war-torn lands into productive farms and wildlife habitats. Roots of Peace will plant two million fruit and nut trees in Afghanistan and provide farmers there with the skills and support necessary for sustainable land use.

Manufactured in Italy by Insight Editions

10 9 8 7 6 5 4 3 2 1

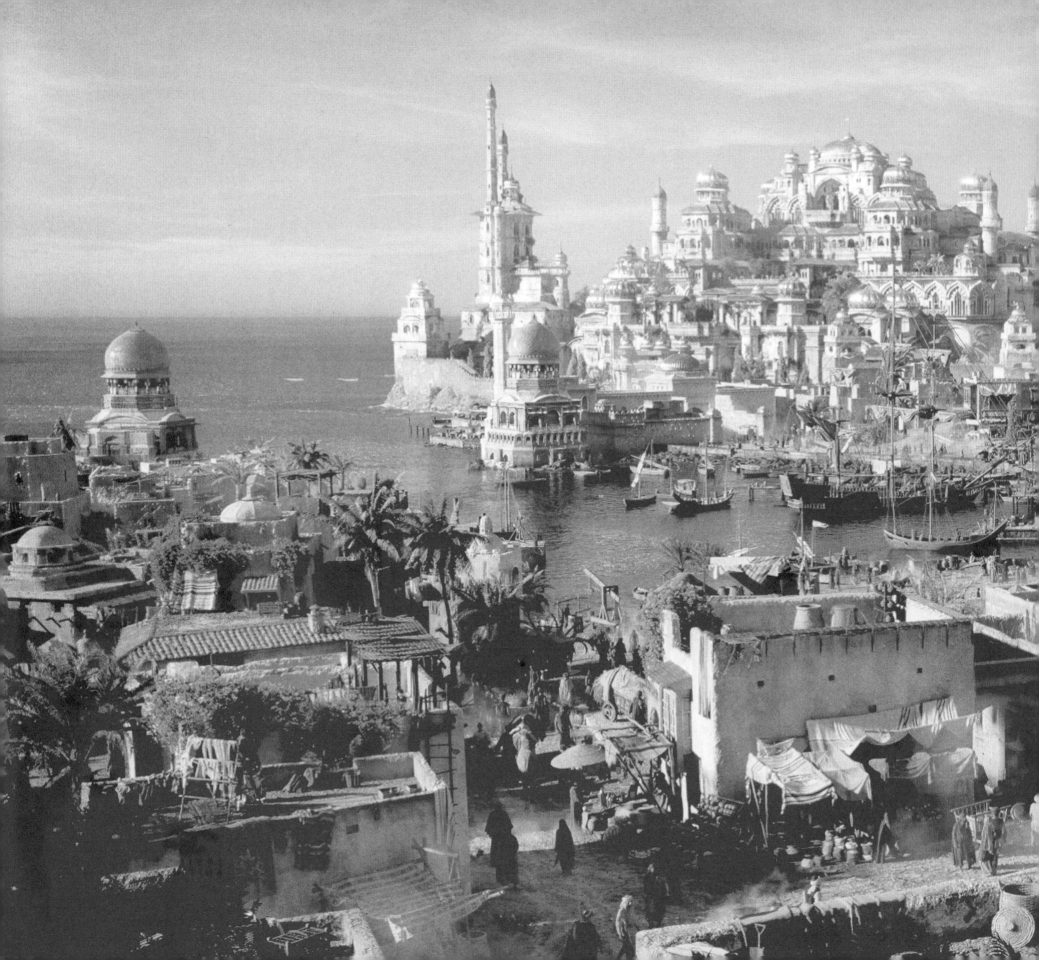